TUESDAY

To Morgan and Cameron

I stepped out of the shower
on the morning of September 11 2001.
Feet on the cool floor.
Lily wagging hello on the bath mat.

I heard steps getting closer, heavy.
Holding Morgan tightly
your mother opened the door
cold air came in
tears in her eyes.
Holding on
holding on to her precious daughter.

I listened to her words, smiled in disbelief and
ran downstairs to witness the second plane hitting 2WTC.

No words.

I dropped into the soft cushion of the sofa.
I watched and watched
listened
sank into thought
oh my God
this will change my life
the life of my family
my two young children.

Witnessing the events that
will be imprinted in my memory forever
those events that we will share as a family
a part of our history
terror and helplessness fell upon me.

I just wanted to hug and protect my family.
I had thought that my love would protect you
that morning I felt completely inadequate.

In a few minutes a country changed.
I changed.
The lives of thousands of people taken.

Why?

Too many thoughts and emotions.

Cameron, impatient crying

Morgan sitting at a small table drawing
your little world upside down
not knowing what to do
with the intense feelings
that your parents were experiencing.

"All the News That's Fit to Print"

The New York Times

Late Edition
New York: Today, mainly sunny and noticeably less humid, high 79. Tonight, clear, low 62. Tomorrow, sunny and cool, high 76. Yesterday, high 86, low 73. Weather map is on Page D8.

VOL. CL .. No. 51,873 Copyright 2001 The New York Times NEW YORK, TUESDAY, SEPTEMBER 11, 2001 $1 beyond the greater New York metropolitan area. **75 CENTS**

THE HOME STRETCH On the last day of campaigning, the mayoral candidates scoured the city for votes. Clockwise from top left, Fernando Ferrer, Peter F. Vallone, Alan G. Hevesi and Mark Green talked with voters in Brooklyn and Manhattan. The polls are open from 6 a.m. to 9 p.m. Page B1.

Photographs, clockwise from top left, by Librado Romero, Ruby Washington, Ruth Fremson and James Estrin/The New York Times

Scientists Urge Bigger Supply Of Stem Cells

Report Backs Cloning to Create New Lines

By SHERYL GAY STOLBERG

WASHINGTON, Sept. 10 — A panel of scientific experts has concluded that new colonies, or lines, of human embryonic stem cells will be necessary if the science is to fulfill its potential, a finding that is likely to inflame the political debate over President Bush's decision to restrict federally financed research to the 64 stem cell lines that are already known to exist.

In a 59-page report that examines the state of human stem cell science, the panel also endorsed cloning technology to create new stem cells that could be used to treat patients. Mr. Bush strongly opposes human cloning for any reason, and the House of Representatives voted in July to outlaw any type of cloning, whether for reproduction or research.

The report by the National Academy of Sciences, perhaps the nation's most eminent organization of scientists, is scheduled to be made public on Tuesday morning at a news conference in Washington. It does not address Mr. Bush's policy directly, though it strongly supports federal financing for stem cell research.

"High quality, publicly funded research is the wellspring of medical breakthroughs," said the report, a copy of which was provided to The New York Times by Congressional supporters of stem cell research. It added that federal financing, and the government oversight that comes with it, "offers the most efficient and responsible means of fulfilling the promise of stem cells to meet the need for regenerative medical therapies."

Though the academy often issues its reports in response to requests from the government, it embarked on this study on its own earlier this year. The study was not an exhaustive review of the scientific literature in stem cells, but was rather intended to examine the prospects for the research and to make policy recommendations. The report was written

Continued on Page A18

Strict Arsenic Limit Sought

Strict standards for arsenic in drinking water, suspended by the Bush administration, were justified, experts have concluded. Page A20.

KEY LEADERS TALK OF POSSIBLE DEALS TO REVIVE ECONOMY

BUSH IS UNDER PRESSURE

Lott Open to More Tax Cuts — Democrat Sees Temporary Dip Into Social Security

By ALISON MITCHELL and RICHARD W. STEVENSON

WASHINGTON, Sept. 10 — Key figures in both parties responded to the darkening economic outlook today by exploring possible compromises on additional tax cuts, and the Democratic chairman of the Senate Budget Committee suggested that such a deal could involve the politically perilous step of tapping temporarily into the Social Security surplus.

Pressure mounted on President Bush to drop his cautious approach to dealing with the weakening economy, much of it from within his own party. Republicans are voicing growing concern that the White House has underestimated public unease about the economy and the threat it poses to members of Congress up for re-election next year.

Confronted with polls showing that support for Republicans was eroding even before the government reported on Friday that the unemployment rate had surged, nervous Republicans moved on a variety of fronts.

In the House, Republican leaders agreed tonight to take up legislation in committee on Tuesday that would require automatic spending cuts if any Social Security money was spent on other government programs in the current fiscal year.

After accounting for the slowing economy and the tax cut signed into law by Mr. Bush in June, the Congressional Budget Office projected last month that the government would spend $9 billion of Social Security receipts in the fiscal year that ends Sept. 30. Both parties now expect that figure to be higher.

The White House sent a memorandum to all cabinet agencies today asking them to look for possible budget cuts as the administration develops tax and spending proposals for its next budget.

In the Senate, Trent Lott of Mississippi, the minority leader, said he was open to an idea floated by Democrats for a tax cut for workers who had not qualified for the current rebate. Workers who do not make enough money to pay federal income taxes but who still pay the payroll taxes that finance Social Security and Medicare will not receive rebate checks this year.

Mr. Lott said he would like to see

Continued on Page A20

Traced on Internet, Teacher Is Charged In '71 Jet Hijacking

By C. J. CHIVERS

Thirty years after a black-power revolutionary hijacked a jetliner from Ontario to Cuba and disappeared, Canadian and federal authorities matched the fingerprints he left on a can of ginger ale in the airplane with those of a teacher in Westchester County and charged the teacher with the crime yesterday.

The teacher, Patrick Dolan Critton, 54, of Mount Vernon, N.Y., was charged with kidnapping, armed robbery and extortion in United States District Court in Manhattan. He is facing extradition to Canada, where a detective had tracked him down through a simple Internet search.

The authorities said that Mr. Critton, a fugitive for 30 years, had been hiding in plain sight for the last seven years, working as a schoolteacher, using his real name, raising two sons and mentoring other children. Even one of the police officers who arrested him said he had the appearance and demeanor of a gentleman.

But as a young man, the authorities said, Patrick Dolan Critton was a revolutionary with a taste for the most daring of crimes.

By 1971, when he was 24, he was wanted by the New York City police on charges that he participated in a bank robbery tied to a frantic gun battle with the police, and that he had worked in a covert explosives factory on the Lower East Side, where the police said he made pipe bombs with other members of a black liberation group, the Republic

Continued on Page B6

Nuclear Booty: More Smugglers Use Asia Route

By DOUGLAS FRANTZ

ISTANBUL, Sept. 10 — The police in Batumi, a Black Sea port in Georgia, heard a rumor in July that someone wanted to sell several pounds of high-grade uranium for $100,000. The most calculating aspect of the tip was that one of the sellers was reportedly a Georgia Army officer.

"All sorts of scoundrels have tried nuclear smuggling in recent years. Many are amateurs; most of what they try to peddle proves useless for making bombs.

But the possible involvement of an army officer gave the Batumi case a measure of deadly seriousness, beyond its status as another example of how the smuggling of nuclear material has shifted to Central Asia.

On the morning of July 20, the local antiterrorist squad burst into a small hotel room near the port, just outside the Turkish border. They arrested four men, including an army captain named Shota Geladze.

On the floor of the room, in a glass jar wrapped in plastic, sat nearly four pounds of enriched uranium 235, according to Revaz Chantladze, one of the police officers. The quantity was less than is usually required for a small atomic bomb.

Subsequent analysis yielded differing opinions. A Western diplomat

Continued on Page A10

In a Nation of Early Risers, Morning TV Is a Hot Market

By BILL CARTER

How much morning television can one nation watch?

Ever since the owlish Dave Garroway ambled through the "Today" program on NBC starting in 1952, sometimes accompanied by a chimpanzee, television screens have greeted awakening Americans with the combination of hard news, feature reports and soft celebrity interviews that has come to be known as the morning news program.

But the competition for bleary eyes has grown more intense as media conglomerates have awakened to

the idea that changing lives, heightened interest from advertisers and other factors have made the morning one of the few areas of growth in the television business.

That trend was underscored last week when CNN raided its rival all-news cable network, Fox News, and took the anchor Paula Zahn for a new morning program it will begin next spring from inside the Time & Life Building at 50th Street on the Avenue of the Americas in Midtown Manhattan.

According to Fox executives, reading from the offer sheet they said CNN gave to Ms. Zahn, CNN agreed to triple her salary, bringing it over the $2 million mark.

The figure would be by far the most money CNN has ever paid for an anchor, far more than double what CNN agreed to pay to Aaron Brown, the anchor it has brought in from ABC to lead a prime-time newscast.

The raid and Fox's response — a lawsuit — represent the latest nasty interchange between Fox News and CNN, and serve as a proxy for a larger corporate battle between

Continued on Page C16

City Voters Have Heard It All As Campaign Din Nears End

By JIM DWYER

The first time the phone rang, Victoria Ehigiator was elbow deep in a sink of soapy dishes. She dried her hands and picked up the phone. It was Al Sharpton on the line, calling about the primary election. He said his piece, and she went back to the dishes. A few minutes later, the phone rang again, and she lifted herself from the bubbles once more.

That time it was Fernando Ferrer. And then it was Gloria Davis. Followed by Adolfo Carrión.

As one digitized caller after another dropped into her home, thanks to new technology that can swamp the telephones in a ZIP code or an entire city with the actual voice of, say, Ed Koch, urging a vote for Peter Vallone, Ms. Ehigiator started to suspect that very few people in New York were not running for something — whether it was mayor, comptroller, public advocate, borough president or City Council.

And as for those few who weren't candidates, they all seemed to be calling her about those who were.

Had Bill Bradley actually phoned her about Herb Berman? And who was Herb Berman, anyway? (Psst: he's a council member running for comptroller.)

"There was another guy — his name starts with S," said Ms. Ehigiator, of Morrisania in the Bronx, offering no other clues. "I'm trying to do the Sunday dishes but I never got off the phone with all these animated

voice messages. It was a real fiesta of phone calls."

Today is the end of the busiest primary campaign around here that anyone can remember, and the candidates are ganging up on the small fraction of the electorate that customarily decides such races. From the high cliffs of northern Manhattan to the ocean foam at Rockaway Beach, New Yorkers report they are coping by slamming down the phone faster, throwing out the mail sooner,

Continued on Page B5

Violence in Mideast, Despite Plans to Talk

With truce talks tentatively set for today, Palestinians and Israelis did not wait for dawn to resume their all-but-declared war. Two Israeli soldiers were slain by Palestinian snipers near the checkpoint separating the Palestinian town of Tulkarm from Israel, and soon Israeli tanks were ringing Jenin, also in the West Bank, shelling Palestinian positions outside the town.

Shimon Peres, the Israeli foreign minister, and Yasir Arafat, the Palestinian leader, negotiated late into the night over arrangements for the meeting today, but events may have made it all academic.

Article, Page A3.

School Dress Codes vs. a Sea of Bare Flesh

By KATE ZERNIKE

MILLBURN, N.J., Sept. 7 — In the tumult of bare skin that is the hallway of Millburn High School, Michele Pitts is the Enforcer.

"Hon, put the sweater on," she barks at a pair of bare shoulders. "Lose those flip-flops," to a pair of bare legs.

One student waves her off as Mrs. Pitts crosses her arms in a "Cover that cleavage" sign. "You talked to me already," the girl insists, then promises, "Tomorrow!" as she disappears around a corner.

Baseball caps, a taboo of yesteryear, pass by unchallenged, having slipped in severity on a list of offenses that now include exposed bellies, backs and thighs. For Mrs. Pitts, the assistant principal, there is simply too much skin to cover.

With Britney Spears and Cosmo Girl setting the fashion trends, shirts and skirts are inching up, pants are slipping down, and schools across the country are finding themselves forced to tighten their dress codes and police their hallways.

This fall, New York State is requiring all public school districts to adopt dress codes as part of a larger code of conduct. In North Carolina, the bill that allowed schools to post the Ten Commandments also required them to institute dress codes.

The days when torn jeans tested the limits are now a fond memory. Today, schools feel the need to remind students that see-through clothing is not appropriate. (The

Don Standing for The New York Times

The dress code at Millburn High School aims to raise standards and self-respect. It frowns on low necklines, bared shoulders, flip-flops and spaghetti straps.

Liverpool Central School District, near Syracuse, learned this when two high school girls showed up on Halloween dressed in Saran Wrap. Only one appeared to be wearing underwear.)

In the new dress codes, spaghetti straps are forbidden (straps must be no less than an inch and a half wide), as is clothing that "bares the private parts"; fishnet stockings and shirts; T-shirts with lewd messages; flip-flops or other clothing more suited to the beach; and skirts or shorts above midthigh. Boys cannot wear tank tops or

Continued on Page B7

INSIDE

Mrs. Dole to Run for Senate
Elizabeth Dole plans to announce that she will run in 2002 for the Senate seat being vacated by Jesse Helms of North Carolina. **PAGE A16**

Afghan Rebel's Fate Unclear
A day after a bombing aimed at the leader of the opposition to the Taliban, there were conflicting reports as to whether he survived. **PAGE A15**

Morgan Stanley Bias Suit
The Equal Employment Opportunity Commission filed a sex-discrimination suit against Morgan Stanley Dean Witter. **BUSINESS DAY, PAGE C1**

Giants Fail in Opener
The Giants allowed touchdowns in every quarter as the host Denver Broncos rolled to a 31-20 victory. **SPORTSTUESDAY, PAGE D1**

Debate Over Shark Attacks
Commercial fishermen are at odds with scientists over the reason for a spate of highly publicized shark attacks. **SCIENCE TIMES, PAGE F1**

FOR HOME DELIVERY CALL 1-800-NYTIMES

Updated news: www.nytimes.com

0 354631 37201

THAT CHANGED OUR LIVES FOREVER

WITNESS

Julian Schnabel

We saw a sky so hot that birds were on fire.

We saw people holding hands jumping to their death sounding like melons smashing, and, when we turned our heads not to look we still heard melons smashing.

We saw people running for their lives trying to get out of there and we saw other people, firemen, policemen, running into the burning buildings giving their lives to save others.

We saw people talking on TV in front of a pile that used to be a building and heard the sound of hundreds of beepers that were coming from the jackets of trapped firemen.

We saw the unseeable.

We saw humans filled with hate and despair fly airplanes into buildings trying to kill as many humans as possible.

We were there. It was also live on TV.

We saw a man holding onto the edge of a building by his fingers for about a minute hoping for the impossible.

We saw a world gone mad infected with self destruction.

We saw great acts of bravery from ordinary people who are in no way ordinary.

We saw people work past the edge of exhaustion.

We saw the future of our children disappear.

We saw our homes disappear and thought of others in faraway places who had no homes too.

We saw politicians talk of dropping food and supplies instead of bombs.

We saw New Yorkers being patient with each other.

We saw musicians, artists and all kinds of people leaning together to heal each other and pray for peace in the name of all of those who have fallen.

We as a nation are witness to the fact that there are people out there that don't like us.

We as a nation need to know why. Need to think of the others that we don't know from different places who have died and suffered because of our unconscious will and myopic business plans.

We need to think of others
 help others
 love others
 forgive others
 educate others
 heal ourselves
 learn from our mistakes
 learn from those who are selfless and generous.

We need to stop changing sides and leaving missiles behind.

We need to think of those people caught in the middle of ideology that just wanted to grow their crops and see their children grow up.

We must stop hate
 violence
 impatience
 fear of what is foreign.

We must do what we can.
 Sing, dance, paint, farm.
 Work, for love to heal each other.

We have seen compassion and resolution and brotherly love in the middle of one of the largest hate crimes in world history.

We have seen sanity in the face of insanity.

We have seen the end.

We don't have a choice we need to make a new beginning.

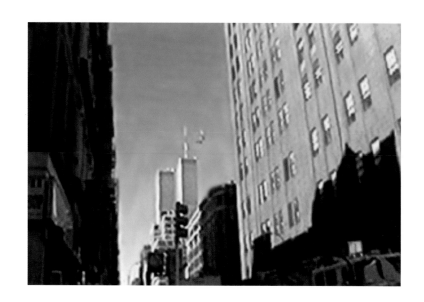

Hijacked American Airlines Flight 11 - a Boeing 767 with 92
passengers on board en route to Los Angeles from Boston - crashes
into the north tower (1WTC) of the World Trade Center.

8.45 AM

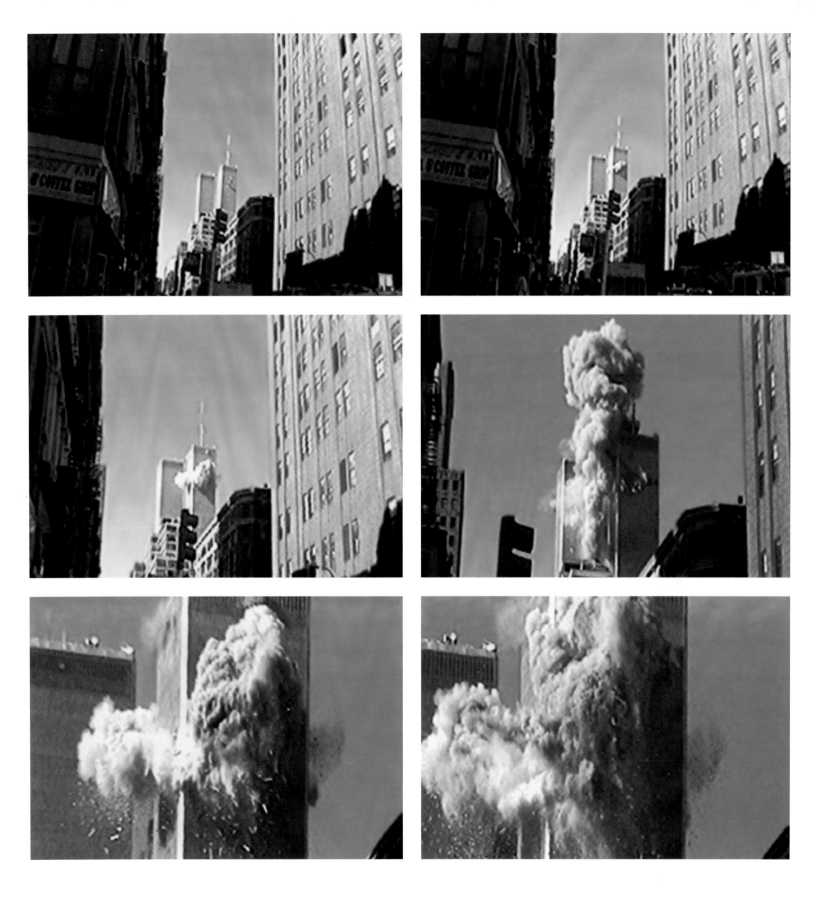

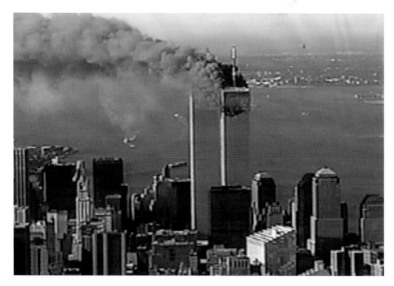
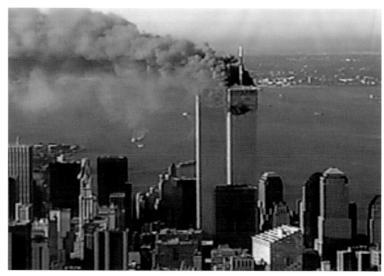
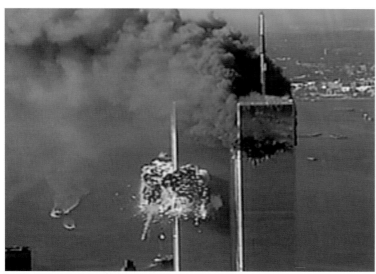
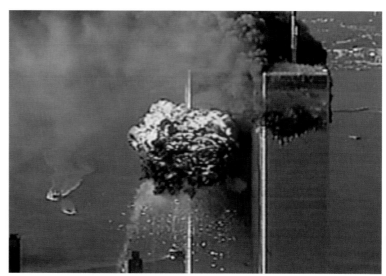

Hijacked United Airlines Flight 175 - a Boeing 767 with 65 passengers on board en route to Los Angeles from Boston - slams into the south tower (2WTC) of the World Trade Center.

9.06 AM

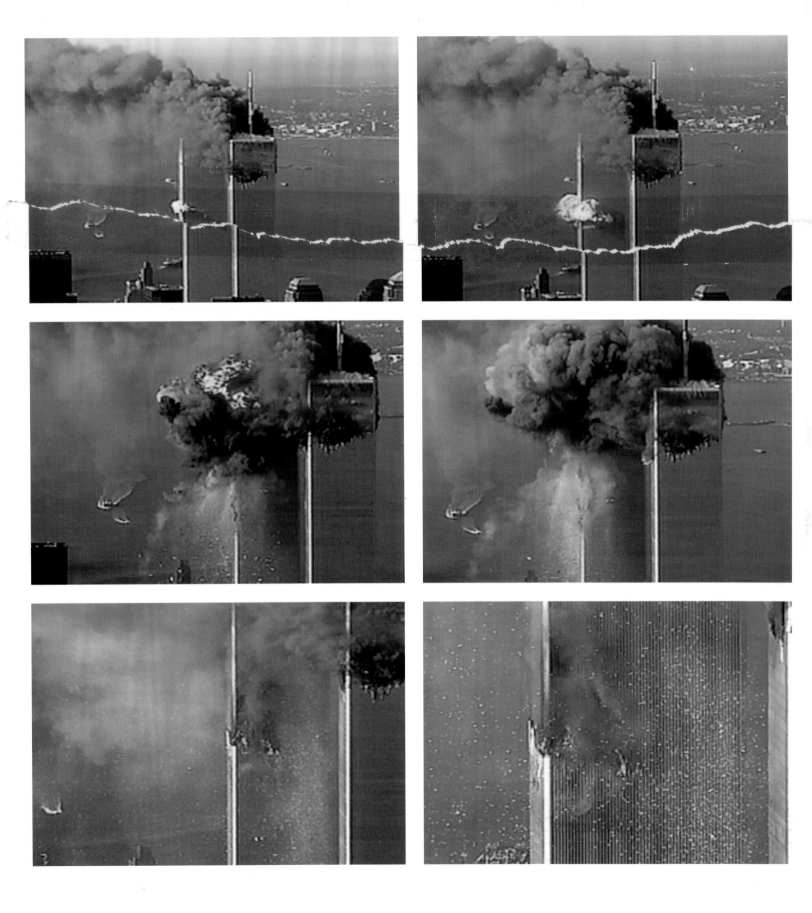

08.48.46 plane crashes into top of 1WTC

08.53.28 male caller states someone fell out of building

08.56.44 male caller states he is on 87 floor - states 4 person there with him - states there is fire
08.56.57 from floor 47 female caller states building shook and smells gas

08.57.02 male caller states smoke on 106 floor - people cannot get down
08.57.26 people screaming in background - states cannot breathe - smoke coming through the door - 103 floor - trapped
08.57.54 male caller states smoke on 104 floor

08.59.17 male caller from 86 floor - ceiling collapsed

09.01.34 male caller 104 floor - states there are 12 people stuck at location
09.01.53 female caller states her son and another male are trapped in room 8617

09.02.10 female caller states people are trapped on top of building - states need someone top of location

09.03.11 male caller wanted to know how to get out of building
09.03.12 male caller states on 105 floor there is smoke with a lot of people inside

09.04.14 male caller states people trapped on the 104 floor in back room - states 35-40 people

09.04.24 male caller states trapped on floor 22 - hole in hallway - smoke coming - unable to breathe - caller states will break window
09.04.50 male caller states 103 floor cannot get out - fire on floor - people getting sick
09.04.50 people falling out of building
09.07.10 jumper
09.07.40 female caller states she is pregnant - floor 103 - 30 people lots of smoke

09.07.51 plane hits 2WTC

09.08.02 female caller screaming
09.08.54 people trapped in the building - 68 floor

09.09.14 male caller states he is in the office with 40 to 60 people - unsure which way to go
09.09.21 male caller states 2WTC - people are jumping out the side of a large hole - no one catching them
09.09.25 male caller states difficult breathing at location
09.09.43 on floor 104 states all stairs are blocked

09.10.22 stuck elevator on 104 floor people in elevator

09.12.18 male caller states on 106 floor about 100 people in room - need directions on how to stay alive

09.13.52 female caller unable to ID exact location needs help

09.14.52 female caller 100 floor - unable to speak - 1WTC

09.15.34 several jumpers from the windows at 1WTC

09.17.20 male caller states he cannot get out - 1WTC
09.17.39 male caller states on 105 floor - stairs collapse

09.19.20 120 people trapped on 106 floor - a lot of smoke cannot see fire - cannot go down or up the stairs
09.19.58 evacuation to top floor of 1WTC

09.21.31 female caller states they are in stairway C floor 82 - doors are locked at location - states need someone to open door

09.22.23 male caller states he is on floor 84 2WTC cannot breathe - call disconnected

09.23.28 female caller states she saw person in building - person is waving

09.27.33 female caller states husband friend just called - still alive on floor 101

09.28.42 female caller states someone waving a white flag 1WTC - 10 floor down from top

09.32.14 2WTC floor 105 - people trapped - open roof to gain access

09.36.33 female caller states they are stuck in the elevator - states people is dying

09.38.52 male caller states - called before states he needs help - states he cannot find staircase to get out of location states people need help on floor 105

09.39.40 female caller states very hot no door - states she is going to die - still on phone - want to call mother

09.40.45 male caller states people passing out
09.42.04 male caller states people still jumping off tower

09.47.15 female caller 2WTC - floor 105 - states floor

underneath her collapsed
09.47.23 male waving jacket - male just jumped

09.49.21 1WTC 20 people on the top waving - they are alive - please send help

09.54.21 hear people crying - no voice contact
09.54.36 male caller states on floor 93 - 30 people in the room - states smoke is getting worse

09.55.28 2WTC - floor 106 - 105 floor crumbling

10.00.45 2WTC has collapsed - all calls disconnected

10.07.54 trapped building fell on them

10.12.35 male caller sates he can barely breathe - floor 105

10.29.42 1WTC entire tower down - all calls disconnected

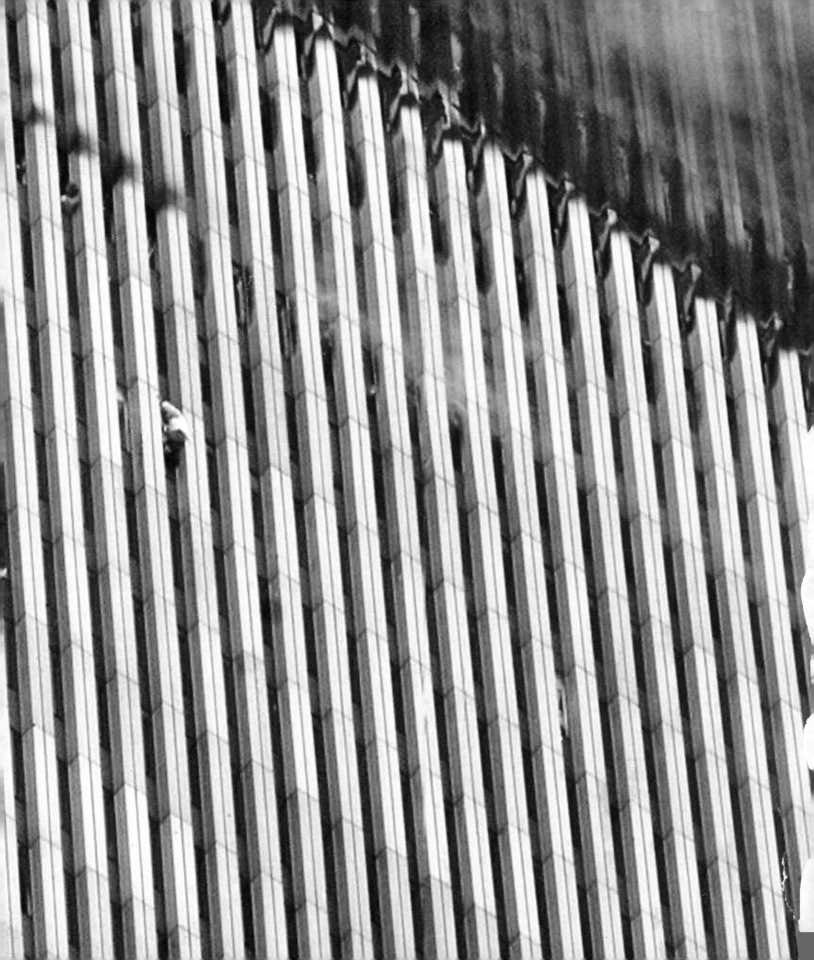

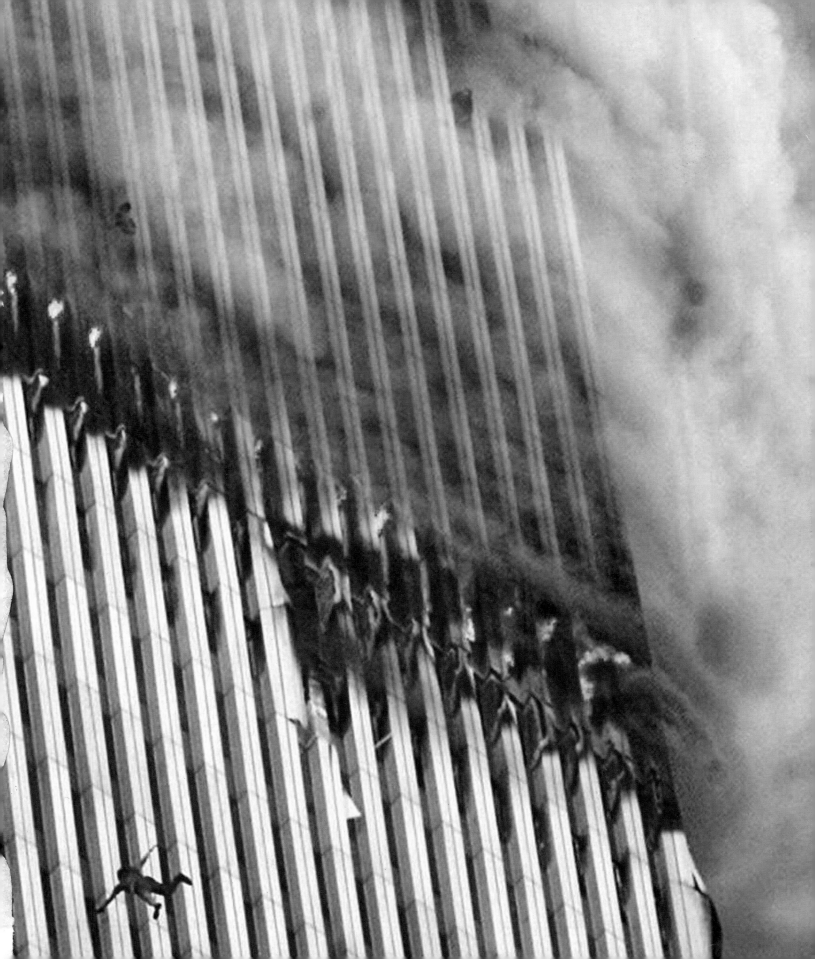

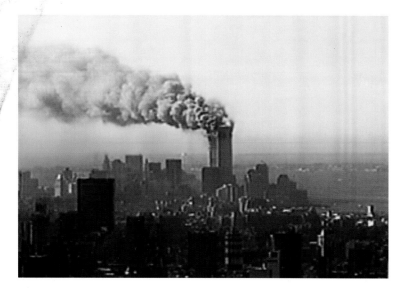
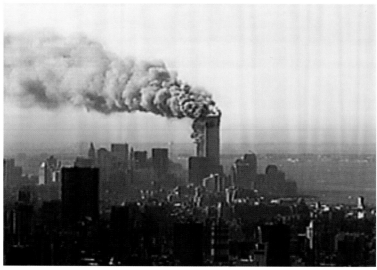
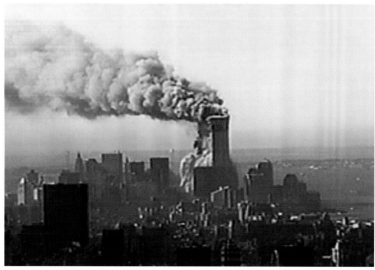
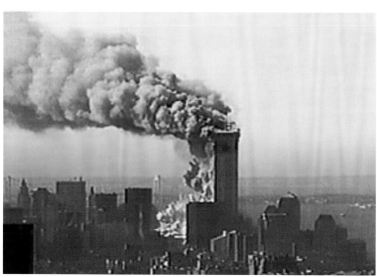

The south tower (2WTC) of the World Trade Center collapses.

10.00 AM

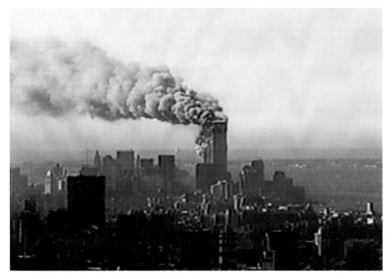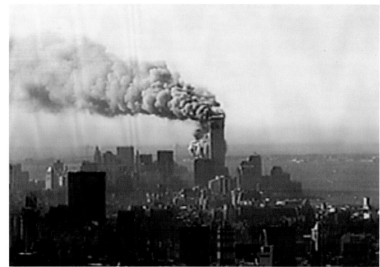
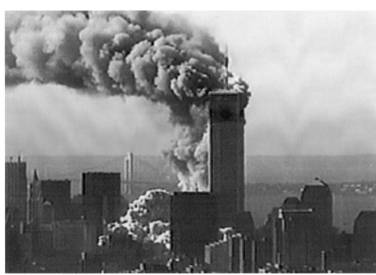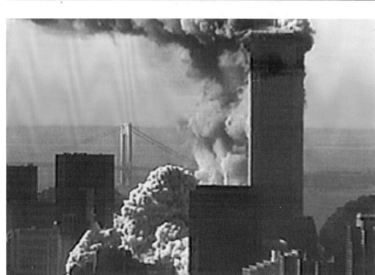

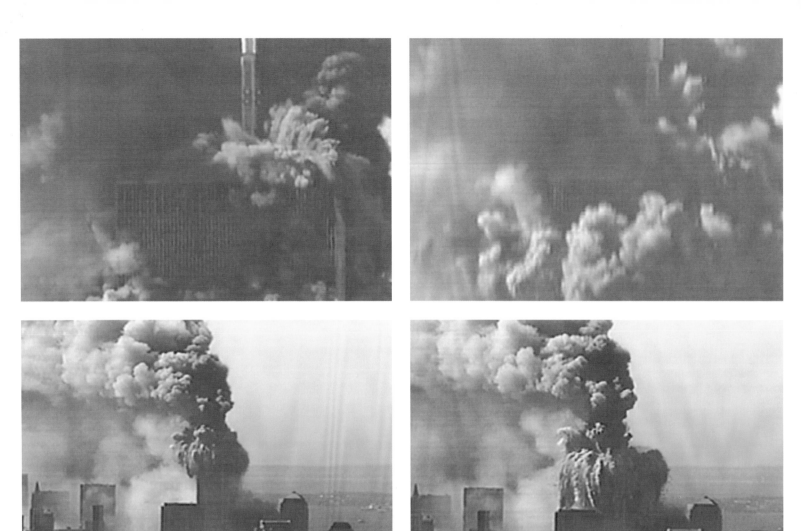

The north tower (1WTC) of the World Trade Center collapses.

10.29 AM

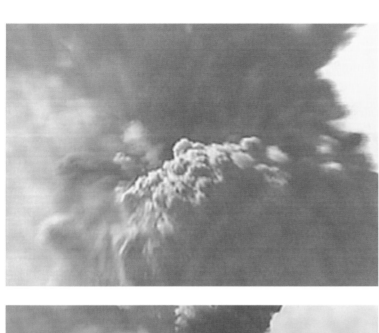
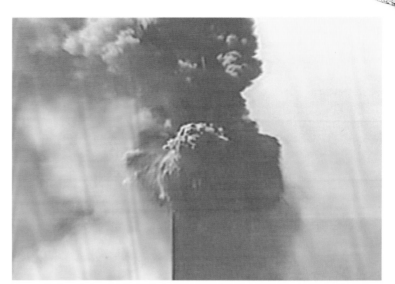
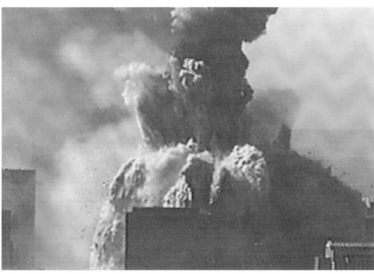
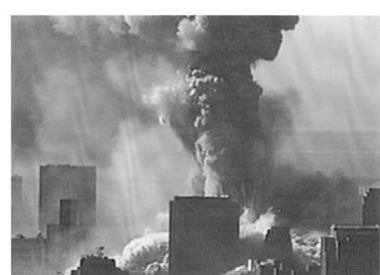
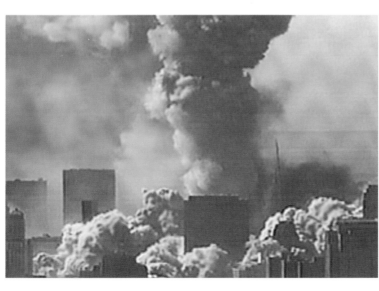
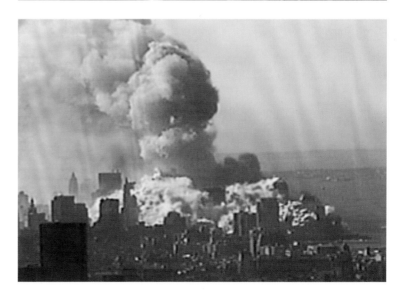

Breathe

Breathing deep
the lungs fill up with

floating souls

Quiet, secret souls
that enter deep into the heart

A calm and quiet
storm they fall
as flakes of ash
or winter snow

These souls carry with them
a message
one your own soul comprehends

Breathing deep again
you hear the souls cry out
your ears and eyes can stand no more
the stomach twists and knots
but your breathing doesn't stop

Dust spills down upon you
your lungs and eyes now burn

Breathing deep I cry
I cry and cry
and cry
for, I know,

this is goodbye

Matthew Modine Greenwich Village 9.11.01

American Airline Flight 11

John Ogonowski
Thomas McGuinness
Barbara Arestegui
Jeffrey Collman
Sara Low
Karen Martin
Kathleen Nicosia
Betty Ong
Jean Roger
Dianne Snyder
Madeline Sweeney
Anna Williams Allison
David Angell
Lynn Angell
Seima Aoyama
Myra Aronson
Christine Barbuto
Berry Berenson
Carolyn Beug
Carol Bouchard
Robin Caplin
Neilie Casey
Jeffrey Coombs
Tara Creamer
Thelma Cuccinello
Patrick Currivan
Andrew Curry
Brian Dale
David DiMeglio
Donald Ditullio
Albert Dominguez
Alex Filipov
Carol Flyzik
Paul Friedman
Karleton D.B. Fyfe
Peter Gay
Linda George
Edmund Glazer
Lisa Fenn Gordenstein
Paige Farley Hackel
Peter Hashem
Robert Hayes
Ted Hennessey
John Hofer
Cora Holland
Nicholas Humber
John Jenkins
Charles Jones
Robin Kaplan
Barbara Keating
David Kovalcin
Judy Larocque
Jude Larson
Natalie Larson
N. Janis Lasden
Daniel John Lee
Daniel C. Lewin
Susan MacKay
Chris Mello
Jeff Mladenik
Antonio Montoya
Carlos Montoya
Laura Lee Morabito
Mildred Naiman
Laurie Neira
Renee Newell
Jacqueline Norton
Robert Norton
Jane Orth

Thomas Pecorelli
Sonia Morales Puopolo
David Retik
Philip Rosenzweig
Richard Ross
Jessica Sachs
Rahma Salie
Heather Smith
Douglas Stone
Xavier Suarez
Michael Theodoridis
James Trentini
Mary Trentini
Mary Wahlstrom
Kenneth Waldie
John Wenckus
Candace Lee Williams
Christopher Zarba
Hijacker 1
Hijacker 2
Hijacker 3
Hijacker 4
Hijacker 5

United Airlines Flight 175

Robert Fangman
Michael Horrocks
Amy Jarret
Amy King
Kathryn Laborie
Alfred Marchand
Victor J. Saracini
Michael Tarrou
Alicia N. Titus
Alona Avraham
Garnet "Ace" Bailey
Mark Bavis
Graham Berkeley
Touri Bolourchi
Klaus Bothe
Daniel Brandhors
David Brandhorst
John Cahill
Christoffer Carstanjen
John "Jay" Corcoran
Gloria de Barrera
Dorothy Dearaujo
Lisa Frost
Ronald Gamboa
Lynn Goodchild
Rev. Francis Grogan
Carl Hammond
Christine Hanson
Peter Hanson
Susan Hanson
Gerald F. Hardacre
Eric Hartono
James E. Hayden
Herbert Homer
Robert Jalbert
Ralph Kershaw
Heinrich Kimmig
Brian Kinney
Robert LeBlanc
Maclovio "Joe" Lopez Jr.
Marianne MacFarlane
Louis Neil Mariani
Juliana Valentine McCourt
Ruth McCourt
Wolfgang Menzel

Shawn Nassaney
Marie Pappalardo
Patrick Quigley
Frederick Rimmele
James M. Roux
Jesus Sanchez
Kathleen Shearer
Robert Shearer
Jane Simpkin
Brian D. Sweeney
Timothy Ward
William Weems
Name undisclosed
Name undisclosed
Name undisclosed
Hijacker 1
Hijacker 2
Hijacker 3
Hijacker 4
Hijacker 5

World Trade Center[2]

Gordon McCannel Aamoth
Edelmiro (Ed) Abad
Maria Rose Abad
Andrew Anthony Abate
Vincent Abate
William F. Abrahamson
Richard Anthony Aceto
Heinz Ackermann
Paul Andrew Acquaviva
Donald L. Adams
Shannon Lewis Adams
Stephen Adams
Ignatius Adanga
Christy Addamo
Terence E. Adderley
Sophia B. Addo
Lee Adler
Daniel Thomas Afflitto
Emmanuel Afuakwah
Alok Agarwal
Mukul Agarwala
Joseph Agnello
David Agnes
Joao A. Aguiar
Lt. Brian Ahearn
Jeremiah J. Ahern
Joanne Ahladiotis
Shabbir Ahmed
Godwin Ajala
Gertrude M. Alagero
Andrew Alameno
Margaret (Peggy) Jezycki Alario
Gary Albero
Jon L. Albert
Peter Alderman
Jacquelyn D. Aldridge
Grace Alegre-Cua
David Alger
Ernest Alikakos
Edward L. Allegrett
Eric Allen
Joseph Ryan Allen
Richard Allen
Christopher Edward Allingham
Janet M. Alonso
Anthony Alvarado
Antonio Javier Alvarez
Juan Cisneros Alvarez

Telmo Alvear
Cesar A. Alviar
Tariq Amanullah
Angelo Amaranto
James Amato
Joseph Amatuccio
Christopher C. Amoroso
Kazuhiro Anai
Calixto Anaya
Joe Anchundia
Kermit Charles Anderson
Yvette Anderson
John Andreacchio
Michael Rourke Andrews
Jean A. Andrucki
Siew-Nya Ang
Joseph Angelini
Joseph Angelini
Laura Angilletta
Doreen J. Angrisani
Lorraine D. Antigua
Peter Paul Apollo
Faustino Apostol
Frank Thomas Aquilino
Patrick Michael Aranyos
David Arce
Michael G. Arczynski
Louis Arena
Adam Arias
Michael J. Armstrong
Jack Charles Aron
Joshua Aron
Richard A. Aronow
Japhet J. Aryee
Carl Asaro
Michael A. Asciak
Michael E. Asher
Janice Ashley
Thomas J. Ashton
Manuel O. Asitimbay
Lt. Gregg Arthur Atlas
Debbie S. Attlas-Bellows
Gerald Atwood
James Audiffred
Frank Louis Aversano
Ezra Aviles
Samuel Ayala
Sandy Ayala
Arlene T. Babakitis
Eustace (Rudy) Bacchus
John Badagliacca
Jane Ellen Baeszler
Robert J. Baierwalter
Brett T. Bailey
Tatyana Bakalinskaya
Michael S. Baksh
Julio Minto Balanca
Michael Andrew Bane,
Gerard Baptiste
Gerard A. Barbara
Paul V. Barbaro
James W. Barbella
Ivan Kyrillos Fairbanks Barbosa
Colleen Ann Barkow
David Barkway
Matthew Barnes
Sheila Barnes
Evan J. Baron
Renee Barrett-Arjune
Arthur T. Barry

Diane Barry
Maurice Barry
Scott D. Bart
Carlton W. Bartels
Guy Barzvi
Inna Basina
Alysia Basmajian
Kenneth W. Basnicki
Lt. Steven J. Bates
Paul James Battaglia
W. David Bauer
Ivhan Luis Carpo Bautista
Marlyn C. Bautista
Jasper Baxter
Michele (Du Berry) Beale
Paul Beatini
Jane S. Beatty
Larry Beck
Manette Marie Beckles
Carl Bedigian
Michael Beekman
Maria Behr
Yelena Belilovsky
Nina Patrice Bell
Andrea Della Bella
Stephen Elliot Belson
Paul Benedetti
Denise Benedetto
Domingo Benilda
Bryan Craig Bennett
Eric Bennett
Oliver Bennett
Margaret L. Benson
Dominick J. Berardi
James Patrick Berger
Steven Howard Berger
John Bergin
Alvin Bergsohn
Daniel D. Bergstein
Donna Bernaerts-Kearns
William Bernstein
David Berray
David S. Berry
Joseph Berry
William Reed Bethke
Timothy D. Betterly
Paul Beyer
Anil T. Bharvaney
Bella Bhukhan
Shimmy D. Biegeleisen
Peter Bielfeld
William Biggart
Brian Bilcher
Carl Bini
Gary Bird
Joshua David Birnbaum
George Bishop
Jeffrey D. Bittner
Balewa Albert Blackman
Christopher Joseph Blackwell
Susan L. Blair
Harry Blanding
Craig Michael Blass
Rita Blau
Richard M. Blood
Michael A. Boccardi
John Paul Bocchi
Michael L. Bocchino
Susan Bochino
Bruce (Chappy) Boehm

Mary Katherine Boffa
Nicholas A. Bogdan
Darren Bohan
Lawrence F. Boisseau
Vincent Boland
Alan Bondarenko
Colin Arthur Bonnett
Frank Bonomo
Yvonne Bonomo
Sean Booker
Juan Jose Borda Leyva
Sherry Ann Bordeaux
Krystine C. Bordenabe
Martin Boryczewski
Richard E. Bosco
John Howard Boulton
Francisco Bourdier
Thomas H. Bowden
Kimberly S. Bowers
Veronique (Bonnie) Nicole Bowers
Larry Bowman
Shawn Edward Bowman
Kevin L. Bowser
Gary Box
Gennady Boyarsky
Pamela Boyce
Michael Boyle
Alfred Braca
Kevin Bracken
David B. Brady
Alex Braginsky
Nicholas Brandemarti
Michelle Renee Bratton
Patrice Braut
Lydia Estelle Bravo
Ronald Breitweiser
Edward A. Brennan
Frank Brennan
Michael Emmett Brennan
Peter Brennan
Tom Brennan
Capt. Daniel Brethel
Gary Bright
Jonathan Briley
Mark A. Brisman
Paul Bristow
Victoria Alvarez Brito
Mark Francis Broderick
Herman C. Broghammer
Keith Broomfield
Lloyd Brown
Capt. Patrick Brown
Mark Bruce
Richard Bruehert
Andrew Brunn
Capt. Vincent Brunton
Ronald Bucca
Eustice R. Bucchus
Brandon J. Buchanan
Greg Joseph Buck
Dennis Buckley
Nancy Bueche
Patrick Joseph Buhse
John E. Bulaga
Stephen Bunin
Matthew J. Burke
Thomas Daniel Burke
Capt. William F. Burke
Donald James Burns
Kathleen A. Burns

Keith James Burns
John Burnside
Milton Bustillo
Thomas Butler
Patrick Byrne
Timothy G. Byrne
Jesus Cabezas
Lillian Caceres
Brian Joseph Cachia
Steven Cafiero
Richard M. Caggiano
Cecile M. Caguicla
Michael Cahill
Scott W. Cahill
Thomas J. Cahill
George Cain
Salvatore B. Calabro
Edward Calderon
Kenny Caldwell
Dominick E. Calia
Capt. Frank Callahan
Liam Callahan
Luigi Calvi
Roko Camaj
Michael Cammarata
David Campbell
Geoff Campbell
Juan Ortega Campos
Sean Canavan
John A. Candela
Vincent Cangelosi
Stephen J. Cangialosi
Lisa B. Cannava
Brian Cannizzaro
Michael R. Canty
Louis A. Caporicci
Jonathan N. Cappello
James Christopher Cappers
Richard M. Caproni
Jose Cardona
Dennis M Carey
Edward Carlino
Michael Carlo
David Carlone
Mark Stephen Carney
Jeremy M. Carrington
Michael T. Carroll
Peter Carroll
James J. Carson
Christopher Newton Carter
James Cartier
John F. Casazza
Paul Cascio
Kathleen Hunt Casey
Margarito Casillas
Thomas Anthony Casoria
William Otto Caspar
Alejandro Castano
Arcelia Castillo
Leonard M. Castrianno
Jose Castro
Richard G. Catarelli
Sean Caton
Robert J. Caufield
Judson Cavalier
Michael Joseph Cawley
Jason D. Cayne
Marcia G. Cecil-Carter
Jason Cefalu
Thomas J. Celic

Ana M. Centeno
Juan Cevallos
Jeffrey M. Chairnoff
Eli Chalouh
Charles (Chip) Chan
Mark L. Charette
Gregorio Manuel Chavez
Pedro Francisco Checo
Douglas MacMillan Cherry
Stephen Patrick Cherry
Vernon Cherry
Nestor Chevalier
Swede Joseph Chevalier
Alexander H. Chiang
Dorothy J. Chiarchiaro
Luis Alfonso Chimbo
Robert Chin
Nicholas Chiofalo
John Chipura
Peter A. Chirchirillo
Catherine E. Chirls
Kaccy Cho
Mohammed S. Chowdbury
Abdul K. Chowdhury
Kirsten L. Christophe
Pamela Chu
Steven P. Chucknick
Wai Chung
Christopher Ciafardini
Alex Ciccone
Frances Ann Cilente
Edna Cintron
Nestor Andre Cintron
Lt. Robert Cirri
Eugene Clark
Gregory A. Clark
Thomas R. Clark
Christopher Robert Clarke
Donna Clarke
Michael Clarke
Kevin F. Cleary
Jim Cleere
Geoffrey W. Cloud
Susan M. Clyne
Steven Coakley
Jeffrey Coale
Patricia A. Cody
Daniel Michael Coffey
Jason Matthew Coffey
Florence Cohen
Kevin Cohen
Anthony Joseph Coladonato
Mark J. Colaio
Stephen J. Colaio
Christopher M. Colasanti
Kevin N. Colbert
Michel P. Colbert
Keith E. Coleman
Scott Coleman
Tarel Coleman
Jean M. Colin
Robert D. Colin
Robert J. Coll
Jean M. Collin
John Collins
Michael L. Collins
Thomas J. Collins
Patricia Malia Colodner
Linda M. Colon
Sol E. Colon

Ronald Comer
Jaime Concepcion
Albert Conde
Denease Conley
Susan Clancy Conlon
Margaret Mary Conner
Cynthia L. Connolly
John E. Connolly
James Lee Connor
Jonathan (J.C.) Connors
Kevin P. Connors
Kevin Francis Conroy
Brenda E. Conway
Dennis Michael Cook
Helen Cook
James L. Cooper
John Cooper
Joseph Coppo
Gerard Coppola
Joseph A. Corbett
Robert Cordice
Ruben D. Correa
Danny A. Correa-Gutierrez
James Corrigan
Carlos Cortes
Kevin M. Cosgrove
Dolores Marie Costa
Digna Costanza
Charles G. Costello
Michael Costello
Conrod K Cottoy
Martin Coughlan
John Gerard Coughlin
Timothy John Coughlin
James E. Cove
Andre Cox
Frederick John Cox
James Raymond Coyle
Michelle Coyle-Eulau
Anne M. Cramer
Christopher S. Crame
Denise Crant
James L. Crawford
Robert Crawford
Joanne Cregan
Lucia Crifasi
John Crisci
Dennis Cross
Helen Crossin-Kittle
Kevin R. Crotty
Thomas G. Crotty
John Crowe
Welles Remy Crowther
Robert L. Cruikshank
Francisco Cruz
John Robert Cruz
Kenneth John Cubas
Richard Joseph Cudina
Neil Cudmore
Thomas Patrick Cullen
Joan McConnell Cullinan
Joyce Cummings
Brian Thomas Cummins
Nilton Albuquerque Fernao Cunha
Michael J. Cunningham
Robert Curatolo
Laurence Curia
Paul Curioli
Beverly Curry
Michael Curtin

Gavin Cushny
Manuel Da Mota
Caleb A. Dack
Carlos S. DaCosta
John Dallara
Vincent D'Amadeo
Thomas A. Damaskinos
Jack L. D'Ambrosi
Jeannine Damiani-Jones
Patrick W. Danahy
Mary D'Antonio
Vincent G. Danz
Dwight Donald Darcy
Elizabeth Ann Darling
Annette Andrea Dataram
Lt. Edward D'Atri
Michael D'Auria
Lawrence Davidson
Michael Allen Davidson
Scott Davidson
Niurka Davila
Clinton Davis
Wayne T. Davis
Calvin Dawson
Edward Day
Jayceryll M. de Chavez
Emerita (Emy) De La Pena
Azucena de la Torre
Cristina de Laura
Oscar de Laura
Frank A. De Martini
William T. Dean
Robert J. DeAngelis
Thomas Deangelis
Tara Debek
Anna Debin
James V. DeBlase
Paul DeCola
Simon Dedvukaj
Jason DeFazio
David A. Defeo
Monique E. DeJesus
Nereida DeJesus
Manuel Del Valle
Donald A. Delapenha
Vito Deleo
Danielle Delie
Joseph Della Pietra
Colleen Ann Deloughery
Anthony Demas
Martin DeMeo
Francis X. Deming
Carol K. Demitz
Manuel J. DeMota
Kevin Dennis
Thomas Dennis
Jean C. DePalma
Jose Nicholas Depena
Robert Deraney
Michael DeRienzo
David Derubbio
Christian D. DeSimone
Edward DeSimone
Lt. Andrew Desperito
Michael J. Desposito
Cindy Deuel
Melanie DeVere
Jerry DeVito
Robert P. Devitt
Dennis Devlin

Gerard Dewan
Simon Dhanani
Michael L. DiAgostino
Lourdes Galleti Diaz
Nancy Diaz
Michael Diaz-Piedra
Joseph D. Dickey
Lawrence P. Dickinson
Michael D. Diehl
John DiFato
Vincent F. DiFazio
Carl DiFranco
Donald J. DiFranco
Alexandra Costanza Digna
Debra Ann DiMartino
Stephen P. Dimino
William J. Dimmling
Marisa Dinardo
Christopher Dincuff
Jeffrey M. Dingle
Anthony DiOnisio
George DiPasquale
Douglas F. DiStefano
Ramzi A. Doany
John J. Doherty
Melissa Doi
Brendan Dolan
Neil Dollard
James Domanico
Benilda P. Domingo
Geronimo (Jerome) Dominguez
Lt. Kevin Donnelly
Jacqueline Donovan
Stephen Dorf
Thomas Dowd
Lt. Kevin Dowdell
Yolanda Dowling
Ray M. Downey
Frank J. Doyle
Joseph Doyle
Randy Drake
Stephen P. Driscoll
Luke A. Dudek
Christopher Michael Duffy
Gerard Duffy
Michael Joseph Duffy
Antoinette Dugar
Sareve Dukat
Richard A. Dunstan
Patrick Dwyer
Dean P. Eberling
Paul Robert Eckna
Gus Economos
Dennis M. Edwards
Mike Edwards
Christine Egan
Lisa Egan
Capt. Martin Egan
Michael Egan
Samantha Egan
Carole Eggert
Lisa Caren Weinstein Ehrlich
John Ernst (Jack) Eichler
Michael Elferis
Mark Ellis
Valerie Silver Ellis
Albert Alfy William Elmarry
Edgar H. Emery
Doris Suk-Yuen Eng
Ulf R. Ericson

Erwin L. Erker
William J. Erwing
Sarah (Ali) Escarcega
Fanny M. Espinoza
Francis Esposito
Lt. Michael Esposito
William Esposito
Ruben Esquilin
Sadie Ettz
Barbara Etzold
Eric Evans
Robert Evans
Meredith Emily June Ewart
John Fabian
Catherine K. Fagan
Patricia M. Fagan
Keith Fairben
William Fallon
William F. Fallon
Anthony J. Fallone
Dolores B. Fanelli
John Joseph Fanning
Kit Faragher
Capt. Thomas Farino
Nancy Farley
Betty Farmer
Douglas Farnum
John W. Farrell
Terrence Farrell
Capt. Joseph Farrelly
Syed Abdul Fatha
Christopher Faughnan
Wendy R. Faulkner
Shannon M. Fava
Bernard D. Favuzza
Robert Fazio
Ronald C. Fazio
William Feehan
Francis J. (Frank) Feely
Sean B. Fegan
Lee Fehling
Peter Feidelberg
Alan D. Feinberg
Rosa M. Feliciano
Edward T. Fergus
George Ferguson
Henry Fernandez
Jose Manuel Contreras Fernandez
Judy H. Fernandez
Elisa Ferraina
Anne Marie Sallerin Ferreira
Bob Ferris
Vincent W. Ferrone
David Francis Ferrugio
Louis V. Fersini
Mike Ferugio
Brad Fetchet
Jennifer Louise Fialko
Kristen Fiedel
Samuel Fields
Michael Bradley Finnegan
Timothy J. Finnerty
Michael Fiore
Stephen J. Fiorelli
Paul M. Fiori
John Fiorito
Lt. John Fischer
Andrew Fisher
Bennett Lawson Fisher
John R. Fisher

Thomas J. Fisher
Lucy Fishman
Thomas Fitzpatrick
Richard Fitzsimons
Sal A. Fiumefreddo
(Donovan) Christina Flannery
Eileen Flecha
Andre Fletcher
Carl Flickinger
John Florio
Joseph W. Flounders
David Fodor
Lt. Michael Fodor
Steven Mark Fogel
Thomas Foley
David Fontana
Dennis Foo
Bobby Forbes
Delrose Forbes-Cheatam
Donald A. Foreman
Christopher Hugh Forsythe
Claudia Foster
Noel J. Foster
Robert J. Foti
Jeffrey L. Fox
Virginia Fox
Lucille V. Francis
Pauline Francis
Gary J. Frank
Morton Frank
Peter Christopher Frank
Richard K. Fraser
Kevin Joseph Frawley
Clyde Frazier
Lillian I. Frederick
Andrew Fredericks
Jamitha Freemen
Brett O. Freiman
Lt. Peter Freund
Arlene Fried
Alan Wayne Friedlander
Andrew K. Friedman
Gregg J. Froehner
Peter C. Fry
Clement Fumando
Steven Elliot Furman
Paul James Furmato
Fredric Gabler
Richard S. Gabrielle
James Andrew Gadiel
Pamela Gaff
Ervin Gailliard
Deanna L. Galante
Grace Galante
Anthony Edward Gallagher
Daniel James Gallagher
John Patrick Gallagher
Lourdes Galletti
Cono E. Gallo
Vincenzo Gallucci
Thomas Edward Galvin
Giovanna (Genni) Gambale
Thomas Gambino
Giann F. Gamboa
Peter J. Ganci
Michael Gann
Lt. Charles Garbarini
Jorge Luis Morron Garcia
Juan Garcia
Marlyn C. Garcia

Douglas B. Gardner
Harvey J. Gardner
Jeffrey B. Gardner
Thomas Gardner
William A. Gardner
Francesco Garfi
Rocco Gargano
James Gartenberg
Matthew Garvey
Bruce Gary
Boyd A. Gatton
Donald Gavagan
Terence D. Gazzani
Gary Geidel
Paul Hamilton Geier
Julie Geis
Peter Gelinas
Steven Paul Geller
Howard G. Gelling
Peter Victor Genco
Steven Gregory Genovese
Alayne F. Gentul
Edward Geraghty
Suzanne Geraty
Ralph Gerhardt
Robert J. Gerlich
Denis Germain
Marina R. Gertsberg
Susan M. Getzendanner
James Gerard Geyer
Joseph M. Giaconne
Lt. Vincent Giammona
Debra L. Gibbon
James Giberson
Craig Neil Gibson
Ronnie Gies
Laura Giglio
Andrew Clive Gilbert
Timothy Paul Gilbert
Paul Stuart Gilbey
Paul J. Gill
Evan Gillette
Ron Gilligan
Sgt. Rodney Gillis
Laura Gilly
Lt. John Ginley
Donna Marie Giordano
Jeffrey Giordano
John Giordano
Martin Giovinazzo
Jinny Lady Giraldo
Kum-Kum Girolamo
Salvatore Gitto
Cynthia Giugliano
Mon Gjonbalaj
Dianne Gladstone
Keith Glascoe
Thomas I. Glasser
Harry Glenn
Barry H. Glick
Steven Lawrence Glick
John T. Gnazzo
William (Bill) R. Godshalk
Michael Gogliormella
Brian Goldberg
Jeff Goldflam
Michelle Herman Goldstein
Monica Goldstein
Steven Goldstein
Andrew H. Golkin

Dennis J. Gomes
Enrique Antonio Gomez
Jose Bienvenido Gomez
Max Gomez
Wilder Gomez
Ana Irene Medina Gonzalez
Jenine Gonzalez
Joel Guevara Gonzalez
Rosa J. Gonzalez
Calvin J. Gooding
Harry Goody
Kiran Reddy Gopu
Kerene Gordon
Sebastian Gorki
Thomas Gorman
Douglas A. Gowell
Yuji Goya
Jon Grabowski
Christopher Michael Grady
Edwin J. Graf
David Graifman
Gilbert Granados
Christopher S. Gray
James M. Gray
Linda Mair Grayling
John Michael Grazioso
Timothy Grazioso
Gayle R. Greene
James Greenleaf
Eileen M. Greenstein
Elizabeth (Lisa) Gregg
Denise Gregory
Donald H. Gregory
Florence M. Gregory
Pedro Grehan
John Griffin
Tawanna Griffin
Joan D. Griffith
Warren Grifka
Joseph F. Grillo
David Grimmer
Kenneth Grouzalis
Matthew J. Gryzmalski
Joseph Grzelak
Robert Joseph Gschaar
Liming Gu
Yan Z. (Cindy) Guan
Geoffrey E. Gujag
Lt. Joseph Gullickson
Babita Guman
Douglas Gurian
Janet H. Gustafson
Philip T. Guza
Sabita Guzman
Barbara Guzzardo
Peter Gyulavary
Gary Robert Haag
Andrea Haberman
Barbara M. Habib
Philip Haentzler
Nizam A. Hafiz
Karen Hagerty
Steven Hagis
Mary Lou Hague
David Halderman
Maile Rachel Hale
Richard Hall
Robert J. Halligan
Lt. Vincent Halloran
James D. Halvorson

Felicia Hamilton
Robert Hamilton
Frederic Kim Han
Christopher Hanley
Sean Hanley
Valerie Joan Hanna
Thomas Hannafin
Kevin James Hannaford
Michael L. Hannan
Dana Hannon
Vassilios G. Haramis
James A. Haran
Jeffrey Hardy
Timothy John Hargrave
Daniel Harlin
Frances Haros
Lt. Harvey Harrell
Lt. Stephen Harrell
Stewart D. Harris
John Hart
John Clinton Hartz
Emeric J. Harvey
Capt. Thomas Haskell
Timothy Haskell
Joseph John Hasson
Leonard William Hatton
Capt. Terence S. Hatton
Michael H. Haub
Timothy Aaron Haviland
Donald G. Havlish
Philip Hayes
William Ward Haynes
Scott Hazelcorn
Lt. Michael Healey
Roberta Bernstein Heber
Charles Francis Xavier Heeran
John Heffernan
H. Joseph Heller
JoAnn Heltibridle
Mark F. Hemschoot
Ronnie Henderson
Janet Hendricks
Brian Hennessey
Michelle M. Henrique
Joseph P. Henry
William Henry
John Henwood
Robert Hepburn
Mary (Molly) Herencia
Lindsay Coates Herkness
Anabel Hernandez
Claribel Hernandez
Eduardo Hernandez
Norberto Hernandez
Raul Hernandez
Gary Herold
Jeffrey A. Hersch
Thomas Hetzel
Capt. Brian Hickey
Ysidro Hidalgo-Tejada
Lt. Timothy Higgins
Robert Higley
Clara V. Hinds
Neal Hinds
Mark D. Hindy
Heather Malia Ho
Tara Yvette Hobbs
Thomas A. Hobbs
James L. Hobin
Robert Wayne Hobson

DaJuan Hodges
Ronald Hoerner
Patrick Aloysius Hoey
Frederick J. Hoffman
Joseph Hoffman
Marcia Hoffman
Michele L. Hoffman
Stephen G. Hoffman
Judith Florence Hofmiller
Thomas Warren Hohlweck
Jonathan R. Hohmann
John Holland
Joseph Francis Holland
Elizabeth Holmes
Thomas P. Holohan
Bradley Hoorn
Montgomery M. Hord
Michael Horn
Matthew D. Horning
Robert L. Horohoe
Aaron Horwitz
Malverse Houscal
Charles J. Houston
Uhuru G. Houston
George Howard
Michael C. Howell
Steven L. Howell
Jennifer L. Howley
Milagros Hromada
Marian Hrycak
Steve Huczko
Kris R. Hughes
Melissa Harrington Hughes
Paul R. Hughes
Thomas F. Hughes
Timothy Robert Hughes
Susan Huie
Kathleen (Casey) Hunt
William C. Hunt
Joseph Hunter
Robert Hussa
Capt. Walter Hynes
Joseph Ianelli
Zuhtu Ibis
Jonathan Ielpi
Michael Patrick Iken
Daniel Ilkanayev
Capt. Frederick III
Abraham Ilowitz
Anthony P. Infante
Louis Inghilterra
Christopher N. Ingrassia
Paul Innella
Stephanie V. Irby
Doug Irgang
Kristin A. Irvine-Ryan
Todd Isaac
Erik Hans Isbrandtsen
William Iselepis
Taizo Ishikawa
Waleed Iskandar
Aram Iskenderian
John Iskyan
Kazushige Ito
Virginia Jablonski
Brooke Jackman
Aaron Jacobs
Jason Kyle Jacobs
Michael Grady Jacobs
Steven Jacobson

Ricknauth Jaggernauth
Yudh V.S. Jain
Maria Jakubiak
Gricelda E. James
Mark Jardin
Mohammed Jawara
Francois Jean-Pierre
Paul E. Jeffers
Alan K. Jensen
Prem N. Jerath
Farah Jeudy
Hweidar Jian
Eliezer Jimenez
Luis Jimenez
Charles Gregory John
Scott Johnson
William Johnston
Allison Horstmann Jones
Arthur J. Jones
Brian L. Jones
Donald T. Jones
Donald W. Jones
Linda Jones
Mary S. Jones
Andrew Jordan
Robert Thomas Jordan
Ingeborg Joseph
Karl Joseph
Stephen Joseph
Jane Eileen Josiah
Lt. Anthony Jovic
Angel C. Juarbe
Karen Susan Juday
Rev. Mychal Judge
Paul W. Jurgens
Thomas E. Jurgens
Shari Kandell
Howard L. Kane
Jennifer Lynn Kane
Vincent Kane
Joon Koo Kang
Sheldon R. Kanter
Deborah H. Kaplan
Alvin P. Kappelmann
Charles Karczewski
William A. Karnes
Douglas G. Karpiloff
Charles L. Kasper
Andrew Kates
Sgt. Robert Kaulfers
Don J. Kauth
Hideya Kawauchi
Edward T. Keane
Richard M. Keane
Lisa Kearney-Griffin
Karol Keasler
Paul H. Keating
Leo Russell Keene
Joseph J. Keller
Peter Rodney Kellerman
Joseph P. Kellett
Frederick Kelley
James Joseph Kelly
Joseph Kelly
Maurice Patrick Kelly
Richard J. Kelly
Thomas Michael Kelly
Thomas R. Kelly
Thomas W. Kelly
Timothy C. Kelly

William Hill Kelly
Robert C. (Bob) Kennedy
Susan Schular Kennedy
Thomas Kennedy
John Keohane
Lt. Ronald Kerwin
Howard L. Kestenbaum
Douglas Ketcham
Ruth E. Ketler
Boris Khalif
Sarah Khan
Taimour Firaz Khan
Rajesh Khandelwal
Seilai Khoo
Michael Kiefer
Andrew Jay-Hoon Kim
Don Kim
Mary Kimelman
Andrew Marshall King
Lucille T. King
Robert King
Lisa M. King-Johnson
Takashi Kinoshita
Glenn Kirwin
Richard J. Klares
Peter Klein
Alan D. Kleinberg
Karen J. Klitzman
Ronald Philip Kloepfer
Eugeuni Kniazev
Andrew Knox
Thomas P. Knox
Rebecca Lee Kobone
Gary Edward Koecheler
Ryan Kohart
Vanessa Lynn Kolpak
Irina Kolpakova
Suzanne Kondratenko
Abdoulaye Kone
Bon-seok Koo
Dorota Kopiczko
Scott Kopytko
Bojan Kostic
Danielle Kousoulis
William Krukowski
Shekhar Kumar
Kenneth Kumpel
Frederick Kuo
Patricia Kuras
Nauka Kushitani
Thomas Kuveikis
Victor Kwarkye
Kui Fai Kwok
Angela R. Kyte
Andrew LaCorte
James P. Ladley
Jeanette LaFond-Menichino
David LaForge
Michael Patrick LaForte
Alan Lafranco
Juan Lafuente
Neil K. Lai
Vincent A. Laieta
William David Lake
Franco Lalama
Chow Kwan Lam
Stephen LaMantia
Amy Lamonsoff
Robert T. Lane
Brendan Lang

Rosanne P. Lang
Venessa Langer
Mary Lou Langley
Peter Langone
Thomas Langone
Michele B. Lanza
Ruth S. Lapin
Carol LaPlante
Ingeborg Astrid Desiree Lariby
Robin Larkey
Christopher Larrabee
Hamidou S. Larry
Scott Larsen
John Adam Larson
Gary E. Lasko
Nicholas C. Lassman
Paul Laszczynski
Amarnath Latchman
Jeffrey Latouche
Stephen James Lauria
Maria Lavache
Denis F. Lavelle
Jeannine M. LaVerde
Anna A. Laverty
Robert A. Lawrence
Nathaniel Lawson
Eugene Lazar
James Leahy
Lt. Joseph Leavey
Neil Leavy
Leon Lebor
Kenneth Charles Ledee
Alan J. Lederman
Elena Ledesma
Alexis Leduc
Gary H. Lee
Hyun-joon (Paul) Lee
Jong-min Lee
Juanita Lee
Kathryn Blair Lee
Lorraine Lee
Myung-woo Lee
Richard Y.C. Lee
Stuart Lee
Yang Der Lee
Stephen Lefkowitz
Adriana Legro
Edward J. Lehman
Eric Andrew Lehrfeld
David Ralph Leistman
David P. LeMagne
Joseph A. Lenihan
John J. Lennon
John Robinson Lenoir
Jorge Luis Leon
Matthew G. Leonard
Michael Lepore
Charles A. Lesperance
Jeffrey Earle LeVeen
John D. Levi
Alisha Caren Levin
Neil D. Levin
Robert Levine
Shai Levinhar
Adam J. Lewis
Margaret S. Lewis
Ye Wei Liang
Orasri Liangthanasarn
Daniel F. Libretti
Ralph M. Licciardi

Steven B. Lillianthal
Carlos R. Lillo
Craig Damian Lilore
Arnold A. Lim
Darya Lin
Weirong Lin
Thomas V. Linehan
Robert Linnane
Alan Linton
Diane T. Lipari
Kenneth P. Lira
Lorraine Lisi
Vincent Litto
Ming-Hao Liu
Joseph Livera
Nancy Liz
Harold Lizcano
Martin Lizzul
George A. Llanes
Elizabeth Claire Logler
Catherine Lisa Loguidice
Jerome Robert Lohez
Michael W. Lomax
Laura M. Longing
Salvatore Lopes
Daniel Lopez
Luis Lopez
Manuel L. Lopez
Chet Louie
Stuart Seid Louis
Joseph Lovero
Michael W. Lowe
Garry Lozier
John Peter Lozowsky
Charles Peter Lucania
Edward (Ted) H. Luckett
James Ludley
Mark G. Ludvigsen
Lee Charles Ludwig
Sean Thomas Lugano
Daniel Lugo
Jin Lui
Marie Lukas
William Lum
Michael P. Lunden
Christopher Lunder
Anthony Luparello
Gary Lutnick
Linda Luzzicone
Alexander Lygin
Farrell Peter Lynch
James Francis Lynch
Louise A. Lynch
Michael Lynch
Michael F. Lynch
Michael F. Lynch
Richard Dennis Lynch
Robert H. Lynch
Sean Lynch
Sean P. Lynch
Michael J. Lyons
Monica Lyons
Patrick Lyons
Robert Mace
Jan Maciejewski
Catherine MacRea
Richard B. Madden
Simon Maddison
Dennis A. Madsen
Noell Maerz

Joseph Maffeo
Jay Robert Magazine
Brian Magee
Charles W. Magee
Joseph Maggitti
Ronald E. Magnuson
Daniel L. Maher
Thomas A. Mahon
William Mahoney
Joseph Maio
Takashi Makimoto
Debora Maldonado
Myrna Maldonado
Alfred R. Maler
Gregory James Malone
Edward Francis (Teddy) Maloney
Joseph E. Maloney
Christian Maltby
Frank Mancini
Joseph Mangano
Sara Elizabeth Manley
Debra M. Mannetta
Marion Victoria Manning
James Maounis
Joseph Marchbanks
Peter Mardikian
Edward J. Mardovich
Lt. Charles Margiotta
Kenneth Marino
Lester Vincent Marino
Vita Marino
Kevin D. Marlo
Jose J. Marrero
John Marshall
James Martello
Michael A. Marti
Lt. Peter Martin
William J. Martin
Brian E. Martineau
Betsy Martinez
Edward J. Martinez
Robert Martinez
Lizie Martinez-Calderon
Lt. Paul Richard Martini
Joseph A. Mascali
Stephen F. Masi
Nicholas G. Massa
Patricia A. Massari
Michael Massaroli
Philip W. Mastrandrea
Rudolph Mastrocinque
Joseph Mathai
Charles William Mathers
William A. Mathesen
Marcello Matricciano
Margaret Mattic
Robert D. Mattson
Walter Matuza
Charles A. (Chuck) Mauro
Charles J. Mauro
Dorothy Mauro
Nancy T. Mauro
Tyrone May
Keithroy Maynard
Robert J. Mayo
Kathy Mazza
Edward Mazzella
Jennifer Mazzotta
Kaaria Mbaya
James J. McAlary

Brian McAleese
Patricia A. McAneney
Colin Richard McArthur
John McAvoy
Ken McBrayer
Brendan McCabe
Michael J. McCabe
Thomas McCann
Justin McCarthy
Kevin McCarthy
Michael Desmond McCarthy
Robert Garvin McCarthy
Katie McCloskey
Charles McCrann
Tonyell McDay
Matthew T. McDermott
Joseph McDonald
Brian McDonnell
Michael McDonnell
John F. McDowell
Eamon J. McEneaney
John Thomas McErlean
Katherine (Katie) McGarry-Noack
Daniel F. McGinley
Mark McGinly
Lt. William E. McGinn
Thomas H. McGinnis
Michael G. McGinty
Ann McGovern
Scott Martin McGovern
William J. McGovern
Stacey McGowan
Francis Noel McGuinn
Patrick J. McGuire
Thomas McHale
Keith McHeffey
Ann M. McHugh
Denis J. McHugh
Dennis P. McHugh
Michael Edward McHugh
Robert G. McIlvaine
Donald James McIntyre
Stephanie McKenna
Barry J. McKeon
Darryl McKinney
George P. McLaughlin
Robert C. McLaughlin
Robert McMahon
Edmund M. McNally
Daniel McNeal
Walter Arthur McNeil
Sean Peter McNulty
Robert McPadden
Terence McShane
Timothy Patrick McSweeney
Martin E. McWilliams
Rocco A. Medaglia
Abigail Medina
Anna Medina
Damian Meehan
William Meehan
Raymond Meisenheimer
Manuel Emilio Mejia
Eskedar Melaku
Antonio Melendez
Mary Melendez
Yelena Melnichenko
Stuart Todd Meltzer
Charles Mendez
Lizette Mendoza

Shevonne Mentis
Steve Mercado
Wesley Mercer
Ralph Mercurio
Alan H. Merdinger
George Merino
Yamel Merino
George Merkouris
Raymond J. Metz
Jill A. Metzler
David R. Meyer
William Edward Micciulli
Martin P. Michelstein
Peter T. Milano
Gregory Milanowycz
Lukasz Milewski
Corey Peter Miller
Douglas C. Miller
Henry Miller
Michael Matthew Miller
Phil Miller
Robert Miller
Robert Alan Miller
Charles M. Mills
Robert Minara
William Minardi
Louis Joseph Minervinog
Thomas Mingione
Nana Akwasi Minkah
Wilbert Miraille
Domenick Mircovich
Rajesh A. Mirpuri
Joe Mistrulli
Lt. Paul Mitchell
Richard Miuccio
Frank V. Moccia
Capt. Louis Modafferi
Boyie Mohammed
Lt. Dennis Mojica
Manuel Mojica
Manuel Dejesus Molina
Carl Molinaro
Justin J. Molisani
Brian Patrick Monaghan
Franklin Monahan
John G. Monahan
Craig D. Montano
Michael Montesi
Cheryl Monyak
Capt. Thomas Moody
Sharon Moore
Abner Morales
Carlos Morales
Martin Morales
Paula Morales
John Moran
Lindsay S. Morehouse
George Morell
Steven P. Morello
Vincent S. Morelloing
Arturo Alva Moreno
Roy Wallace Moreno
Yvette Nichole Moreno
Dorothy Morgan
Richard Morgan
Blanca Morocho
Leonel Morocho
Dennis G. Moroney
John Morris
Lynne Irene Morris

Seth A. Morris
Christopher M. Morrison
Fred V. Morrone
William David Moskal
Mark Motroni
Jude Moussa
Peter C. Moutos
Damion Mowatt
Christopher Mozzillo
Stephen V. Mulderry
Richard Muldowney
Michael D. Mullan
Dennis Mulligan
Michael Joseph Mullin
James Donald Munhall
Carlos Mario Munoz
Theresa (Terry) Munson
Robert M. Murach
Cesar Augusto Murillo
Marc A. Murolo
Brian Joseph Murphy
Charles Murphy
Christopher W. Murphy
Edward C. Murphy
James F. Murphy
James Thomas Murphy
Kevin James Murphy
Patrick Sean Murphy
Lt. Raymond E. Murphy
John J. Murray
John J. Murray
Susan D. Murray
Fall Mustafa
Richard Todd Myhre
Lt. Robert Nagel
Takuya Nakamura
Alexander J.R. Napier
Frank Naples
John Napolitano
Catherine A. Nardella
Mario Nardone
Manika Narula
Karen S. Navarro
Joseph Navas
Francis J. Nazario
Glenroy Neblett
Marcus R. Neblett
Jerome O. Nedd
Laurence Nedell
Luke G. Nee
Pete Negron
Ann Nicole Nelson
David W. Nelson
James Nelson
Michelle Ann Nelson
Peter A. Nelson
Oscar Nesbitt
Gerard Terence Nevins
Jody Tepedino Nichilo
Martin Niederer
Alfonse J. Niedermeyer
Frank Niestadt
Gloria Nieves
Juan Nieves
Paul R. Nimbley
John Ballantine Niven
Daniel R. Nolan
Robert Walter Noonan
Daniela R. Notaro
Brian Novotny

Soichi Numata
Brian Nunez
Jose R. Nunez
Jeffrey Nussbaum
James A. Oakley
Dennis Oberg
James P. O'Brien
Michael O'Brien
Scott O'Brien
Timothy Michael O'Brien
Lt. Daniel O'Callaghan
Jefferson Ocampo
Diana O'Connor
Keith K. O'Connor
Richard J. O'Connor
Amy O'Doherty
Marni Pont O'Doherty
Douglas Oelschlager
Albert Ogletree
Philip Ognibene
James Andrew O'Grady
Joseph Ogren
Lt. Thomas O'Hagan
Samuel Oitice
Patrick O'Keefe
Capt. William O'Keefe
Gerald M. Olcott
Gerald O'Leary
Christine Anne Olender
Elsy Carolina Osorio Oliva
Linda Oliva
Edward K. Oliver
Leah E. Oliver
Eric Olsen
Jeffrey J. Olsen
Maureen L. Olson
Steven Olson
Matthew Timothy O'Mahoney
Toshihiro Onda
John P. O'Neill
Peter J. O'Neill
Sean Gordon Corbett O'Neill
Michael C. Opperman
Chris Orgielewicz
Margaret Orloske
Virginia Ormiston-Kenworthy
Kevin O'Rourke
Juan Romero Orozco
Ronald Orsini
Peter K. Ortale
David Ortiz
Emilio (Peter) Ortiz
Paul Ortiz
Sonia Ortiz
Masaru Ose
Patrick O'Shea
Robert W. O'Shea
James Robert Ostrowski
Timothy O'Sullivan
Jason Douglas Oswald
Michael Otten
Isidro Ottenwalder
Michael Ou
Todd Joseph Ouida
Jesus Ovalles
Peter J. Owens
Angel Pabon
Israel Pabon
Roland Pacheco
Michael B. Packer

Deepa K. Pakkala
Jeffrey Palazzo
Thomas Anthony Palazzo
Richard Palazzolo
Orio Joseph Palmer
Frank Palombo
Alan N. Palumbo
Christopher M. Panatier
Dominique Pandolfo
Paul Pansini
John M. Paolillo
Edward J. Papa
Salvatore Papasso
James Pappageorge
Vinod K. Parakat
Vijayashanker Paramsothy
Hardai (Casey) Parbhu
James W. Parham
Debbie Paris
George Paris
Gye-Hyong Park
Philip L. Parker
Michael A. Parkes
Robert Emmett Parks
Hasmukh Parmar
Robert Parro
Diane Parsons
Leobardo Lopez Pascual
Michael J. Pascuma
Jerrold Paskins
Horace Robert Passananti
Suzanne Passaro
Victor Antonio Martinez Pastrana
Avnish Ramanbhai Patel
Dipti Patel
Manish K. Patel
Steven B. Paterson
James Patrick
Manuel Patrocino
Bernard E. Patterson
Cira Marie Patti
James R. Paul
Patrice Paz
Sharon Cristina Millan Paz
Victor Paz-Gutierrez
Stacey L. Peak
Richard Pearlman
Durrell Pearsall
Thomas E. Pedicini
Todd D. Pelino
Anthony Peluso
Angel R. Pena
Jose D. Pena
Richard A. Penny
Salvatore Pepe
Carl Allen Peralta
Robert David Peraza
Maria Percoco
Jon A. Perconti
Alejo Perez
Angel Perez
Angela Susan Perez
Anthony Perez
Ivan Perez
Nancy E. Perez
Joseph John Perroncino
Edward J. Perrotta
Emelda Perry
Lt. Glenn Perry
John Perry

Franklin Allan Pershep
Daniel Pesce
Michael J. Pescherine
William Russel Peterson
Mark Petrocelli
Lt. Philip S. Petti
Glen K. Pettit
Dominick Pezzulo
Kaleen E. Pezzuti
Lt. Kevin Pfeifer
Tu-Anh Pham
Lt. Kenneth Phelan
Ludwig J. Picarro
Matthew Picerno
Joseph O. Pick
Christopher Pickford
Dennis Pierce
Maxima Pierre
Bernard T. Pietronico
Nicholas P. Pietrunti
Susan Elizabeth Ancona Pinto
Joseph Piskadlo
Todd Pitman
Josh Piver
Joseph Plumitallo
John M. Pocher
William H. Pohlmann
Laurence M. Polatsch
Thomas Polhemus
Steve Pollicino
Susan M. Pollio
Joshua Poptean
Anthony Portillo
James Edward Potorti
Daphne Pouletsos
Richard Poulos
Stephen E. Poulos
Brandon Powell
Shawn Powell
Tony Pratt
Gregory M. Preziose
Wanda Prince
Vincent Princiotta
Kevin Prior
Everett Martin (Marty) Proctor
Carrie B. Progen
David L. Pruim
Richard Prunty
John F. Puckett
Robert D. Pugliese
Edward F. Pullis
Patricia Ann Puma
Edward R. Pykon
Christopher Quackenbush
Lars P. Qualben
Lincoln Quappe
Beth Ann Quigley
Lt. Michael Quilty
Ricardo Quinn
Carol Rabalais
Christopher Peter A. Racaniello
Leonard Ragaglia
Eugene J. Raggio
Laura Marie Ragonese-Snik
Michael Ragusa
Peter F. Raimondi
Harry A. Raines
Ehtesham U. Raja
Valsa Raju
Edward Rall

Julio Fernandez Ramirez
Maria Isabel Ramirez
Harry Ramos
Vishnoo Ramsaroop
Lorenzo Ramzey
A. Todd Rancke
Adam D. Rand
Shreyes Ranganath
Robert Arthur Rasmussen
Amenia Rasool
Roger (Mark) Rasweiler
David Alan James Rathkey
William R. Raub
Gerard Rauzi
Alexey Razuvaev
Gregory Reda
Sarah (Prothero) Redheffer
Michele Reed
Judith A. Reese
Donald J. Regan
Lt. Robert Regan
Thomas M. Regan
Christian Regenhard
Gregory Reidy
James B. Reilly
Kevin Reilly
Timothy E. Reilly
Joseph Reina
Thomas Barnes Reinig
Frank B. Reisman
Joshua Scott Reiss
Karen Renda
John Armand Reo
Richard Rescorla
John Thomas Resta
Luis C. Revilla
Bruce Reynolds
Frederick Rhodes
John Rhodes
Francis S. Riccardelli
David Rice
Eileen M. Rice
Kenneth F. Rice
Lt. Vernon Richard
Claude D. Richards
Gregory Richards
Michael Richards
Venesha O. Richards
James Riches
Alan Jay Richman
John M. Rigo
Theresa (Ginger) Risco
Rose Riso
Moises N. Rivas
Joseph Rivelli
Isaias Rivera
Linda Rivera
David Rivers
Joseph R. Riverso
Paul Rizza
Stephen Louis Roach
Joseph Roberto
Leo A. Roberts
Michael Roberts
Michael Roberts
Donald W. Robertson
Fazio Robery
Jeffrey Robinson
Michell Robotham
Donald Robson

Antonio Augusto Tome Rocha
Raymond J. Rocha
Laura Rockefeller
John M. Rodak
Antonio Jose Carrusca Rodrigues
Anthony Rodriguez
Carlos Cortez Rodriguez
Carmen Rodriguez
Gregory E. Rodriguez
Marsha A. Rodriguez
Richard Rodriguez
David B. Rodriguez-Vargas
Matthew Rogan
Karlie Rogers
Scott Rohner
Keith Roma
Joseph M. Romagnolo
Elvin Santiago Romero
James Romito
Sean Rooney
Eric Ropiteau
Aida Rosario
Angela Rosario
Mark H. Rosen
Brooke David Rosenbaum
Sheryl L. Rosenbaum
Linda Rosenbaun
Lloyd D. Rosenberg
Andrew I. Rosenblum
Joshua Rosenblum
Joshua Rosenthal
Richard David Rosenthal
Daniel Rossetti
Norman Rossinow
Nicholas Rossomando
Michael Craig Rothberg
Donna Marie Rothenberg
Nick Rowe
Timothy Roy
Ameenia Rsaool
Paul Ruback
Ronald J. Ruben
Joanne Rubino
Bart Joseph Ruggiere
Susan Ann Ruggiero
Adam K. Ruhalter
Gilbert Ruiz
Obdulio Ruiz-Diaz
Stephen Russell
Steven Harris Russin
Lt. Michael Russo
Edward Ryan
John J. Ryan
Jonathan Stephan Ryan
Matthew L. Ryan
Christina Ryook
Jason E. Sabbag
Thomas E. Sabella
Scott Saber
Joseph Sacerdote
Francis Sadocha
Brock Safronoff
John Patrick Salamone
Hernando R. Salas
Juan Salas
Esmerlin Salcedo
John Salvatore Salerno
Richard L. Salinardi
Wayne Saloman
Catherine Salter

Frank Salvaterra
Paul R. Salvio
Samuel R. Salvo
Carlos Samaniego
Rena Sam-Dinnoo
James K. Samuel
James T. Samuel
Michael V. San Phillip
Hugo Sanay-Perafiel
Alva J. Sanchez
Jacquelyn P. Sanchez
Eric Sand
Stacey Leigh Sanders
Herman Sandler
James Sands
Maria Theresa Santillan
Susan G. Santo
Christopher Santora
John Santore
Mario Santoro
Rafael Humberto Santos
Rufino Condrado F. Santos
Guy Carpenter
Kalyan K. Sarkar
Paul F. Sarle
Deepika K. Sattaluri
Gregory Saucedo
Susan Sauer
Anthony Savas
Jackie Sayegh
John Sbarbaro
Dawn Elizabeth Scala
Robert L. Scandole
Michelle Scarpitta
Dennis Scauso
John A. Schardt
Fred Claude Scheffold
Scott M. Schertzer
Sean Schielke
Steven Francis Schlag
Jon S. Schlissel
Ian Schneider
Thomas G. Schoales
Marisa Schorpp
Frank G. Schott
Gerard P. Schrang
John Schroeder
Sue Schuler
Edward W. Schunk
Mark Schurmeier
Clarin Schwartz
John Schwartz
Mark Schwartz
Adriane Victoria Scibetta
Raphael Scorca
Randolph Scott
Arthur Scullin
Michael Seaman
Margaret Seeliger
Jason Sekzer
Matthew Carmen Sellitto
Howard Selwyn
Larry Senko
Frankie Serrano
Alena Sesinova
Adele Sessa
Situ Sewnarine
Karen Seymour-Dietrich
Davis (Deeg) Sezna
Thomas Sgroi

Jayesh Shah
Khalid M. Shahid
Mohammed Shajahan
Gary Shamay
Earl Richard Shanahan
Shiv Shankar
L. Kadaba Shashikiran
Kathryn Anne Shatzoff
Barbara A. Shaw
Jeffrey Shaw
Robert J. Shay
Daniel James Shea
Joseph Patrick Shea
Linda Sheehan
Hagay Shefi
Terrance H. Shefield
John A. Sherry
Atsushi Shiratori
Thomas Shubert
Mark Shulman
See-Wong Shum
Allan Shwartzstein
Carmen Sierra
Johanna Sigmund
Dianne T. Signer
Gregory Sikorsky
Stephen Siller
David Silver
Craig A. Silverstein
Nasima H. Simjee
Bruce Edward Simmons
Arthur Simon
Kenneth Alan Simon
Michael John Simon
Marianne Simone
Barry Simowitz
George V. Sims
Kamini Singh
Khamladai K. (Khami) Singh
Roshan R. (Sean) Singh
Thomas Sinton
Peter A. Siracuse
Muriel F. Siskopoulos
Joseph M. Sisolak
John P. Skala
Francis J. Skidmore
Toyena C. Skinner
Paul Skrzypek
Christopher Paul Slattery
Vincent R. Slavin
Robert Sliwak
Paul K. Sloan
Stanley S. Smagala
Wendy L. Small
Catherine T. Smith
Daniel Laurence Smith
George Eric Smith
James G. Smith
Jeffrey Randall Smith
Joyce Smith
Karl Trumbull Smith
Kevin Smith
Leon Smith
Moria Smith
Rosemary Smith
Sandra Fajardo Smith
Bonnie S. Smithwick
Leonard J. Snyder
Astrid Elizabeth Sohan
Sushil Solanki

Naomi Solomon
Daniel W. Song
Michael Sorresse
Fabian Soto
Timothy P. Soulas
Gregory T. Spagnoletti
Donald Spampinato
Thomas Sparacio
John Anthony Spataro
Robert Spear
Maynard S. Spence
George E. Spencer
Robert Andrew Spencer
Frank J. Spinelli
William E. Spitz
Joseph P. Spor
Klaus Sprockamp
Saranya Srinuan
Michael F. Stabile
Lawrence Stack
Capt. Timothy Stackpole
Richard James Stadelberger
Eric A. Stahlman
Gregory M. Stajk
Corina Stan
Mary D. Stanley
Joyce Stanton
Patricia Stanton
Anthony M. Starita
Jeffrey Stark
Derek J. Statkevicus
Craig W. Staub
William Steckman
Eric T. Steen
Alexander Robbins Steinman
Andrew Stergiopoulos
Andrew Stern
Martha Stevens
Michael J. Stewart
Richard H. Stewart
Lonny J. Stone
Jimmy Nevill Storey
Timothy Stout
Thomas S. Strada
James J. Straine
Edward W. Straub
George L. Strauch
Edward T. Strauss
Steven F. Strobert
Walwyn W. Stuart
Benjamin Suarez
David S. Suarez
Ramon Suarez
Yoichi Sugiyama
William Christopher Sugra
Daniel Suhr
David M. Sullins
Lt. Christopher P. Sullivan
Patrick Sullivan
Patrick Sullivan
Thomas Sullivan
Larry Sumaya
James Joseph Suozzo
Colleen Supinski
Robert Sutcliffe
Selina Sutter
Claudia Suzette Sutton
John F. Swaine
Kristine Swearson
Brian Sweeney

Kenneth J. Swensen
Thomas F. Swift
Derek O. Sword
Kevin T. Szocik
Harry Taback
Joann Tabeek
Norma C. Taddei
Michael Taddonio
Keiichiro Takahashi
Keiji Takahashi
Phyllis Talbot
Robert R. Talhami
Sean Tallon
Paul Talty
Maurita Tam
Rachel Tamares
Hector Tamayo
Michael Andrew Tamuccio
Kenichiro Tanaka
Rhondelle Cherie Tankard
Michael Anthony Tanner
Dennis G. Taormina
Kenneth Joseph Tarantino
Allan Tarasiewicz
Ronald Tartaro
Donnie Brooks Taylor
Lorisa Ceylon Taylor
Michael M. Taylor
Paul Tegtmeier
Yesh Tembe
Anthony Tempesta
Dorothy Temple
David Tengelin
Brian J. Terrenzi
Goumatie Thackurdeen
Thomas F. Theurkauf
Lesley Thomas-O'Keefe
Clive Thompson
Glenn Thompson
Nigel Bruce Thompson
Perry Anthony Thompson
Vanavah Thompson
Capt. William Harry Thompson
Eric R. Thorpe
Nichola A. Thorpe
Sal Tieri
John Patrick Tierney
William R. Tieste
Kenneth Tietjen
Stephen Edward Tighe
Scott C. Timmes
Michael E. Tinley
Jennifer M. Tino
Robert Frank Tipaldi
John J. Tipping
Hector Tirado
Michelle Titolo
John J. Tobin
Richard J. Todisco
Steve Tompsett
Doris Torres
Luis Eduardo Torres
Amy E. Toyen
Christopher M. Traina
Daniel Patrick Trant
Abdoul Karim Traore
Glenn J. Travers
Walter (Wally) P. Travers
Felicia Traylor-Bass
Abdoul Karim Treore

Lisa L. Trerotola
Karamo Trerra
Michael Trinidad
Francis J. Trombino
Gregory J. Trost
William Tselepis
Zhanetta Tsoy
Michael Patrick Tucker
Lance Richard Tumulty
Simon Turner
Donald Joseph Tuzio
Jennifer Tzemis
John G. Ueltzhoeffer
Tyler Ugolyn
Michael A. Uliano
Jonathan Uman
Anil S. Umarkar
Allen V. Upton
Diane Maria Urban
John Damien Vaccacio
Bradley H. Vadas
Mayra Valdes-Rodriguez
Felix Antonio Vale
Ivan Vale
Santos Valentin
Carlton Francis Valvo
Erica Van Acker
Kenneth W. Van Auken
Daniel M. Van Laere
Jon C. Vandevander
Richard Vanhine
Frederick T. Varacchi
Gopalakrishnan Varadhan
Scott C. Vasel
Azael Vasquez
Santos Vasquez
Arcangel Vazquez
Peter A. Vega
Sankara Velamuri
Jorge Velazquez
Lawrence Veling
Anthony M. Ventura
David Vera
Loretta A. Vero
Christopher Vialonga
Matthew Gilbert Vianna
Robert A. Vicario
Celeste Victoria
Joanna Vidal
John T. Vigiano
Joseph Vigiano
Frank J. Vignola
Joseph B. Vilardo
Sergio Villanueva
Chantal Vincelli
Melissa Vincent
Francine A. Virgilio
Lawrence Virgilio
Joseph G. Visciano
Ramsaroop Vishnu
Josh Vitale
Richard Vito
Maria Percoco Vola
Lynette D. Vosges
Garo H. Voskerijian
Alfred Vukuosa
Gregory Wachtler
Gabriela Waisman
Wendy Wakeford
Benjamin Walker

Glen J. Wall
Mitchel Wallace
Peter Wallace
Lt. Robert F. Wallace
Roy Wallace
Jean Marie Wallendorf
Matthew Blake Wallens
John Wallice
Barbara P. Walsh
James Walsh
Jeffrey Patrick Walz
Weibin Wang
Lt. Michael Warchola
Stephen G. Ward
James A. Waring
Brian G. Warner
Derrick Washington
Charles Waters
Capt. Patrick J. Waters
Kenneth Watson
Michael H. Waye
Todd C. Weaver
Walter E. Weaver
Nathaniel Webb
Dinah Webster
Joanne F. Weil
Michael Weinberg
Steven Weinberg
Scott Jeffrey Weingard
Steven Weinstein
Simon Weiser
David Weiss
David T. Weiss
Vincent Wells
Timothy Welty
Chris Wemmers
Ssu-Hui (Vanessa) Wen
Oleh D. Wengerchuk
Peter M. West
Whitfield West
Meredith Whalen
Eugene Whelan
Adam White
Edward White
James Patrick White
John S. White
Leonard Anthony White
Malissa White
Wayne White
Leanne Marie Whiteside
Mark Whitford
Michael T. Wholey
Mary Lenz Wieman
Jeffrey David Wiener
William J. Wik
Allison M. Wildman
Lt. Glenn Wilkinson
John Willett
Brian Patrick Williams
Crossley Williams
David Williams
Kevin Williams
Louis Williams
Lt. John Williamson
Cynthia Wilson
Donna Wilson
William E. Wilson
David H. Winton
Glenn J. Winuk
Thomas Francis Wise

Alan L. Wisniewski
Frank T. Wisniewski
David Wiswall
Sigrid Charlotte Wiswe
Michael R. Wittenstein
Christopher Wodenshek
Martin P. Wohlforth
Jennifer Y. Wong
Jenny Seu Kueng Low Wong
Siu Cheung Wong
Yin Ping (Steven) Wong
Yuk Ping Wong
Brent J. Woodall
James Woods
Patrick Woods
Richard H. Woodwell
Capt. David T. Wooley
John B. Works
Martin M. Wortley
Rodney James Wotton
William Wren
John Wright
Neil R. Wright
Sandra Wright
Naomi Yajima
Jupiter Yambem
Matthew D. Yarnell
Myrna Yaskulka
Olabisi L. Yee
Paul Yoon
Kevin Patrick York
Raymond York
Suzanne Youmans
Barrington L. Young
Jacqueline (Jakki) Young
Elkin Yuen
Joseph Zaccoli
Adel A. Zakhary
Arkady Zaltsman
Robert Alan Zampieri
Mark Zangrilli
Ira Zaslow
Aurelio Zedillo
Kenneth Zelman
Zhe (Zack) Zeng
Marc Zeplin
Ivelin Ziminski
Charles A. Zion
Julie L. Zipper
Salvatore J. Zisa
Prokopios Paul Zois
Andrew S. Zucker

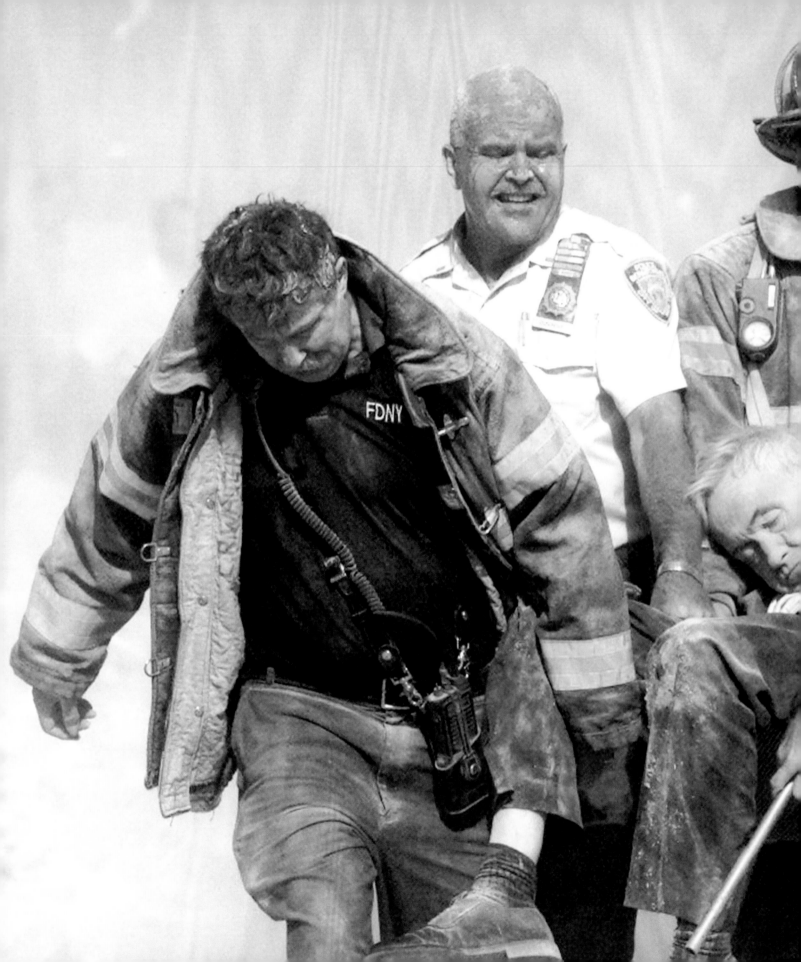

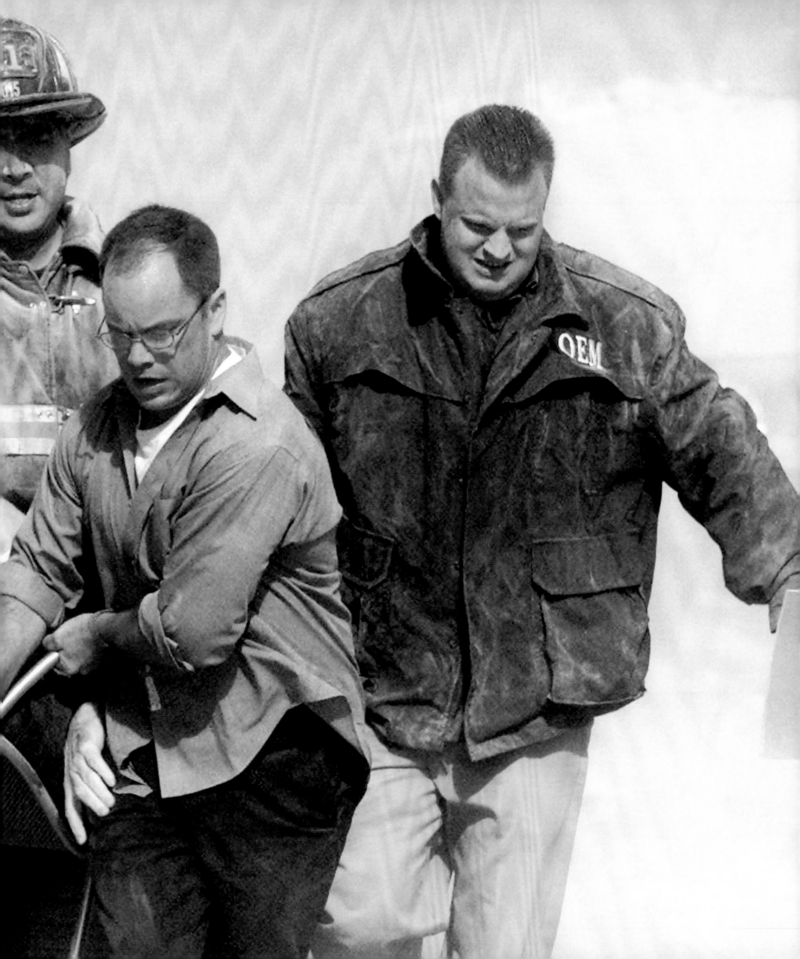

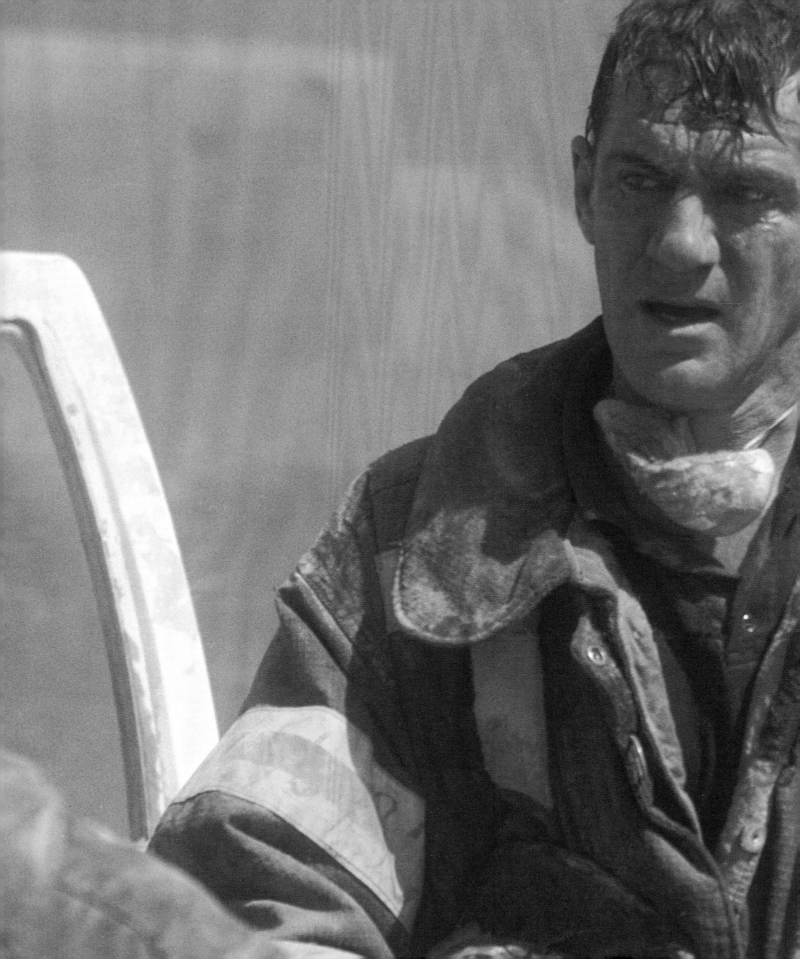

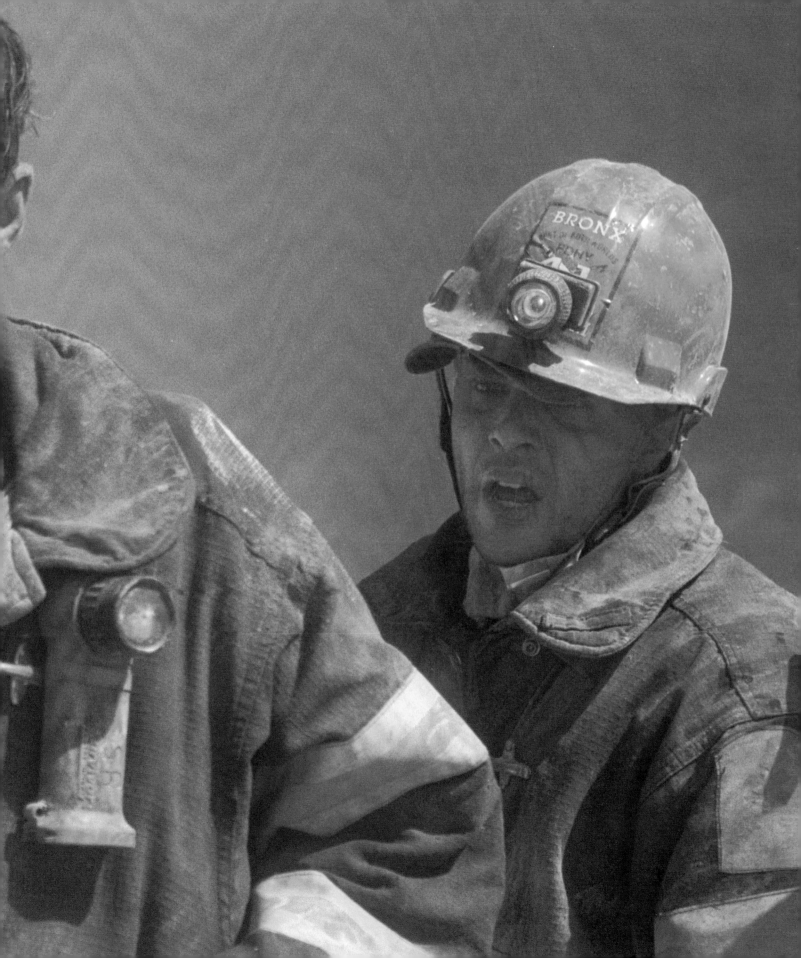

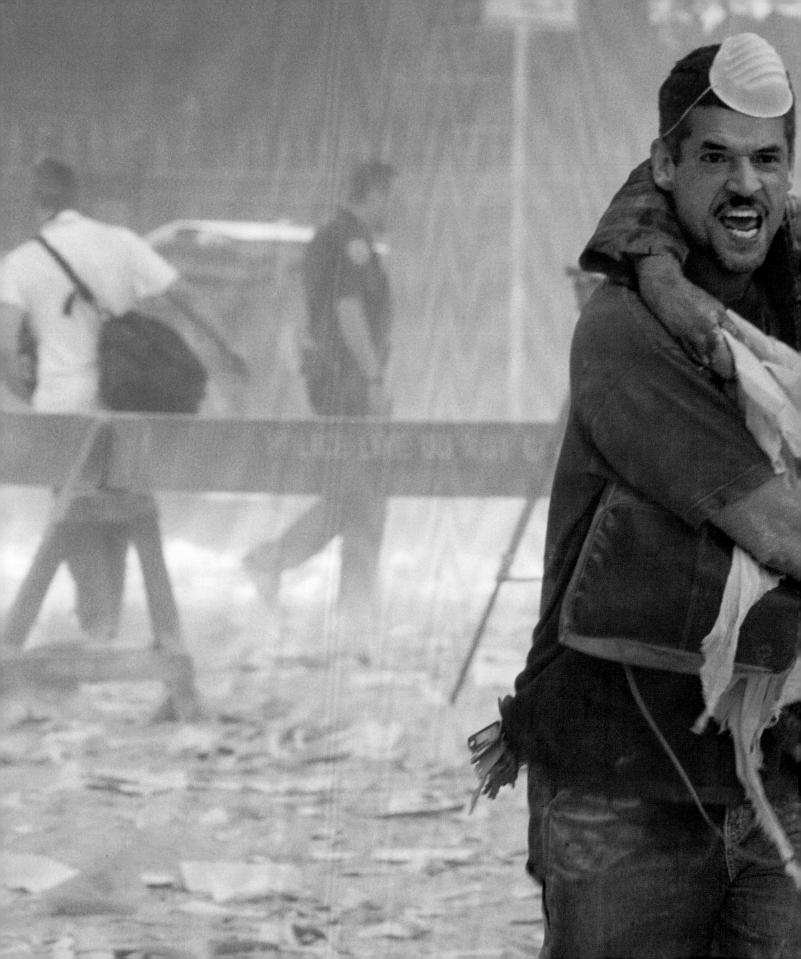

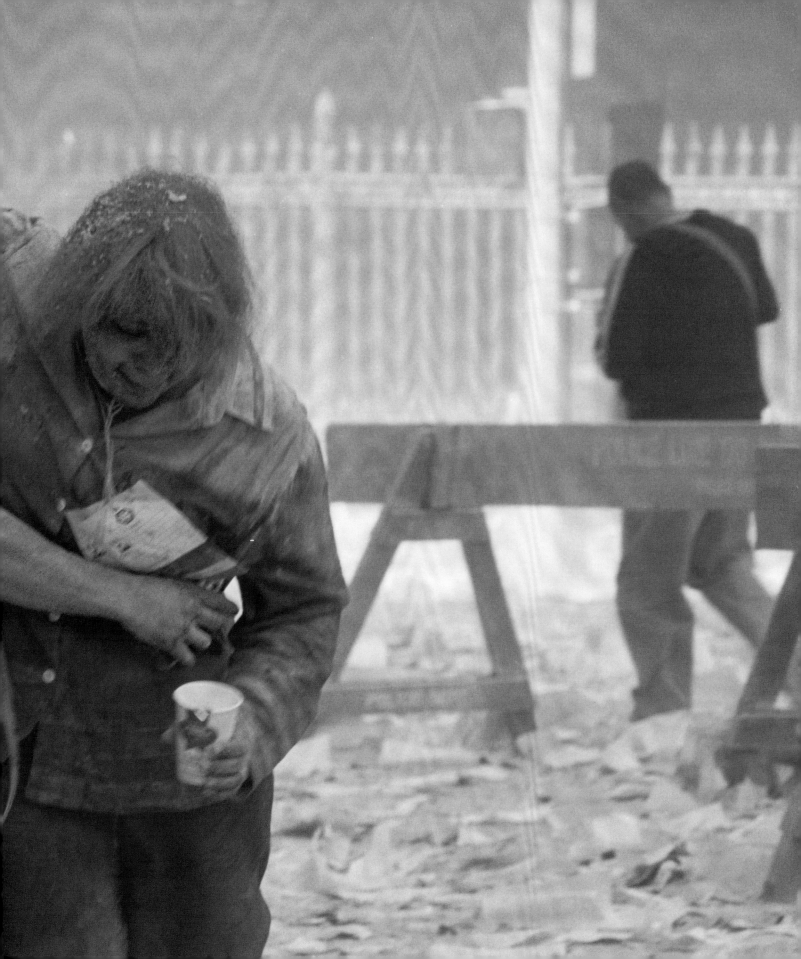

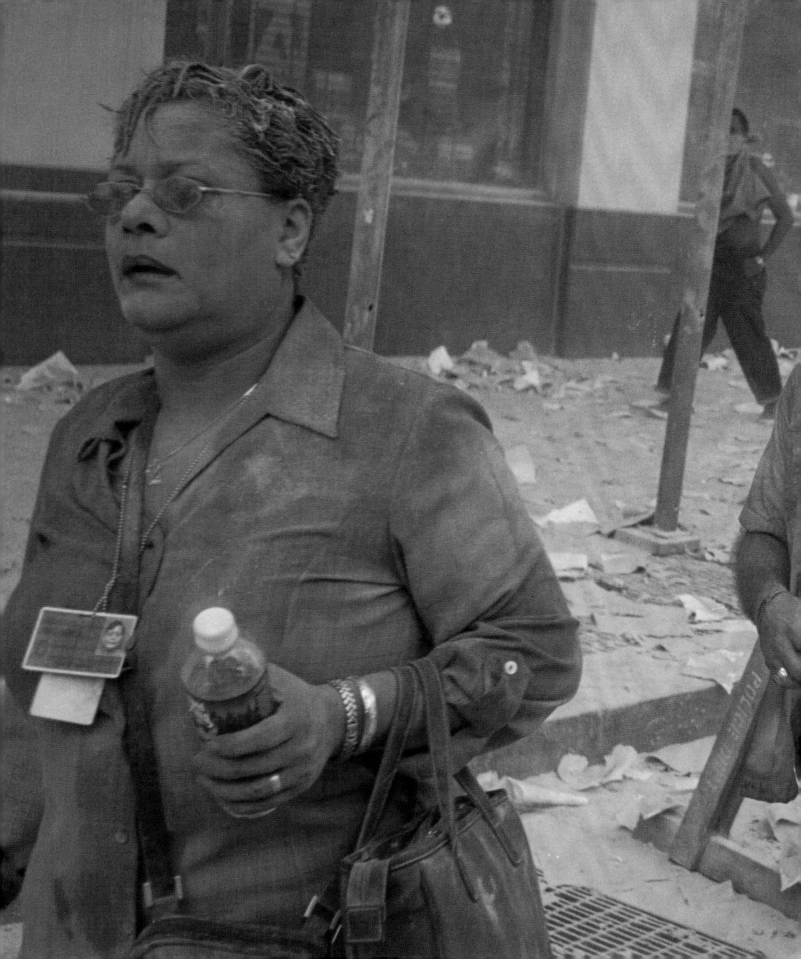

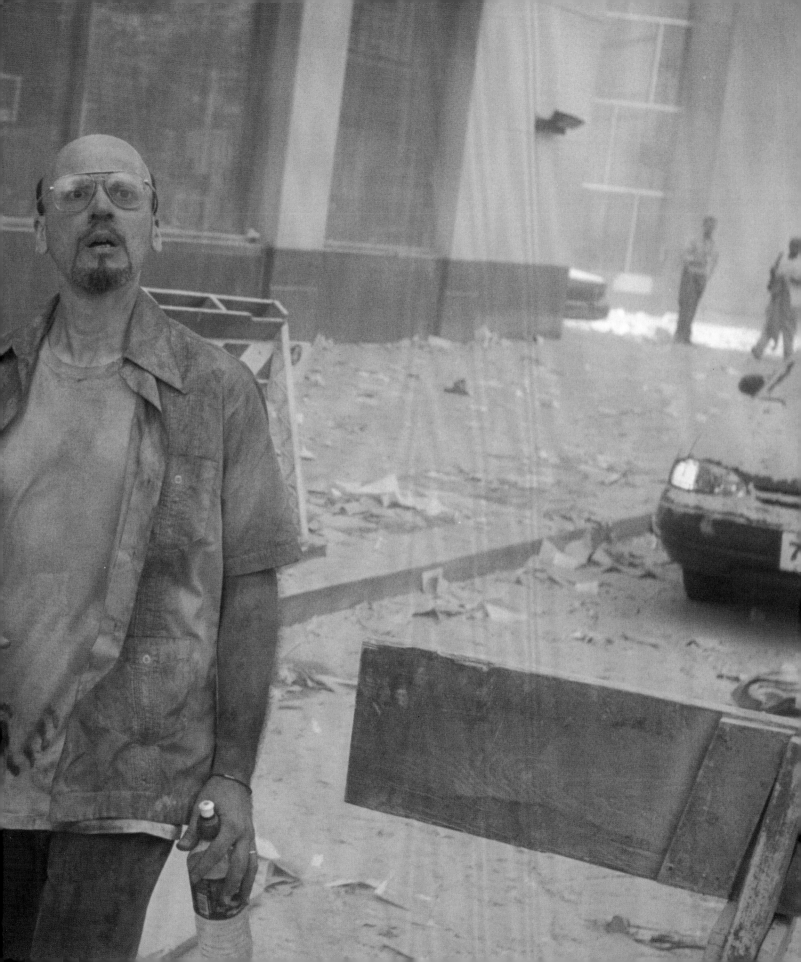

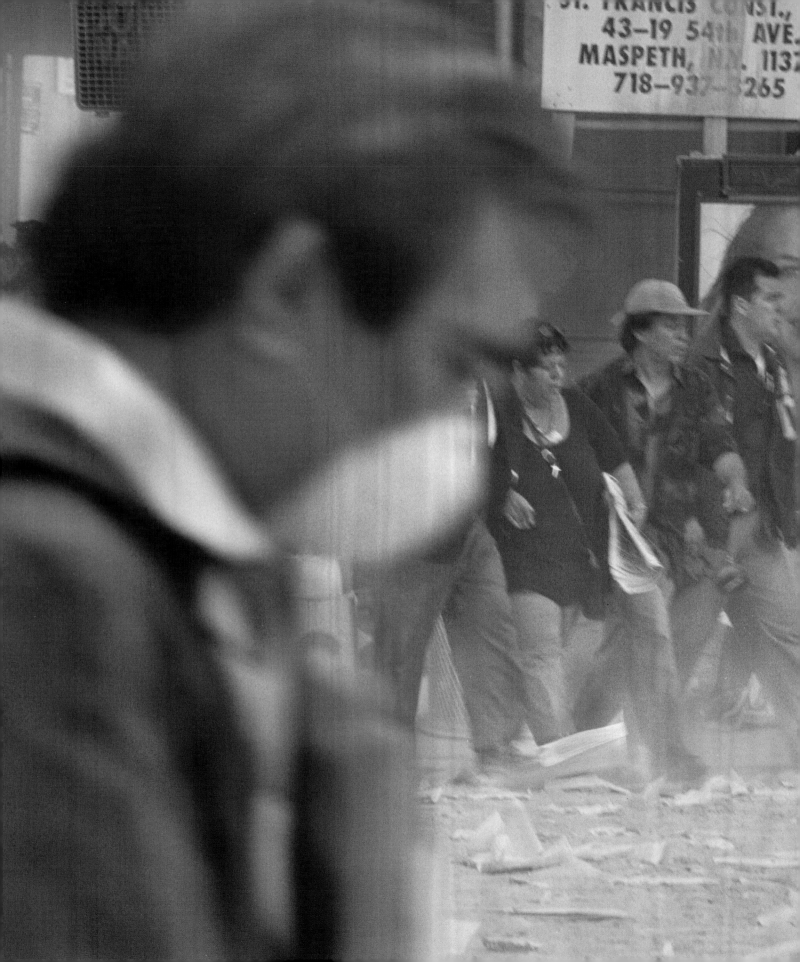

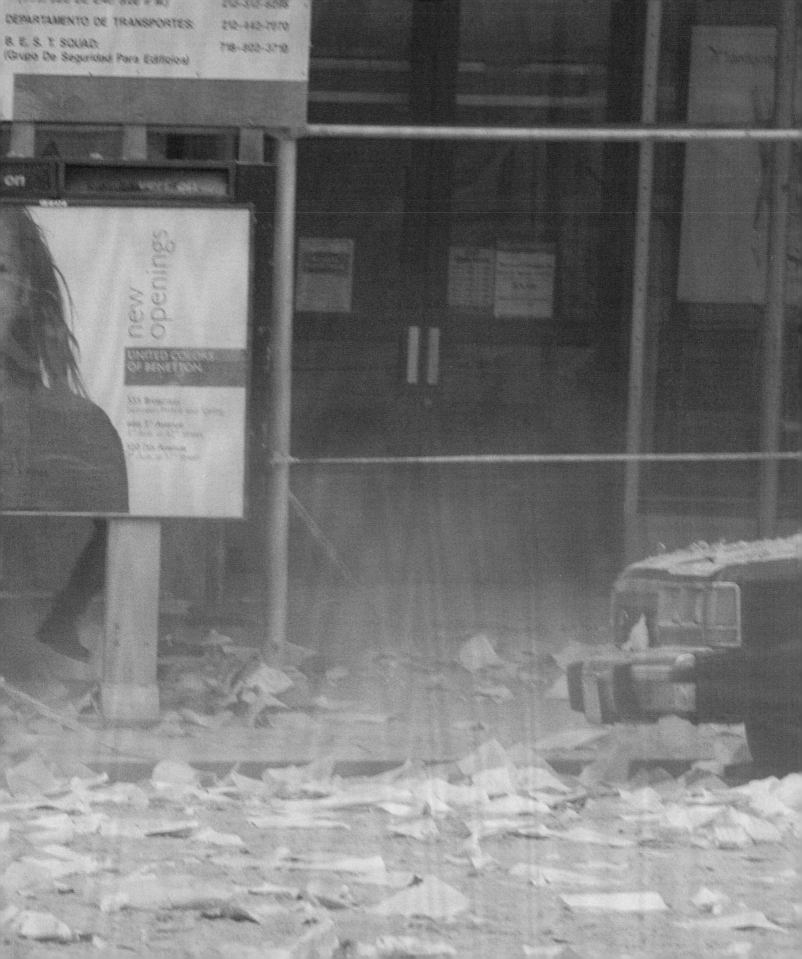

How can I not believe in miracles when I walked out of the World Trade Center unhurt? How can I not believe in love when I see the outpouring of it from the friends and family who have been calling and e-mailing me since the attack? Rather than seeing the world as an uglier place after the attack, I see it as a beautiful place where people give all they can when called upon to do so. I will never forget the police and firemen who walked past me to save lives in the building and never walked out. Who went in knowing that the chances were good they would never walk out. I will never forget the people I worked with who were not as lucky as me. As the stories come out of those who did not make it, you realize how every second made such a difference; how one wrong decision could have been fatal.

I worked on the 72nd floor of the north Tower (Tower 1) whenever I am in New York. On that fateful day I had arrived in New York late on Monday night so the next day Tuesday September 11 a group of us from Bechtel & Port Authority could attend Primavera's user conference in Philadelphia. Going up in the elevator I decided that I would spend some time on responding to my e-mails and be ready by 10AM when we were suppose to leave for Philadelphia. At 8:40 AM I remember I was on the phone leaving a message for one of Port Authority Division Managers when the plane hit the Tower 1 (North Tower) on about the 90th floor, I even remember saying oh my God we got hit, oh my God we got hit as part of my message! When the first plane hit the North Tower it was nowhere near as dramatic as you would think on the 72nd floor, as it would be on the higher floors. There was a definite explosion and the building shook violently. There was a big flash of light. The really scary part was how much the building moved, and kept moving, for a long time before re-stabilizing. At the same time we saw out the window that flaming pieces of the building were flying past our floor window on their way down. People on the floor were a little confused, should we stay there or start to evacuate, I heard some of the secretaries crying and hugging each other. The Floor Wardens with their red hats had not yet mobilized to give us instructions. They probably would have suggested we stay in the hall and wait for an announcement. Not knowing what hit us, I didn't feel it was anything serious, so I went back to my desk to finish answering my e-mails. Next I noticed the smoke filling the floor and most of the people had already evacuated the floor. One of the Port Authority managers asked me what I am doing here and I need to leave the floor immediately. I asked him if everybody had been evacuated, he told me he wasn't sure and if I want I could search the floor. So I started running on the floor and shouting on top of my considerable lungs, everybody has to evacuate immediately. I came back to the manager, by now it was only us two left on the floor. So we moved toward the stairs to leave when we heard cries from the elevator. One of the elevators had four people stuck in it. So we tried to open the elevator door to no avail. I ran back to the office trying to find some tool to use as a lever to open elevator door. I found a heavy-duty stapler that we tried to use to pry the elevator door open. We tried for ten minutes and we could only open the door by few inches leaving the stapler between the doors so they could get some air, even though, there was smoke in the air but still it was better than the air in the elevator. By now the floor was getting really hot and full of smoke, our eyes were burning. I was running back and forth to the Men's room and bringing wet paper towel to put on our eyes and eyes of people in the elevator.

Humankind has a great ability to forget about oneself and try to help others that are in worst shape than you are. By now my survival instincts were kicking in and I knew that we needed to leave. So I told my comrade in arm that we need to leave since we cannot do anything for the people in the elevator except to let the firemen

know that there are four people in the elevator in 72nd floor. He told me I should leave since I have young kids. He was going to stay so he could tell the firemen about the people in the elevator. I started my descent with my heart still with the people on the 72nd floor. The stairs were deserted, I started to get worried and thinking have I stayed too long not knowing the full danger of the moment. I was able to get to the 40th floor fairly easily, after that we were slowed up by people coming in from other floors some people were crying, some people were tired and not in that good a shape, but we all helped the weaker. There were several times that 2 landings ahead of me were empty because I was helping a heavy woman named Michele who was having trouble with her knees. No one pushed past, no one yelled at us. Many people in the stairs with me had been in the last World Trade Center bombing in 1993, and they kept telling us this was much better than that time. The lights were on, the smoke was not so bad, the bomb was above, and not below us of course we were going to make it out. It wasn't until all the traffic on the stairs stopped that people got panicky and started to yell, but then a stop & go pattern developed and we were calm again. It was on the stairs that I started to worry about my wife and my kids and the fact that I wasn't ready to die yet. We started to hear that a plane had hit the building, and I wondered if it might not bounce into the other tower. I kept trying my cell phone but it wouldn't work no surprise. We kept walking down the stairs. The smoke was acrid, for a brief moment I thought we may get poisoned, that perhaps we were not yet safe, but that passed quickly too. Of course we were safe, we were near the ground (just 20 or so flights to go). We saw the first rescue worker coming up our stairway on the 17th floor. I remember that because one woman said that last time she first saw them on the 18th floor. Their coming up slowed us down a little more, but we had all the time in the world or so we thought. When we were almost all the way down we came upon a floor that had water pouring out from under the door. This caused a waterfall all the rest of the way down, there were several inches of water on the floor, but it was passable and did not slow us up much. We came out on the mezzanine level, which is the ground floor street level on the front of the

building. In all it took us about 50 minutes to get down the stairs. There was probably less than few minutes before the south tower would collapse. The plaza was filled with burning debris, but it did not look very bad, that is until you look again. The sight of a heart in its entirety stuck against the mezzanine window got my attention, so I looked again at the plaza debris and all of a sudden I noticed a horrible scene of body parts and human organs, maimed bodies all over the plaza. Arms, legs, guts, half bodies, a sight that I would never ever forget as long as I live. I kept thinking this can't be real it is movies, oh how much I wanted it to be just that. The lower level windows to West Street were completely blown out, but nothing looked bad out in the street. It was then; however, that the seriousness of the situation became apparent. The police had panic in their voice. They yelled at us with a real sense of urgency to move. When we came out of stairwell the police asked us to walk in single file and do not run, after we got to the concourse level they were asking us to run. You very quickly realized you were not safe yet. At the lower level they routed us through the basement mall. It was a surreal scene. It was completely empty except for a few rescue workers, the lights were out, the sprinklers were all going off and the floor was flooded. We ran down the corridor past the PATH train, I saw the doors on the North side of the tower and the street there looked fine, but they were making us go a different way. That door was closer, but I decided to trust the police and so I went up the escalator and out the door by where the Borders bookstore was the North-east corner of the complex. When we got outside they yelled for us to run, some stuff was on the ground and I realized that I could still be killed by falling debris. They kept yelling, "don't look up" but I couldn't help myself and I turned around to see the fate of the buildings. By now both Towers were hit, I kind of froze looking up at these magnificent Towers with fire and smoke billowing out of them.

I still did not feel safe right at the base of the buildings where so many people stopped to watch people that were throwing themselves from the building. I saw the looks of horror on the onlookers' faces and I knew I did not want to look back. I saw one policeman scream that another body was falling and then quickly turn his head away. There was nothing I wanted to see back in that building. Those were not images I could bear to imprint on my memory cells so they could haunt me for decades to come. I moved fast, searching only for a free phone to call my wife and the kids (my wife is in California & my kids in upstate New York). At this time more debris started to fall from the Tower Two along with loud crackling sound. Somehow I knew that something bad is going to happen and I started to run for my life, this is the time that Tower Two started to fall. I somehow had injured my left knee coming down the stairs and I couldn't run as well, but it was matter of life and death and I wasn't going to let anything to happen to me as long as I could help it. I was able to outrun the falling building but not the thick smoke. I remember running and kept looking back and seeing the smoke is getting closer and closer until finally it engulfed us and turned the sunshine into darkness and horror. People began screaming and others in the street ran by the building, (think of Godzilla movies). The South Tower, the second one hit and the first to fall, had collapsed, imploding upon itself. Later I learned that the smoke was traveling at 50 miles an hour covering up to 2 miles of the surrounding area. After the smoke

got clear I found myself covered in what seemed like a gray ash. Medics had setup a makeshift station to tend to the injured. I had difficulty breathing so I was given some oxygen and a mask and kept there for what seemed like an eternity. Thinking back to that moment I do not remember hearing the sound of the building falling, the sound that people said was like a bomb exploding. All I remember was running away from smoke and then darkness and silence.

I started to walk uptown and looking for phone. Cell phones didn't work. Of course every phone had a long line of people waiting, and I was brought up too polite to push them aside. I felt their calls were as important as mine, we all had just suffered incredibly horrible things. Besides, never one to follow the crowd, I did not want to be herded with everyone and never be able to get near a free phone. So I ran across Broadway and up Fulton Street, dashing to some of the smaller side streets where there were less people; always heading north. Even on the back streets all the phones had lines.

On Canal Street, while walking with a co-worker named Sam, we got stuck for a minute while traffic passed ahead of us. I had a clear view of the remaining tower, the one I had worked in. As I watched in disbelief the building chose that moment to fall. It crumbled, appearing to melt down from the top. It looked like a very controlled demolition, and I began to theorize that the elevator workers had planted bombs, but I heard enough since then to realize that the building was actually designed to fall that way if the worst happened. As an engineer I was so impressed and proud that they had incredibly planned for what had happened. So many lives saved because of such careful, well thought out design. When I later found out that a 767 loaded with fuel had hit the building I was even more impressed. The impact was so minor, the swaying of the building so much less than one would have expected, the explosion so

muffled, that I could not believe how well the building was constructed. Were it not for this we all would be dead today. The buildings gave us a lot of time to get out. It was like they valiantly held themselves together as long as possible so the greatest number of people could get out, and then expired in a way that harmed the least number of people in their passing.

But as I walked uptown from Canal Street my mind was not on the buildings, it was on my wife & kids, I kept trying my cell phone to no avail. By the time I was able to talk to my wife it was 4:30PM New York time. She said she died and came back to life until she finally heard from me, she thought that I didn't make it especially that I was the last one in my group to be accounted for. I thank God for my wife's strength and loyalty, she had been in touch with my kids throughout the day by talking to them and giving them hope that somehow I will be ok.

So what are we left with, in the aftermath of this great tragedy? Thousands of people are dead; our world stands poised on the edge of senseless destruction, and survivors like me fear a repeat performance. If that were all, the Taliban would have succeeded, and struck a victory. Instead, in that dramatic morning, because of a cruel and inhuman act, the world was given back its humanity. Places of worship are full, and we are discussing world events more than our personal lives. People have donated time, money, clothes, their blood, and most important of all, their lives, to help others through this difficult time. We are taking the first steps toward being a better people. Unfortunately, there are always ignorant and cruel people in every culture, and some Americans are senselessly attacking innocent people from the Middle East who live in America. Typically, this happens quite far from the place where the attack took place, and is perpetrated by those who lost no one or nothing in the attack, except their feeling of security. At Ground Zero we feel only numbness, and an intense feeling of vulnerability. We want only a place of safety.

When we ran that day down the stairs we thought we were safe until a plane hit the building while we were still inside. When we miraculously got to the downstairs we thought we were safe until the first building fell, and when we were not hit by debris we heaved a sigh of relief, only to have our lungs filled with dust from the pulverized building. Now although some of us are back home in our own beds, we still did not find a place of safety, because of world events. My heart pounds and the adrenaline flows when it is not needed and I find it hard to eat. But still we get up, shower and dress and go about our everyday lives, and try to find the greater meaning. I for one will try to find it in helping others every day, in being kinder and more patient, in re-establishing my ties with God, and in sending out messages of hope like this so my worst fears do not come true.

May God bless all of you and help us all to find our inner humanity.

Mehdi Dadgarian

Luc Sante

On the morning of September 11 I was happily oblivious. I got my two-year-old son out of bed, fed him breakfast, played with him, then took him to the library for story hour. I didn't listen to the radio in the car because I wanted to hear a tape -- doo wop; I sang along. Near the bank was a cluster of Red Cross vehicles. I thought a drill or a fund-raiser might be in the works. At the library attendance was lower than normal and the adults were behaving a bit oddly, their smiles fixed, their postures rigid, but I didn't think much of it. When we got home, at noon, my wife met me at the door. My mother's cousin had called from Belgium to make sure we were still alive.

We live in the country, two hours north of New York City. The fields and the woods had not heard the news. I looked out at the valley and the low hills beyond and felt as if I were looking into the past. **That afternoon we took a drive with my in-laws, who were visiting and insisted on going out when what I wanted to do was to curl up on the floor.** Along the way every small town, every natural prospect was perfect, and infinitely pathetic in its innocence. All those familiar settings were now heavily foreshadowed, like the pastoral opening shots of a film overladen with ominous music.

Before moving to the country I was a New Yorker for nearly 30 years.

I saw the towers of the World Trade Center being built, floor by floor, as I walked beneath them every weekday morning from 1968 to 1971, bound for high school.

A few years later I stood in a crowd around the giant disembodied arm of an ape lying in the plaza between the towers -- the 1976 remake of King Kong. Like every New Yorker I used the towers as my compass when I emerged, momentarily disoriented, from an unfamiliar subway exit, or when I drove toward the city along the latticework of highways to the west. **The week of September 11 I felt guilty for not being in my city at its darkest hour.** I felt like one of those Parisians who fled to the Midi in 1940 and then suffered, over the newspaper and the shortwave, the pain of a missing limb.

Before lists of the missing were published I pored over lists of survivors that appeared on the Web. You could see that the composition of the city was mirrored in the population of the towers -- Spanish names and Polish

names and Arabic names, and Chinese and Italian and Jewish and Anglo-Saxon and every other ethnicity. The attackers had hit a symbol of power, but they had also killed window washers and busboys and secretaries and security guards and copy-machine operators and maintenance workers -- the breadwinners of families uneasily getting along in cramped apartments in the powerless parts of town.

I don't have a nationality. The passport I carry is issued by a country I haven't inhabited for longer than a few months in forty years. I love the place where I live now -- I'm vitally concerned with its history and its culture; I'm a part of it. **But my own history deprived me of whatever is required in order to believe in flags. For years I said my nationality was New Yorker, because that babel of names and faces and cultures and languages was something I could feel at one with. I've felt that again in the aftermath of September 11.**

Patriotism toward New York City is, in effect, a global patriotism.

What was done to New York City that day is an atrocious crime. War -- that is, the unleashing of military power of such scale that many will die who were not party to the crime -- is therefore an act of treason. Violence may occasionally solve problems, but violence will not solve violence.

"Those to whom evil is done do evil in return." That's what started all this. I tremble as I think that there is no likely end in sight.

My son still doesn't know what happened on his second birthday. I don't want him to grow up in a world whose every detail is dictated by the repercussions of that day.

the world will neve

be the same after...

9.11.2001. do you

The horrendous terrorist attacks on Tuesday are something quite new in worl

think so? [3]Noam Chomsky:
affairs, not in their scale and character, but in the target.

For the US, this is the first time since the War of 1812 that its national territory has been under attack, even threat. Its colonies have been attacked, but not the national territory itself.

During these years the US virtually exterminated the indigenous population, conquered half of Mexico, intervened violently in the surrounding region, conquered Hawaii and the Philippines (killing hundreds of thousands of Filipinos), and in the past half century particularly, extended its resort to force throughout much of the world. The number of victims is colossal.

**For
the
first
time,
the
guns
have
been
directed
the
other
way.**

The same is true, even more dramatically, of Europe. Europe has suffered murderous destruction, but from internal wars, meanwhile conquering much of the world with extreme brutality. It has not been under attack by its victims outside, with rare exceptions (the IRA in England, for example). It is therefore natural that NATO should rally to the support of the US; hundreds of years of imperial violence have an enormous impact on the intellectual and moral culture.

It is correct to say that this is a novel event in world history, not because of the scale of the atrocity -- regrettably -- but because of the target. **How the West chooses to react is a matter of supreme importance.** If the rich and powerful choose to keep to their traditions of hundreds of years and resort to extreme violence, they will contribute to the escalation of a cycle of violence, in a familiar dynamic, with long-term consequences that could be awesome.

Of course, that is by no means inevitable.

An aroused public within the more free and democratic societies can direct policies towards a much more humane and honorable course.

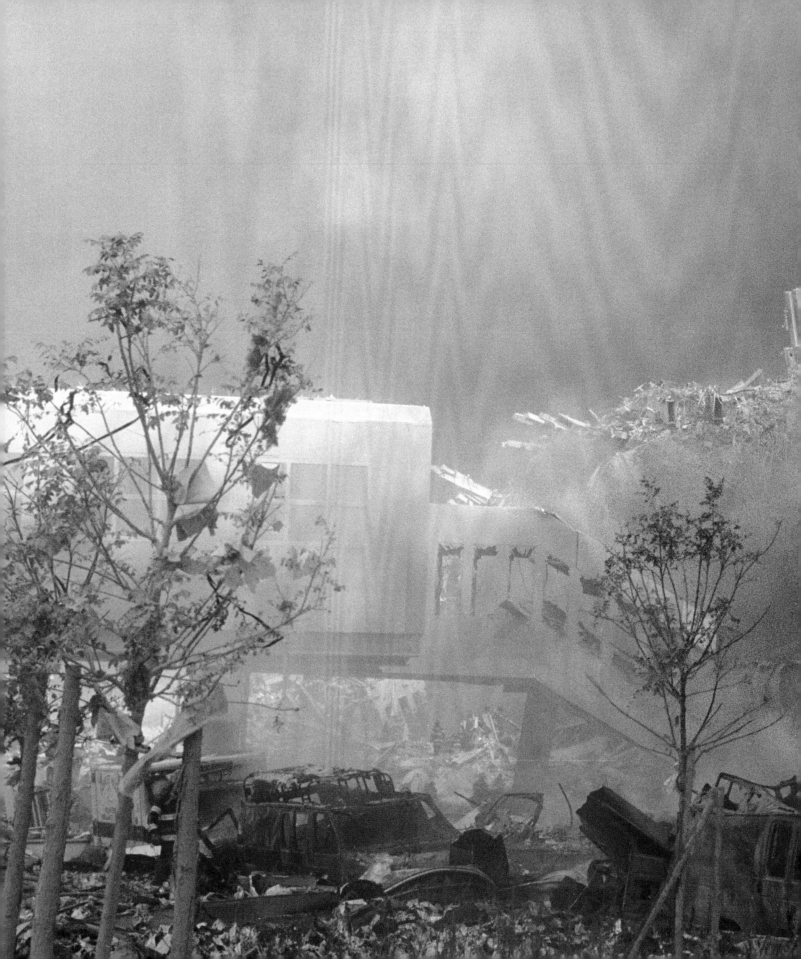

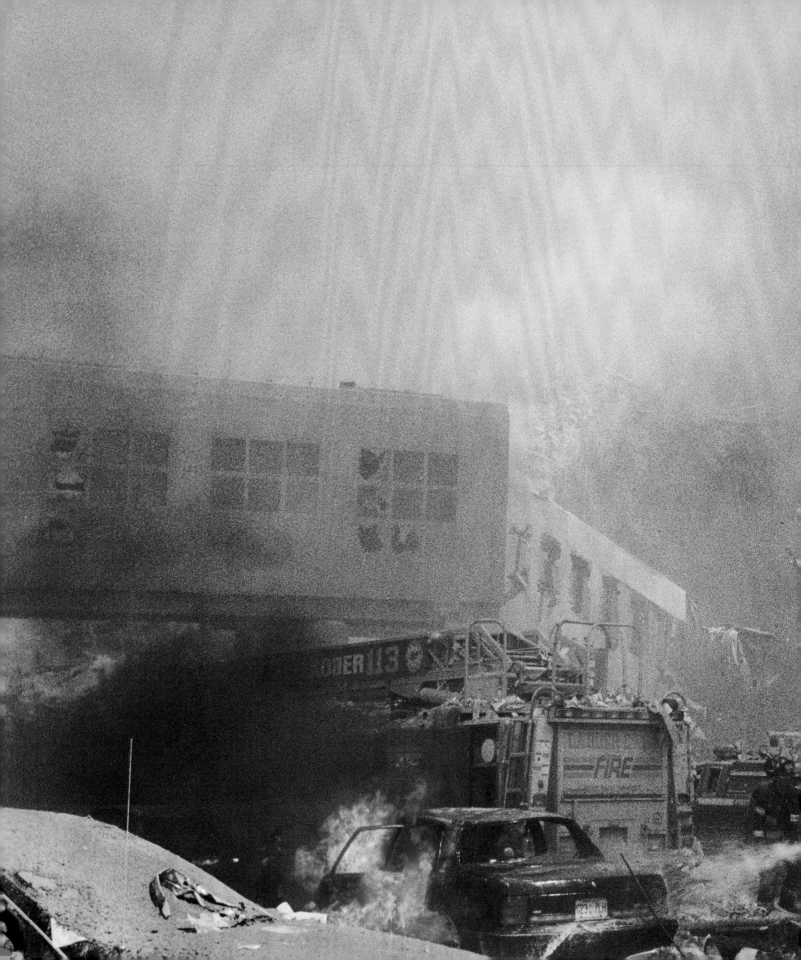

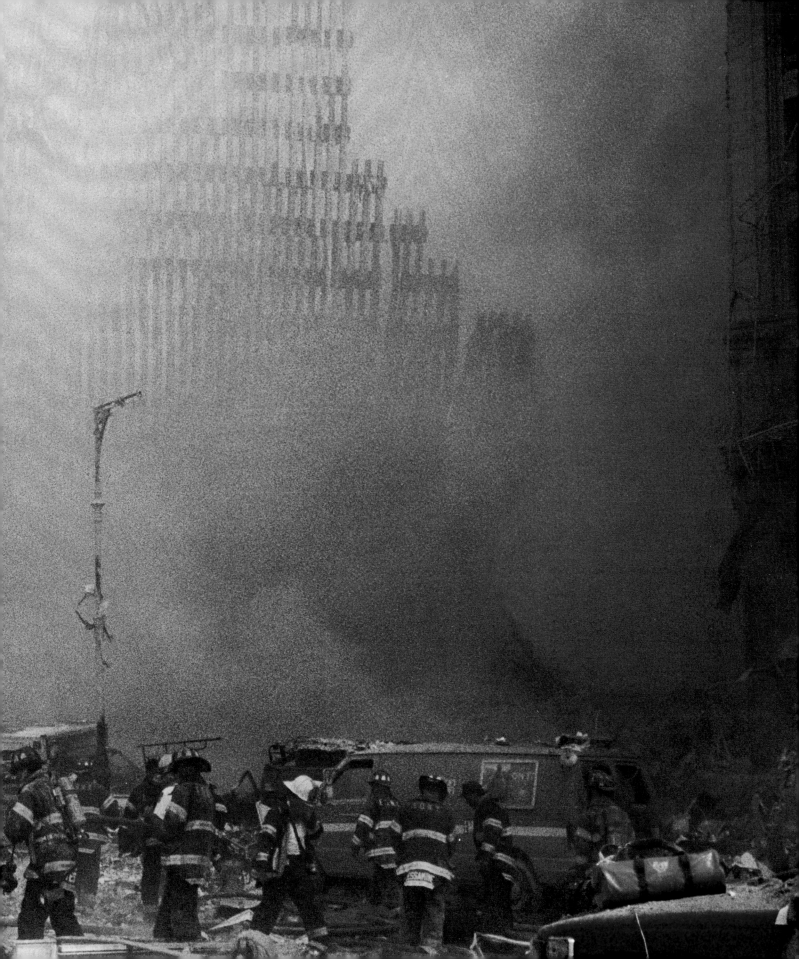

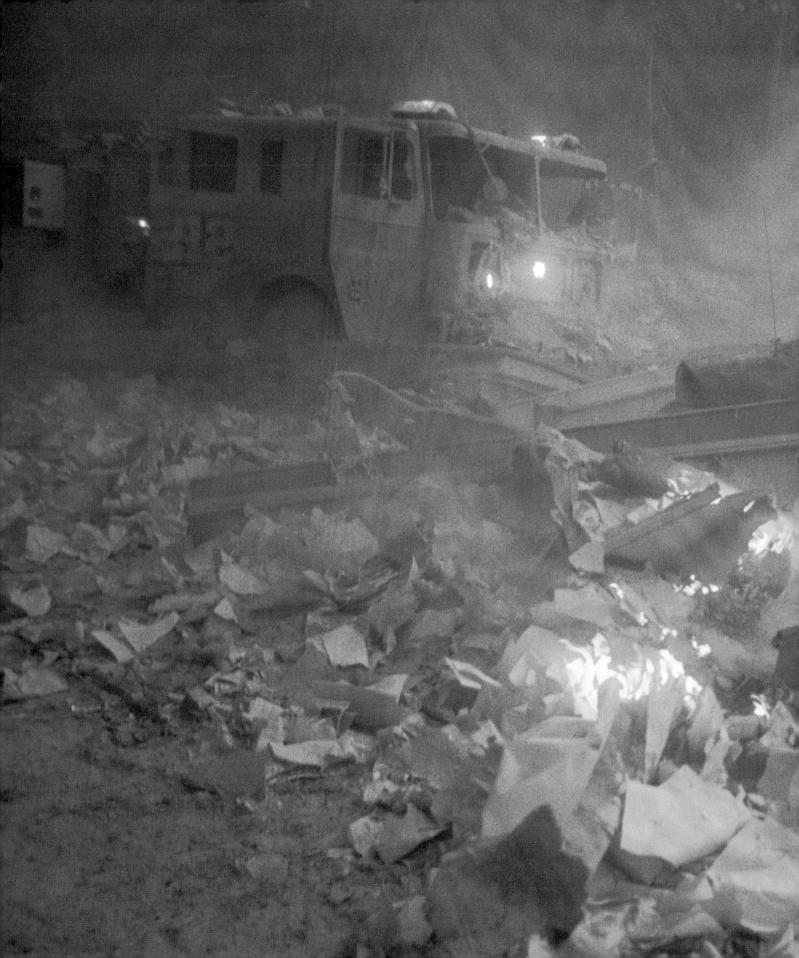

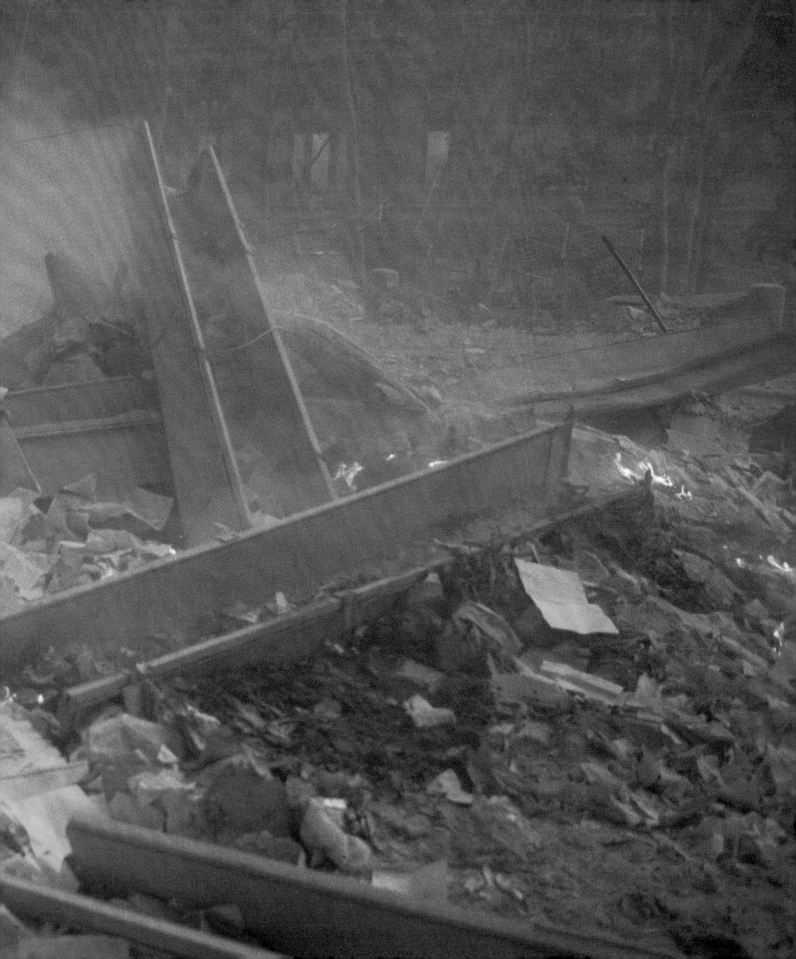

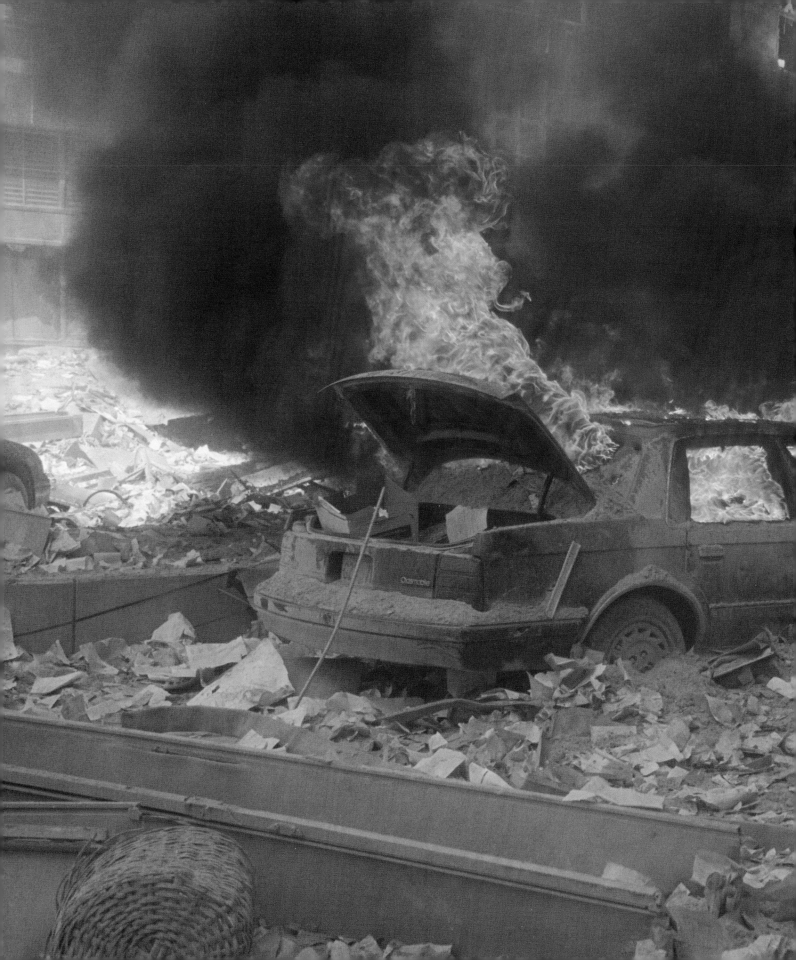

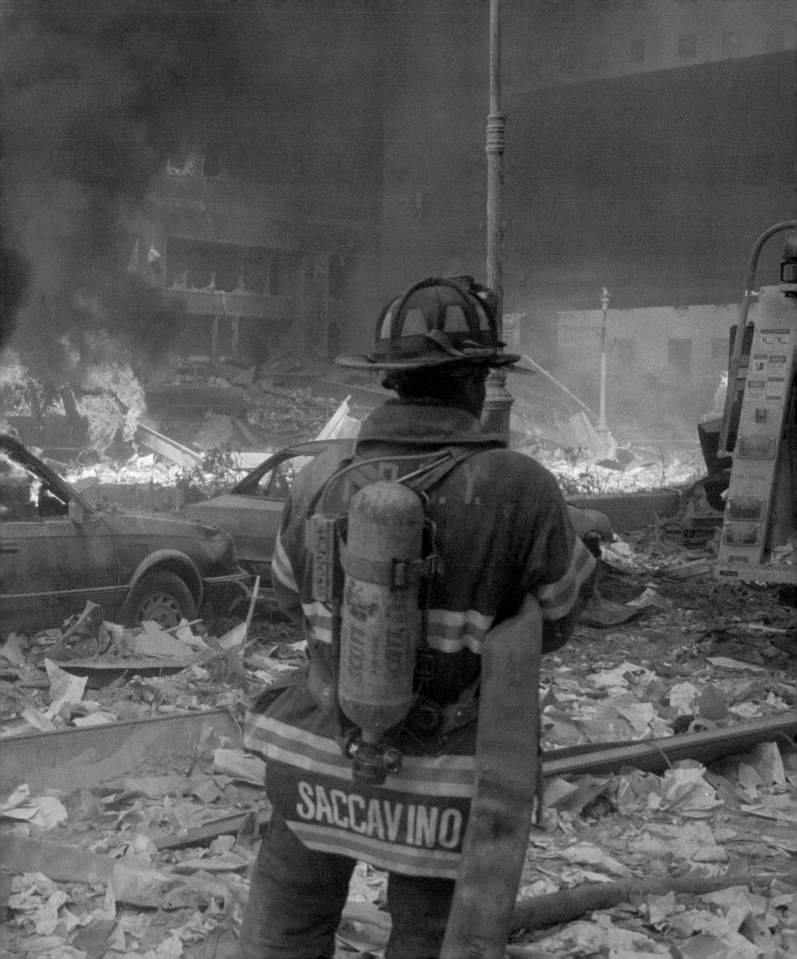

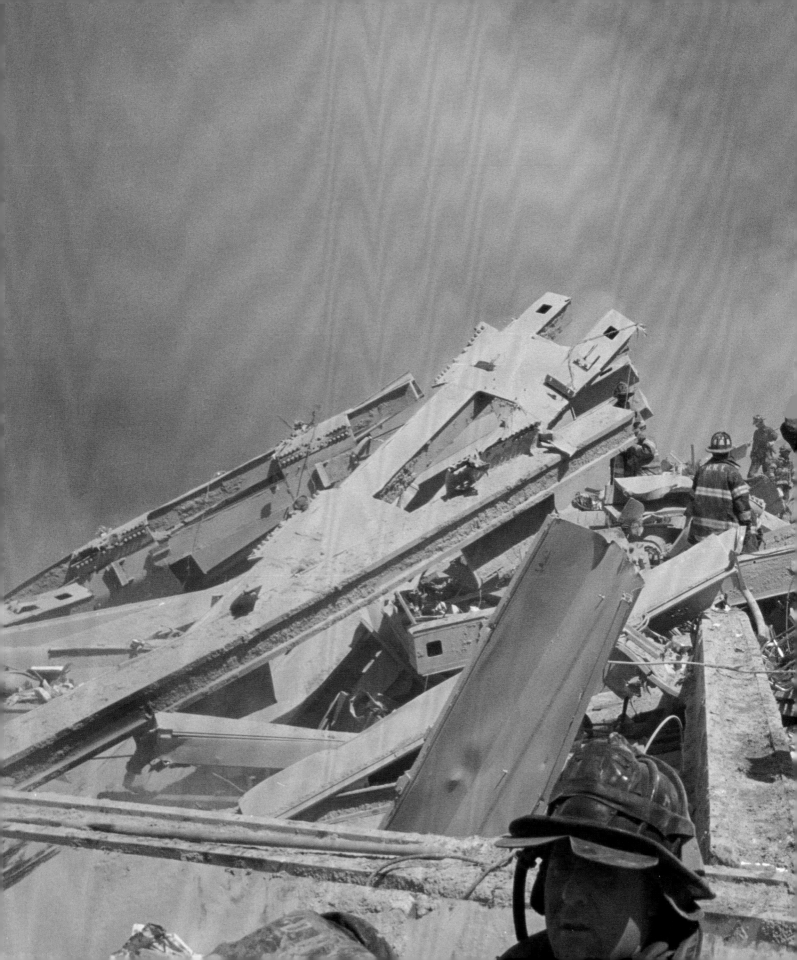

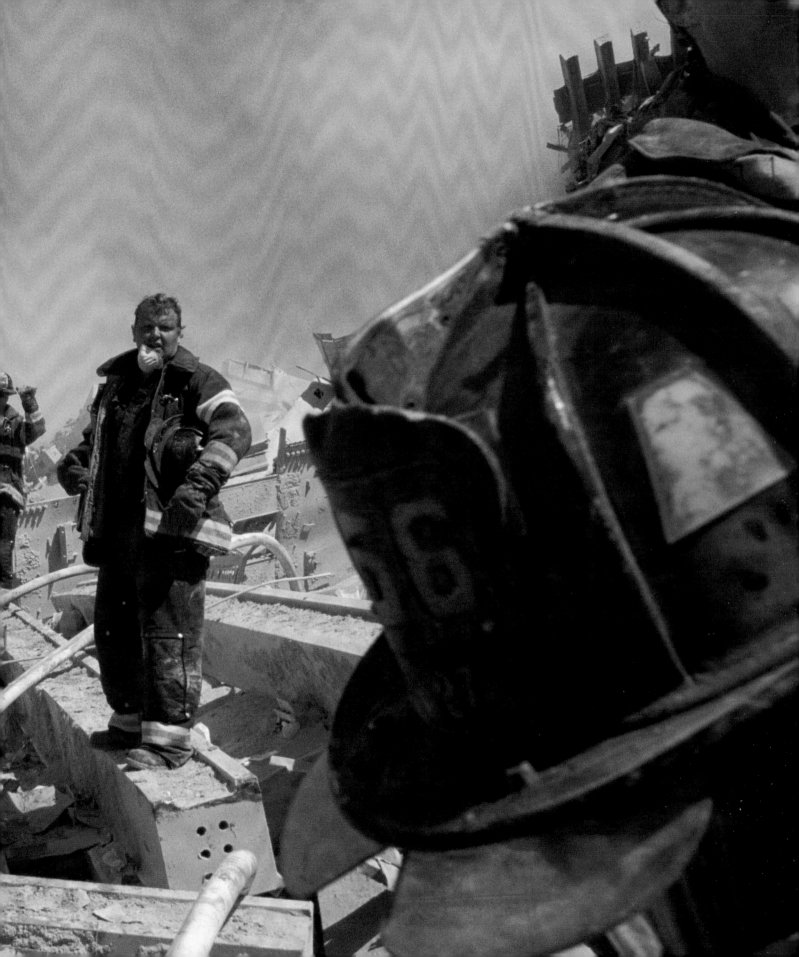

The phone call came at 8:55 am.

The voice said a plane hit the Trade Towers.

Within a couple of minutes I was on the express train heading downtown. I was trying to process the information from the phone call and the only image I could drum up was a small two-seat plane hitting the building. When our train reached the Chambers street station I was starting to understand something different. As the doors to the train opened Police were running down the platform screaming to get out of the subway by any exit available. People started running in all directions in panic. I reached street level and looked up and knew my life would never be the same.

Confusion. Disbelief. The two towers were on fire and dark smoke was scarring the beautiful blue sky.

People were screaming, crying and running past me, away from the towers. I'm a photojournalist so my reaction was to run towards the Towers. I reached the base of the World Trade Center and everything from that moment on seemed like a blur of unreal events. I went by a street level open area of a building that trucks would back into and unload their cargo. The building was WTC number Seven. There were no trucks present … But what was there was a mini-triage area with a row of stretchers with doctors, nurses, firemen and police waiting for the wounded to come out. I then walked further up the street and stopped. What happened next I don't think anyone expected to happen. A loud shifting noise prompted myself and a fireman to look up at the sight of a 110 story building coming down on top of us. I looked at the fireman as he screamed "building collapse" as we both made a mad sprint to find shelter under the open area of WTC building number Seven.

As soon as we reached that open area the debris started to fly and crash down. The light went from sunlight to white light, then to the black of all blacks. When I say you couldn't see in front of you, I mean not even an inch.

The noise of the building coming down can't be described. I wish I could give you an idea of the sound but I can't. I've stopped trying.

Then everything went silent … Until people started screaming in panic.

A fireman was yelling for everyone not to panic, which is almost impossible because you know that one of the tallest buildings in the world just collapsed on top of you. This is the building I used to stand at the base of and look up in awe like I was a little kid again. **If you weren't yelling in panic you sure felt like it.**

The hardest part (for me anyway) was the feeling that someone was covering my mouth so I couldn't breathe. The smoke was so thick that it was becoming a real chore to find oxygen. Every breath had less and less air. When you panic you use a lot of air so I tried to calm myself down. Then someone whose voice was cracking with panic yelled that we needed to get out of there now … and that's when a strange feeling came over my body. It was a feeling that went from fear to resignation. I became very calm and a warmth covered my body from head to toe. **I just said to myself that I've photographed in some crazy places and the chances of something happening to me were very real, I just didn't know when and I said that this must have been it.**

And then, after some time had passed – which seemed like a lifetime, a man was yelling that he had found a way out. The closeness of his voice let me know that I was standing almost right next to him. He then started yelling for me to stobe the flash on top of my camera. I held my camera up in the direction in which I thought most people were and repeatedly snapped the shutter of my camera to make the flash go off.

The man is now instructing everyone to follow the flash of light. The next thing I know we are now walking from blackness, through a white haze, to a place where you could see blue sky. **I feel selfish in saying I wish I could share with you the feeling of seeing the blue sky again** … Considering how many innocent people lost their lives. **The picture I've enclosed is one of the only photographs from that roll where you can recognize an image through the black smoke. I don't know who the man is but I am sure that if it weren't so black we would have all had the same look on our faces.**

It's almost three weeks later as I write this and I am still trying to understand and come to terms with what has happened on September 11, 2001.

Gary Fabiano

In 1999, soon after moving to the Fort Greene section of Brooklyn, my wife and I were befriended by Frank and Nicole De Martini, a couple whose lives were closely twinned with the towers of the World Trade Center. Both Frank and Nicole are architects. As Construction Manager of the World Trade Center, Frank's offices were on the 88th floor of Tower 1. Nicole is an employee of the engineering firm that built the World Trade Center, Leslie E. Robertson Associates. Hired as a "surveillance engineer," she was a member of a team that conducted year-round structural integrity inspections of the twin towers. Her offices were on the 35th floor of Tower 2.

Frank is forty-nine, sturdily-built, with wavy salt-and-pepper hair and deeply-etched laugh lines around his eyes. His manner is expansively avuncular and nothing pleases him more than when the conversation turns to a subject on which he can offer his expert advice. For Frank, the twin towers were both a livelihood and a passion: he would speak of them with the absorbed fascination with which poets sometimes speak of Dante's canzones. Nicole is forty-two, blonde and blue-eyed, with a gaze that is at once brisk and friendly. She was born in Basel, Switzerland, and met Frank while studying design in New York. They have two children, Sabrina, 10, and Dominic, 8, who are unusually well-matched with mine, in age, gender and temperament: it was through our children that we first met.

Frank and Nicole's relationship with the World Trade Center was initiated by the basement bomb explosion of 1993. Shortly afterwards, Frank was hired to do bomb damage assessment. An assignment that he had thought would last only a few months, turned quickly into a consuming passion. "He fell in love with the buildings," Nicole told me. "For him they represented an incredible human feat; he was awed by their scale and magnitude, by the innovative design features, and by the efficiency of the use of materials. One of his most repeated sayings about the towers is that they were built to take the impact of a light airplane."

Nicole saw that Frank was hanging back. She stopped beside him and begged him to come with her, imploring him to think of the family. He shook his head and told her to go on, without him. There were people on their floor who'd been hurt by the blast, he said; he would follow her down as soon as he had helped the injured on their way. She could tell that she would have no success in swaying her husband; his belief in the building was absolute; he was not persuaded that the structure was seriously harmed – nor for that matter was she, but now she could only think of her children. She joined the people in the stairway while Frank stayed behind to direct the line.

Frank must have gone back to the Port Authority offices shortly afterwards for he made a call from his desk at about nine o' clock. He called his sister Nina on West 93rd street in Manhattan and said: 'Nicole and I are fine. Don't worry.'

After the World Trade Center

On the morning of Tuesday, September 11, 2001, Frank and Nicole dropped their children off at their school, in Brooklyn Heights, and then drove on to the World Trade Center. Traffic was light and they arrived unexpectedly early, so Nicole decided to go up to Frank's office for a quick cup of coffee. It was about a quarter past eight when they reached Frank's office. A half hour later Nicole pushed back her chair and stood up to go. She was on her way out the door, when the walls and the floor suddenly heaved under the shock of a massive impact. Frank's office commanded a panoramic southwards view, looking towards the Statue of Liberty and the harbour. Now, through the thick plates of glass, she saw a wave of flame bursting out overhead, like a torrent spewing from the floodgates of a dam. The blast was clearly centered on the floor directly above: she assumed that it was a bomb. Neither she nor Frank were unduly alarmed: very few people knew the building's strength and resilience better than they. They assumed that the worst was over and the structure had absorbed the impact: it was now a question of coping with the damage. Sure enough, within seconds of the initial tumult, a sense of calm descended on their floor. Frank herded Nicole and a group of some two dozen other people into a room that was relatively free of smoke. Then he went off to scout the escape routes and stairways. Minutes later he returned to announce that he had found a stairway that was intact: they could reach it fairly easily, by climbing over a pile of rubble.

The bank of rubble that barred the entrance to the fire escape was about knee-high. Just as she was about to clamber over,

Amitav Ghosh[4]

Nicole remembers the descent as quiet and orderly. The evacuees went down in single file, leaving room for the firemen who were running in the opposite direction. All along the way, people helped each other, offering water and support to those who needed them. On every floor, there were people to direct the evacuees and there was never any sense of panic. In the lower reaches of the building there was even electricity. The descent took about half an hour, and on reaching the plaza Nicole began to walk in the direction of the Brooklyn Bridge. She was within a few hundred feet of the Bridge when the first tower collapsed. "It was like the onset of a nuclear winter," she recalls. "Suddenly everything went absolutely quiet and you were in the middle of a fog that was as blindingly bright as a snowstorm on a sunny day."

It was early evening by the time Nicole reached her home in Fort Greene. She had received calls from several people who had seen Frank on their way down the fire escape, but he had not been heard from directly. Their children stayed with us that night while Nicole sat up with Frank's sister Nina, waiting by the telephone. It was decided that the children would not be told anything until there was more news.

Next morning, Nicole decided that her children had to be told that there was no word of their father. Both she and Nina were calm and perfectly collected when they arrived at our door; although they had not slept all night, neither their faces nor their bearing betrayed the slightest sign of what they had lived through. Nicole's voice was grave but unwavering as she spoke to her children about what had happened the day before. I was awed by her courage: it seemed to me that this example of everyday heroism was itself a small victory – if such could be imagined – over the unspeakable horror the city had witnessed the day before.

The children listened with wide-eyed interest, but soon afterwards they went back to their interrupted games. A little later, my son came to me and whispered: "Guess what Dominic's doing?"

"What?" I said, steeling myself.

"He's learning to wiggle his ears."

This was, I realized, how my children – or any children, for that matter – would have responded: turning their attention elsewhere, during the age that would pass before the news began to gain purchase in their minds.

At about noon we took the children to Fort Greene Park. It was a bright, sunny day and the children were soon absorbed in riding their bicycles and scooters. In the meanwhile, my wife Deborah and I sat on a shaded bench and spoke with Nicole. "An hour passed between the blast and the fall of the building," she said. "Frank could easily have got out in that time. The only thing I can think of is that he stayed back to help with the evacuation. Nobody knew the building like he did and he must have thought he had to do it."

Nicole paused. "I think it was only because Frank saw me leave, that he decided that he could stay," she said. "He knew that I would be safe and the kids would be looked after. That was why he felt he could go back to help the others. He loved the towers and had complete faith in them. Whatever happens, I know that what he did was his own choice."

World War III

Jerusalem, September 13 2001 . THOMAS L. FRIEDMAN[5]

As I restlessly lay awake early yesterday, with CNN on my TV and dawn breaking over the holy places of Jerusalem, my ear somehow latched onto a statement made by the U.S. transportation secretary, Norman Mineta, about the new precautions that would be put in place at U.S. airports in the wake of Tuesday's unspeakable terrorist attacks: There will be no more curbside check-in, he said. I suddenly imagined a group of terrorists somewhere here in the Middle East, sipping coffee, also watching CNN and laughing hysterically: "Hey boss, did you hear that? We just blew up Wall Street and the Pentagon and their response is no more curbside check-in?"

I don't mean to criticize Mr. Mineta. He is doing what he can. And I have absolutely no doubt that the Bush team, when it identifies the perpetrators, will make them pay dearly. Yet there was something so absurdly futile and American about the curbside ban that I couldn't help but wonder: Does my country really understand that this is World War III? And if this attack was the Pearl Harbor of World War III, it means there is a long, long war ahead.

And this Third World War does not pit us against another superpower. It pits us -- the world's only superpower and quintessential symbol of liberal, free-market, Western values -- against all the super-empowered angry men and women out there. Many of these super-empowered angry people hail from failing states in the Muslim and third world. They do not share our values, they resent America's influence over their lives, politics and children, not to mention our support for Israel, and they often blame America for the failure of their societies to master modernity.

What makes them super-empowered, though, is their genius at using the networked world, the Internet and the very high technology they hate, to attack us. Think about it: They turned our most advanced civilian planes into human-directed, precision-guided cruise missiles -- a diabolical melding of their fanaticism and our technology. Jihad Online. And think of what they hit: The World Trade Center -- the beacon of American-led capitalism that both tempts and repels them, and the Pentagon, the embodiment of American military superiority.

And think about what places in Israel the Palestinian suicide bombers have targeted most. "They never hit synagogues or settlements or Israeli religious zealots," said the Haaretz columnist Ari Shavit. "They hit the Sbarro pizza parlor, the Netanya shopping mall. The Dolphinarium disco. They hit the yuppie Israel, not the yeshiva Israel."

So what is required to fight a war against such people in such a world? To start with, we as Americans will never be able to penetrate such small groups, often based on family ties, who live in places such as Afghanistan, Pakistan or Lebanon's wild Bekaa Valley. The only people who can penetrate these shadowy and ever-mutating groups, and deter them, are their own societies. And even they can't do it consistently. So give the C.I.A. a break.

Israeli officials will tell you that the only time they have had real quiet and real control over the suicide bombers and radical Palestinian groups, such as Hamas and Islamic Jihad, is when Yasir Arafat and his Palestinian Authority tracked them, jailed them or deterred them.

So then the question becomes, What does it take for us to get the societies that host terrorist groups to truly act against them?

First we have to prove that we are serious, and that we understand that many of these terrorists hate our existence, not just our policies. In June I wrote a column about the fact that a few cell-phone threats from Osama bin Laden had prompted President Bush to withdraw the F.B.I. from Yemen, a U.S. Marine contingent from Jordan and the U.S. Fifth Fleet from its home base in the Persian Gulf. This U.S. retreat was noticed all over the region, but it did not merit a headline in any major U.S. paper. That must have encouraged the terrorists. Forget about our civilians, we didn't even want to risk our soldiers to face their threats.

or an American one? If it wants a U.S. embassy, then it cannot play host to a rogue's gallery of terrorist groups.

Does that mean the U.S. must ignore Palestinian concerns and Muslim economic grievances? No. Many in this part of the world crave the best of America, and we cannot forget that we are their ray of hope. But apropos of the Palestinians, the U.S. put on the table at Camp David a plan that would have gotten Yasir Arafat much of what he now claims to be fighting for. That U.S. plan may not be sufficient for Palestinians, but to say that the justifiable response to it is suicide terrorism is utterly sick.

Third, we need to have a serious and respectful dialogue with the Muslim world and its political leaders about why many of its people are falling behind. The fact is, no region in the world, including sub-Saharan Africa, has fewer freely elected governments than the Arab-Muslim world, which has none. Why? Egypt went through a whole period of self-criticism after the 1967 war, which produced a stronger country. Why is such self-criticism not tolerated today by any Arab leader?

Where are the Muslim leaders who will tell their sons to resist the Israelis -- but not to kill themselves or innocent non-combatants? No matter how bad, your life is sacred. Surely Islam, a grand religion that never perpetrated the sort of Holocaust against the Jews in its midst that Europe did, is being distorted when it is treated as a guidebook for suicide bombing. How is it that not a single Muslim leader will say that?

These are some of the issues we will have to address as we fight World War III. It will be a long war against a brilliant and motivated foe. When I remarked to an Israeli military official what an amazing technological feat it was for the terrorists to hijack the planes and then fly them directly into the most vulnerable spot in each building, he pooh-poohed me.

The people who planned Tuesday's bombings combined world-class evil with world-class genius to devastating effect.

And unless we are ready to put our best minds to work combating them -- the World War III Manhattan Project -- in an equally daring, unconventional and unremitting fashion, we're in trouble. Because while this may have been the first major battle of World War III, it may be the last one that involves only conventional, non-nuclear weapons.

Second, we have been allowing a double game to go on with our Middle East allies for years, and that has to stop. A country like Syria has to decide: Does it want a Hezbollah embassy in Damascus

"It's not that difficult to learn how to fly a plane once it's up in the air," he said. "And remember, they never had to learn how to land."

No, they didn't. They only had to destroy. We, by contrast, have to fight in a way that is effective without destroying the very open society we are trying to protect. We have to fight hard and land safely. We have to fight the terrorists as if there were no rules, and preserve our open society as if there were no terrorists. It won't be easy. It will require our best strategists, our most creative diplomats and our bravest soldiers.

Semper Fi.

ONE
WORLD
FINANCIAL
CENTER

VOTE HERE
➡
VOTE AQUÍ

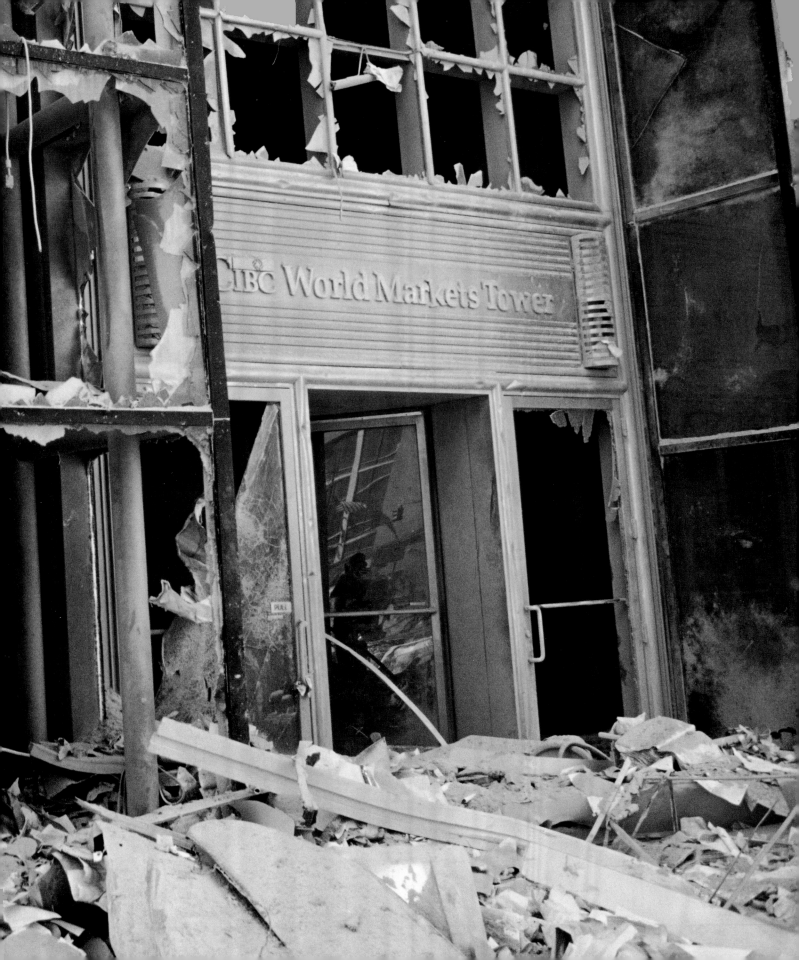

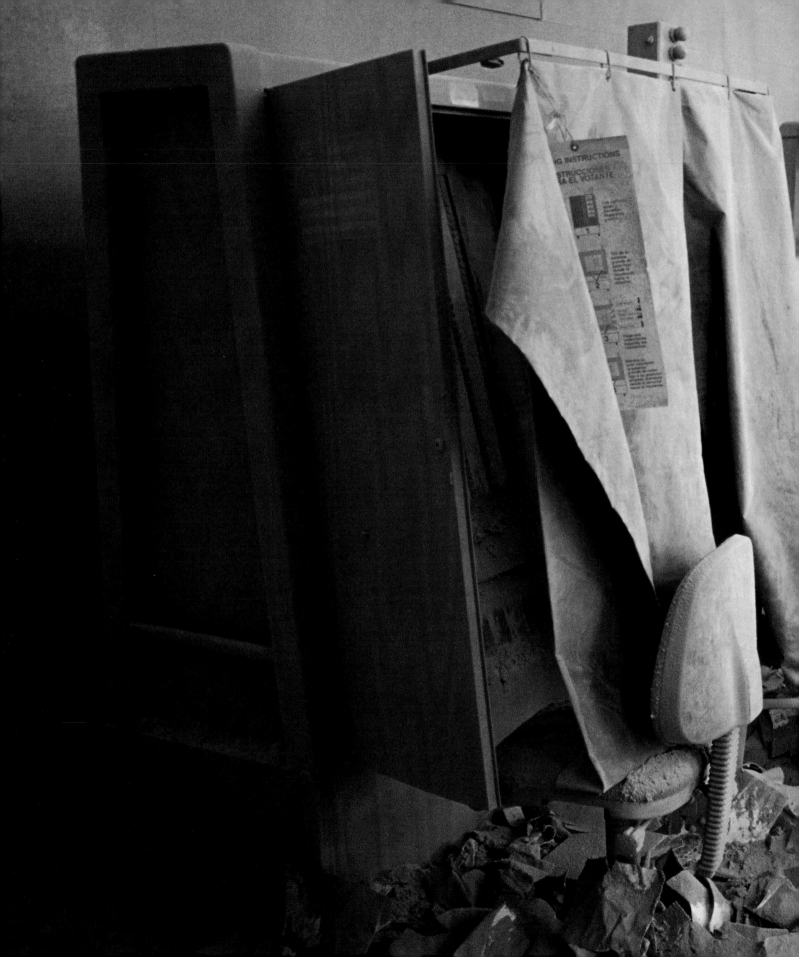

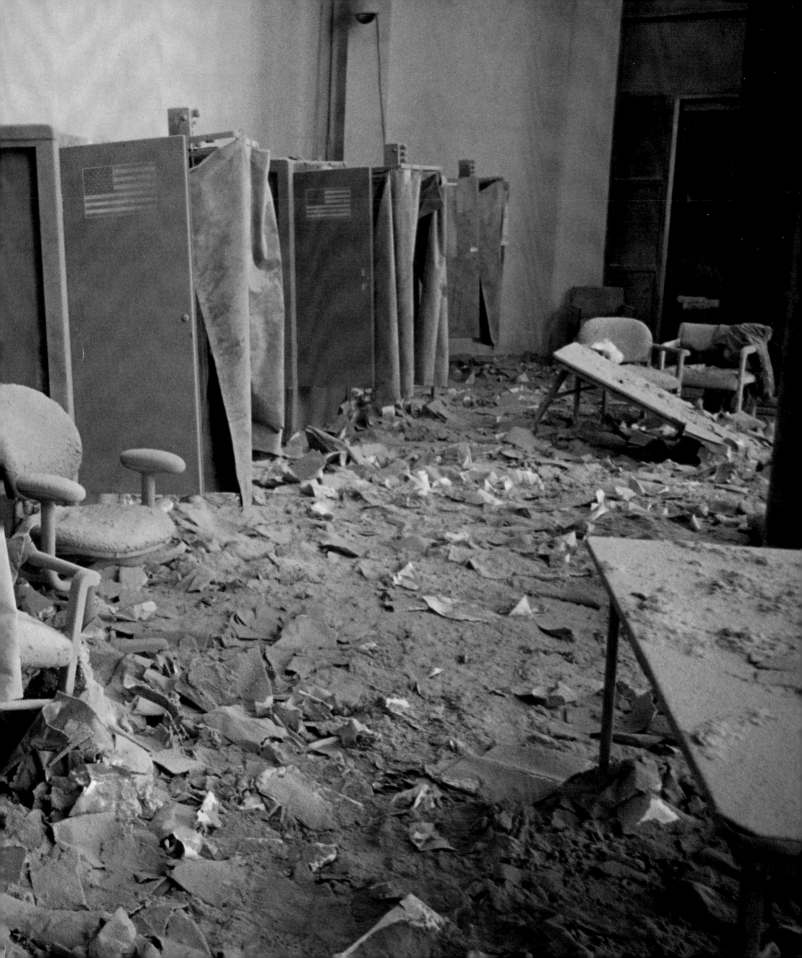

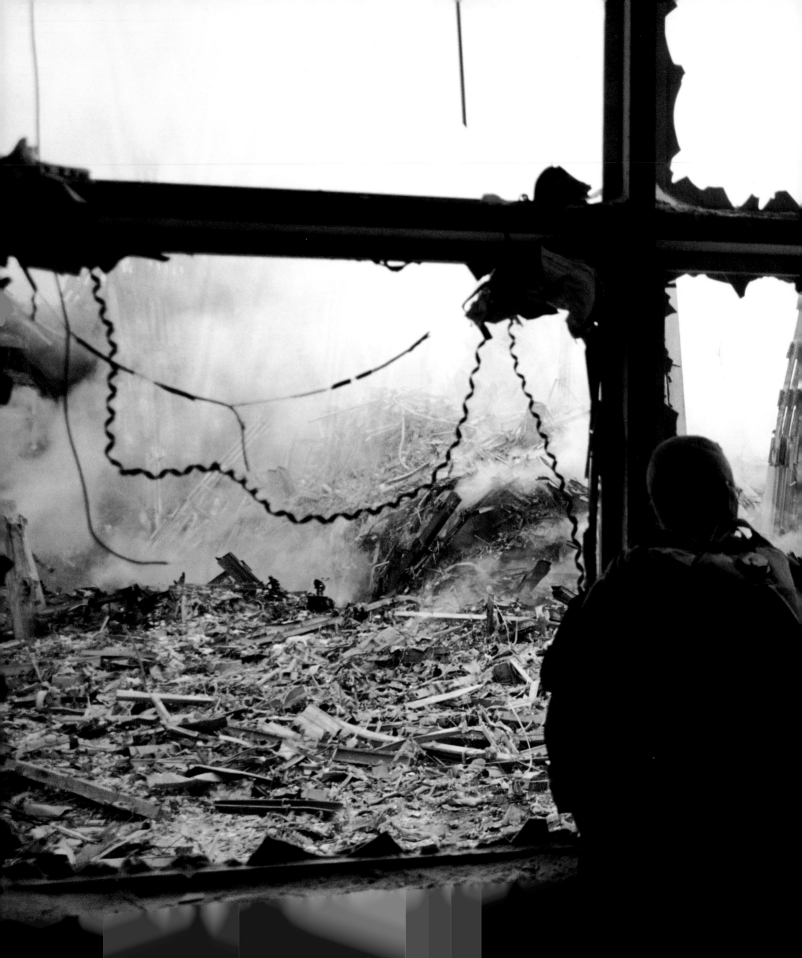

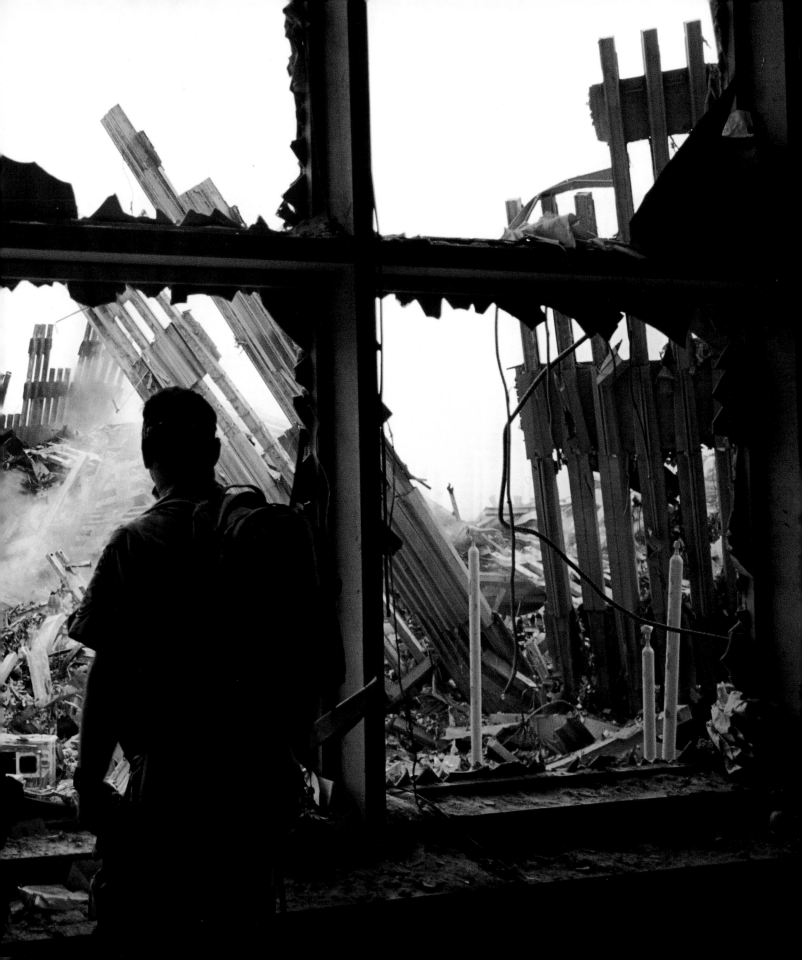

Walking through a burned out building I notice that only small signs of the structure's former life are evident. Phones ring eerily at the concierge's desk. I can barely make out the computer screens still glowing through the 1/2 - inch thick layer of gray soot and ash. My shoes slide precariously on the marble now hidden under a layer of the powder – the remains of the World Trade Center.

There is a scramble of noise outside - equipment starting to arrive on the scene, firefighters and police instinctively moving to get organized. Light attempts to stream in through the blown out windows ... diffusing nicely at times, it is hauntingly beautiful through the floating debris in the air.

I see evidence of rapid flight throughout the lobby – half made sandwiches in Au Bon Pain, jackets over the back of an office chair, spare change left on the counter. Pompeii comes to mind.

With each step another cloud of ash rises. I can't stop looking down; there is so much paper. It is the only recognizable element from the collapse. I see tax forms, emails, faxes, hand written notes and - the most disturbing - personal photographs from workers' desks. I step over them anyway, not sure how to react. I'm in the World Financial Plaza buildings at Ground Zero. I don't know if something above me will fall or if something under my feet will give way. But I want to keep shooting because it's amazing and the rest of the world needs to see what I am seeing because it is indescribable.

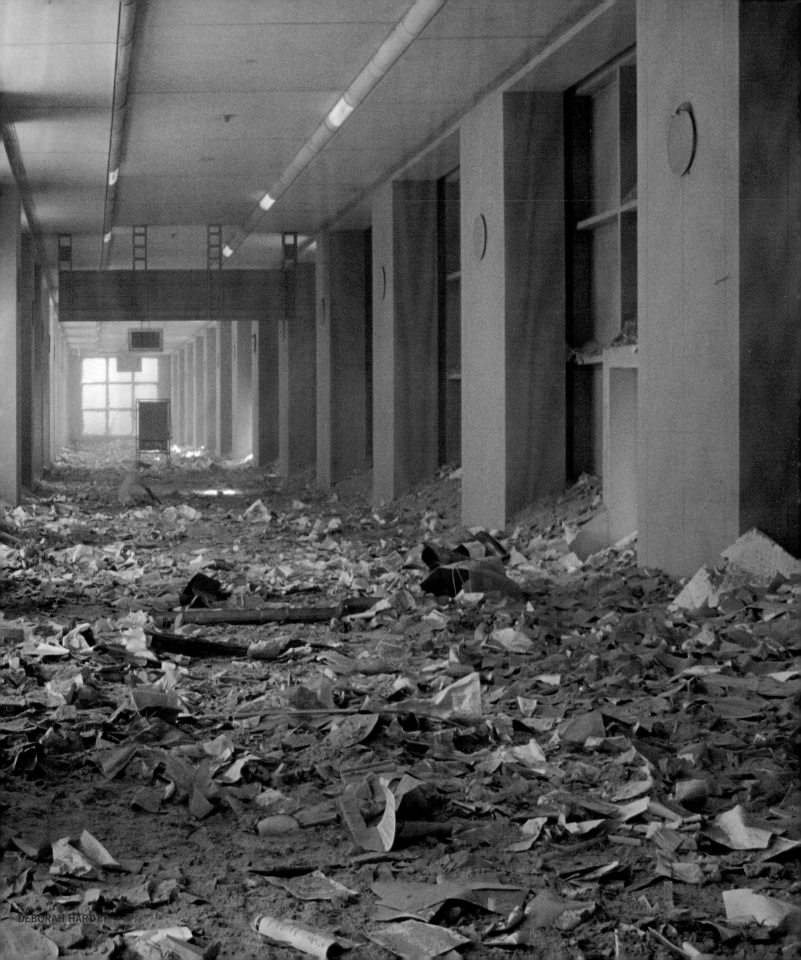

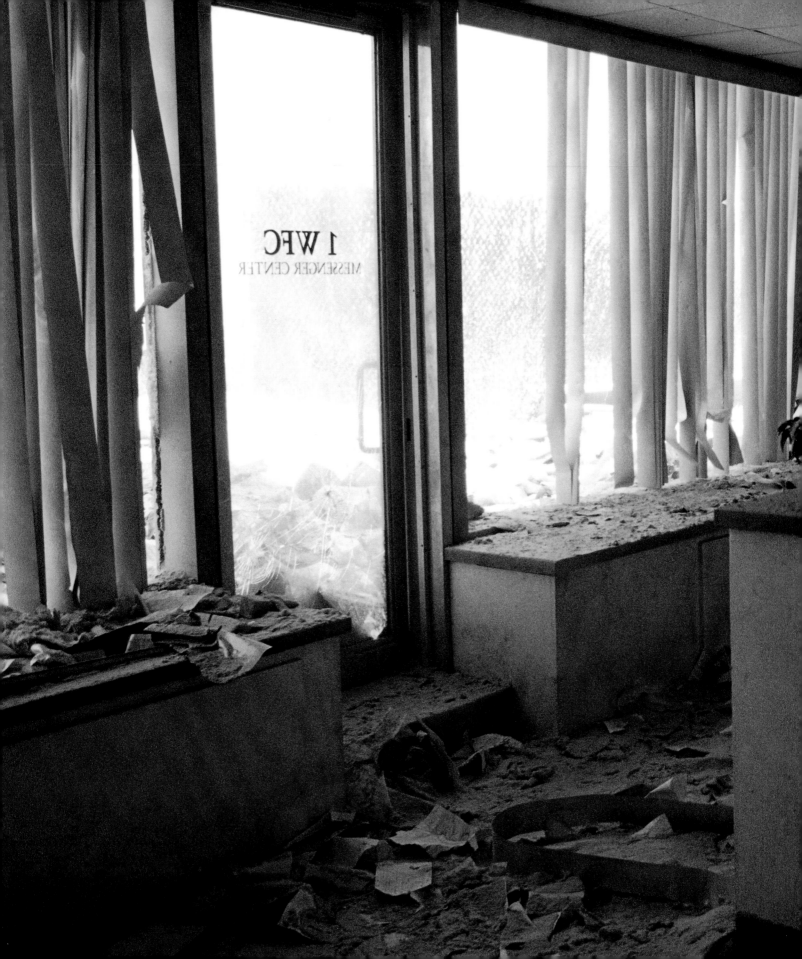

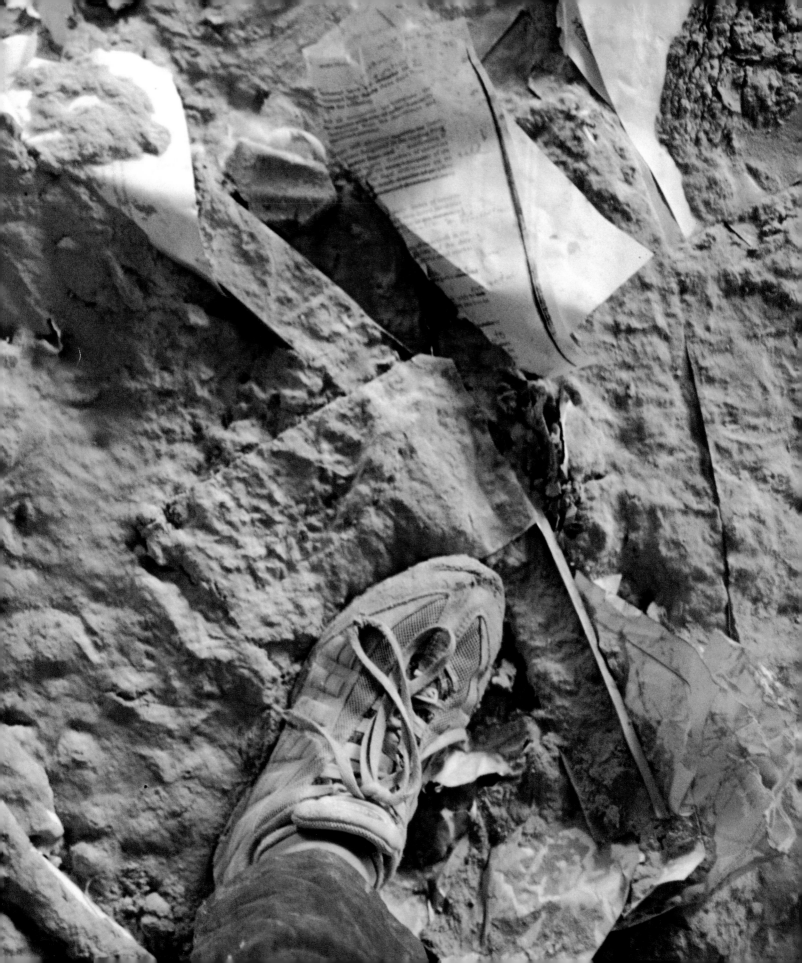

Yesterday.

September 11, 2001.
A spectacular
morning.
72 degrees Fahrenheit,
cloudless.
The air crisp,
clean.

The kind of day that blesses New York maybe thirty times a year, the kind of day my friends and I used to sit in Union Square Park watching Greg from Shipping do back flips off the base of the flag pole. The sky blue like blue steel, a bold sky, a sky good for bold architecture. Not ornate monuments from the first half of the century like Grand Central and the Public Library. Not the soulless, computer-generated edifices of the last twenty years. No, a day to show off the brazen lines of New York City's modern apogee, the streaking explosion of the Sixties and Seventies, the spirited gust that blew the JFK Airport terminal into its low-slung take-off sweep -- and mostly, perfectly, a day made for the sleek metal glass heaven-touching spires of the Twin Towers.

Eight blocks north, at the corner of Harrison and Hudson, a southward glance offers up the full vista of the Centers' proud elegance. The eye is drawn down into a thickening canyon of buildings; at the horizon, the space between them bisected by the silver towers soaring up, up, up. So clean, so stark, the gleaming columns seem to have been cut out of a magazine and pasted on the sky. It must have been for a day like this, for a street like this, they were raised.

That's where we were,

8:45 AM on Tuesday,

me and my six year-old. We were there because we were late for school. We are always late for school. Emanuel can't be rushed. Despite constant entreaties to "get a move on," along the way he insists on playing "mind games" -- games without props, inventing more of the Pokemon creatures that have been battling in his brain all summer. Hudson street is our Rubicon; when we gain the street the game stops; hand-in-hand we wait for a break in the south-moving traffic to cross to the school. Yesterday, Emanuel climbed onto a brown metal riser on the corner, his head rising nearly to my shoulder. That's when we heard the crack of what sounded like a sonic boom and looked up.

It happened quickly. Later, after, time would bend and twist like the wreckage itself; seconds becoming minutes, minutes seconds, and hours swept and snapped into different time signatures like modern jazz. But in that first instant, it was fast. A glimpse. A speeding black projectile, maybe two, shooting from left to right into the side of World Trade Center One. An instant later the sonic noise crescendoing in an enraged screaming roar of explosion. An orange plume bursting from the face of the tower like the blossom of a carnation. The bloom did not last; it grew slowly into its fullness, then passed out of the world like an expired breath.

wtc journal

It was beautiful, you know, heartachingly beautiful. The exquisite orange fireball laced with black, so perfectly toned against the blue sky, the silver tower. A fireworks show. Emanuel was smiling nervously, his cartoon fantasies come suddenly true. Only after the bloom depleted itself, when the gaping wound in the tower began to belch ugly black smoke, when it was certain that this was no ultra-expensive film shoot, did what had happened become clear. "They blew it up!" someone from the faceless crowd shouted.

Now it comes back to me every few minutes; the black projectile, the impact, the roar, the explosion, this first shock cutting me deeper than anything else I saw, this instant of execution, the noise, the plane slicing through the neck of the tower like it was a stick of butter. The fireball. But while I reeled against the image, the next fifteen minutes still held the possibility of folding it into other terrible city events, say, the 1993 bombing of the World Trade Centers, or the John Lennon shooting, horrible incidents to be sure, but already assimilated, part of the terror of modern life -- all still somehow manageable. The insistence on life-as-normal is overwhelming. How else to explain grabbing Emanuel's hand and taking him across the street into his class? I met his principal on the stairs. She affirmed my decision. "This is the safest place for them," she said. But I think I didn't want to look at him. I wanted to shield him, yes, but he had become hard to look at, his face become somehow unrecognizable, gripped by an emotion I'd never seen him wear before. An unease. A stunned, hollow, unease. "This is like a movie that's too scary," he said quietly.

After two or three minutes, I returned outside and stood on the sidewalk in front of the school with some other parents staring up at the top of the burning Trade Center. A steady flood of people streamed past us moving northbound, away from the explosion. The parents expressed an array of reactions -- shock, disbelief, gallows humor. Simon's mother was holding her head and weeping. Quinn's mother stood silent and determined. Oliver's father dryly asked if Mayor Guiliani didn't have his security headquarters up there -- but to my ears it all sounded banal, all the words already used up on lesser tragedies. Many people were holding their hands to their mouths. To stifle screams? To pat down nausea? Or maybe just to keep from speaking? When anyone spoke, a spell dissolved. The emotions were real; the words phony. At the intersection, a queasy impossibility.

Then the second explosion.

This time, I didn't see the plane; the impact took place much lower. It seemed chronologically, in terms of height and force, secondary, less severe. But it was then, that moment, that emotions became unhinged. For a second blast couldn't help but imply the possibility of a third, a fourth. A great and terrible unknown yowled open before us.. The mind stopped trying to fold the event into itself, to confine it, and released hold of its sanity to allow for the idea that anything might happen. People might be transformed into birds, cars might fly. At the same moment our kids were having "meeting time," people began to leap from the right side of the burning tower. Black silhouetted figures tumbling off the steel side of the structure like lemmings, like part of the debris that continued to blow around the building. With each jump, a sickening groan going up from the crowd.

People came running past our position, some screaming and crying, others laughing, telling jokes, still others with stereotypical New Yorker aplomb, as if to say "Well, that's the Big Apple." Pride mingled with idiocy. A crush of bodies, cell phones, each with its own personal response, a crush of emotions, an emotional Babel, the first suggestion of hell as Dante might have seen it -- not a static mourning and tragedy, but an endless parade of disparity, a nightmare of diversity.

Suddenly cameras -- video, digital, point-and-shoot -- were everywhere. One young woman, face puffed into a red ball, walked about dazed with a Leica taking photos and crying at the same time. Weirdly, I had the sudden vision of her as a surreal advertisement for the camera -- "Leica: Our Photographers Cry."

After the second explosion, I felt a growing, gnawing need to get my son out of school. I wanted to talk with him, but a woman wouldn't let me upstairs to the class. He could be brought down, but I couldn't go up. I fumed. I just wanted to see that he was okay; I didn't want to alarm him. Incredibly, I still hadn't decided to just get him out. After a few minutes I saw him come down the

stairs and we sat on the bench in the school lobby surrounded by the kids' drawings tacked up on the wall, turtles and self-portraits and bright crayola colors. He was giddy seeing me, a strange treat this being called out of class, taken downstairs to see your dad. I asked if he wanted to go home. He asked -- trying to tailor the new situation to his specific needs -- if we could go home together a little later. "Why, is there something fun you want to do first?" "Yeah. recess," he said. I told him that I didn't think there would be a recess today.

Though it now seems dangerously late, I was -- minus those who upon the first explosion immediately panicked and literally ran down Hudson Street with their kids in their arms -- one of the first to leave. I held his hand and we walked down the steps and emerged onto the street where the once beautiful south-looking vista was now billowing smoke.

We walked, a march that usually takes thirty minutes, but now might have lasted two minutes or two weeks. Even when we got as far as West Houston and entered that safe zone of our own neighborhood, Greenwich Village, Leroy Street Park, Nanny's Bar on the corner, it didn't feel secure. When I opened the door to our apartment, my wife let out a kind of animal yelp. Tears burst from her eyes. Emanuel was behind me and I secretly shushed her. The boy was quickly sent into a room to watch cartoons. Tal and I paced around our four hundred square foot apartment like animals in a cage. People called. Friends came by. Laini called looking for Rick. Rachel called looking for Keely. All the faces in our lives needed to be accounted for. After a few hours, when most of them were, the walls grew too confining, the apartment suffocating,

Quickly I angled his body away from the view, wanting to shield him. But it was impossible, to. Every time I turned back to look, so would he. Every time I ran into some parent, some friend, he would turn around. He was asking questions. Six years old. No sense of loss of life. He wanted to know how long it would take to fix the building. "Oh, a long time," I said. "Maybe a year." He wanted to know why they didn't make buildings out of a stronger metal; educated from Pokemon in metallurgy, he suggested titanium. "Yeah, that's a really good idea," I said brightly. He asked why the pilot hit the buildings, why he didn't turn the plane and crash it someplace safer. I decided to be more honest. "Well, I think he did it on purpose." This seemed not to register with him. Didn't the pilot know he would get hurt? I suggested the man was "crazy," but as the whole idea of crazy is precisely what is beyond understanding, he didn't get it.

And then the first tower collapsed behind us.

I spun around and watched World Trade Center One melt sickeningly into the earth. Earlier, I'd wanted to get my son home, finding the area vaguely unsafe; it had occurred to me that the tower might topple over, and that if it did, it might hit us -- but I never really believed it. Now I lurched forward, my body mimicking the collapse, air sucked from my guts like a deflated balloon.

Horror came mixed with a desire to protect my son from seeing it. Hudson Street had become a one-way thoroughfare, a street of exodus. We quickened our step. A feeling of vulnerability, of panic had to be held down. In every direction, people, police cars, sirens. I promised to buy Emanuel an ice cream. He didn't want to look back. His belly hurt, he said. His belly was scared.

Like the others in this line I have a desire to see. At its worst, it's a prurient thing, something obscene about it, gazing into things that at base you know nothing about, cannot apprehend, inevitably fail to fully appreciate and convey. At its best, and I see this especially in the photographers I work with -- it's a noble trade. Full of brave men and women, a strange race elected to scour the world and bring back its stories for everyone else to see. At moments it feels important.

I have no idea which sentiment was driving me as I crossed the first police barricade. All I really knew for sure is that I went. I weaved downtown, south and east, wading among the firemen and police who moved about like gods, men. The catastrophe, the sudden tremendous failure of law enforcement combined with the loss of their own, gave their eyes the enraged glint of impotence. After passing the last line, I reached City Hall. The streets had turned gray. The entire park and everything down Broadway was covered with a film of soot and shreds of papers. The Canyon of Heroes looked like the site of a grim ticker-tape parade on the morning after, like the ones they hold for the Yankees each year after they win the World Series. In fact, parked just in front of the Hall was a van done up in Yankee pinstripes, ridiculous and dusty.

At St. Peter's Church the tombstones in the cemetery abutting Broadway were blanketed with a thick coat of debris. All around another world, the new world, an emptied, apocalyptic, smoldering world; broken glass, an unimaginable tour through city land marks: the Post Office, Wall Street, the bronze bull, symbol of capitalist enterprise, now sooty, wasted. One woman emerged from a gargantuan office building and I watched her fumble with the front door, locking up behind her, the last to leave, as if it was her house. It did not, as some TV commentators suggested, look to me like the moon. But it did, as others said, look like Mt. St. Helens. Or like the end of the world, a volcanic spew of ash and ATM receipts, lost souls in eerie white masks scuttling over the debris, kicking up trails of dust as they walked.

Just as Dante's hell can only be gained through circular descent, so I had to make a circle around the tip of the island. I curved with Battery Park to where the air became lighter and cleaner. When I reached the water, I headed back north along the river. Just south of the World Financial Center I met Lori Grinker, a photographer. She'd been on the site of the devastation all day and was covered head to toe in ash. I followed her across what used to be the plaza of the World Financial Center, but which had now been converted into a makeshift entryway onto the abyss. Some months before I had come here to see a Vietnamese puppet show. "Follow me," Lori said. I trailed behind her into Two World Financial Center. Inside, a hushed quiet, the interior colorless, bombed out, a shell, reduced to its most simple elements: stairs, round walls, shattered windows, dust. Only the ceiling, the blue copula, was intact. The escalators were stilled, covered with fragments of plaster and glass. We took the stairs. On the second floor, wrap around windows, broken remaining shards opening a jagged vista onto the thing itself.

Ground Zero.

Through the windows three large spiky remnants of the towers remained standing, stuck into the mound of rubble helter skelter, tilted askew, surrounded on all sides by charred lonely buildings. Six or seven stories high, they looked like giant sepulchral hands reaching out of the ground. The buildings to the north and south were burning. Chunks were missing from others. I lost all sense of scale. In the funereal mound one could pick out nine or ten fire and rescue vehicles, the first on the scene, blown upside down, looking somewhat shameful with their tires in the air, strewn about like a kid's Tonka toys.

A dozen
firemen
were standing
to
my
right.
A single yellow crane worked listlessly.
There
was no
major effort in
progress.

It was over.

It was all gone.

Orange jumpsuits crawled grotesquely at the edge of the debris like ants. I moved left to right, from window to window, scanning the wreckage. The floor we were on was deserted. Only two or three photographers, firemen. No one spoke. The site was holy. The sound of muffled footfalls on the dust, crunching over broken glass, a church on the edge of the abyss, a church of apocalyptic vision, a church of incomprehensible death and darkness. A church on the edge of an instantaneous, monumental grave, pulsating, radiating with all our thousands of friends.

of fragments of evidence, blown all over town, evidence rained from the sky like hail. We were walking in it, covered in it, breathing it in.

There were no bodies to be seen, no injured. The devastation was complete.

A hole where last week Emanuel and I had watched the Mambo spectacular after reading in Borders bookstore. It occurred to me that my first job in New York had been here, 1982, in a Kelly film lab in the mall beneath the towers. I remembered rush hour, the wave of bodies pouring out of the buildings toward the subway, making it impossible to cross from one side of the mall to the other.

For photographers looking for pictures, there were pictures everywhere: a flag raised by firemen over the ruins, an overturned car with its blinkers still on -- but the entirety no camera could capture, no lens was wide enough to see.

The reverent hush of the inner sanctum was shattered by the shout of a fireman.

**"It's
coming
down!
Everybody
out!
Run!"**

It's coming down.

What goes through your mind?

Nothing goes through your mind.

You do what you are told.

You run.

The service is over, the church condemned. When we exited the building, the firemen were falling back. Two policemen were inter-rogating a Latino kid who was holding a twisted bit of steel in his hand. "What are you, souvenir hunting?" one asked aggressively. "You know that's against the law, that's evidence. You're tampering with evidence." The claim seemed preposterous. There were billions

The next morning I left our apartment around eight AM. At the corner of Bleecker Street and Sixth Avenue I stared down at where the towers used to faithfully appear. The smoke was gone and I realized that even the smoke, that wisping, ghostly approximation of the towers, was preferable to what I now saw, which was nothing. Nothing at all.

All the stores on Bleecker Street were closed. Scattered souls moved about with grim phantom faces. Out before all others, they had come like priests to christen the new day, to sanctify the new life. Serious and ashen, they glided over the altar of Father Demo Square, their cameras swinging from their sides like censors, dancing a choreography of sacred despair, a waltz of death.

How can a New Yorker describe the feeling? A good friend of mine said to me with embarrassment, "You know, I know about the people, all the death, the suffering of it, but the thing that I can't handle is that the towers are gone. I can't look out the window anymore."

Now I forget which streets they could be seen down from. Now, like an abandoned lover I think I picture them at the end of all streets, rising up in majesty, glinting in the sunshine. But then they don't; they're invisible, withdrawn, dead, buried. The moment of the first impact, unwanted, plays in my mind, plays whenever it chooses, the knife of a plane thrusting through the side of the tower, bursting out the front, the roar and fireball. Every thirty minutes or so I break into tears. My hands shake. I tried to watch cartoons with Emanuel, who has been doing little else since, but the attack insinuated itself into the show, every cartoon bang or boom mapped onto our downtown. It becomes unbearable. He breaks a glass, knocks down his plastic leopard with a rubber snake and it's more than I can stand. There's a hole in my heart that looks like the pit I saw, surrounded on all sides by collapsing buildings.

Jacques Menasche

MICHAEL KORS

MY SPRING SHOW WAS SCHEDULED FOR THE MORNING OF
SEPTEMBER 12TH, INSTEAD OF DRESSING BEAUTIFUL
WOMEN IN LUXURIOUS CLOTHES THAT MORNING I
STARED FROM MY TERRACE IN THE WEST VILLAGE
AT WHAT WAS NOW KNOWN AS GROUND ZERO.
EIGHT DAYS LATER I HELD A SMALL PRESENTATION
FOR EIGHTY INSTEAD OF THE USUAL 1000. NORMALLY
I PUT A RELEASE DESCRIBING MY FASHION
VISION FOR THE SEASON ON THE CHAIRS, THIS
TIME THE ONLY THING I HAD TO SAY IS THE
FOLLOWING.

LIFE CONTINUES ON, BUT IT IS AN UNAVOIDABLE TRUTH THAT LIFE IS
ALSO IRREVOCABLY CHANGED. WE MUST REMEMBER THAT FASHION,
AND THE FASHION COMMUNITY HAVE ALWAYS BEEN RECEPTIVE TO
CHANGE. PLEASE LET'S STAY UNIFIED, STRONG, ENERGETIC AND
COMPASSIONATE. I KNOW WE WILL ALL BE ABLE TO MOVE FORWARD IN
THESE TRYING TIMES. THANKS TO ALL OF YOU FOR YOUR SUPPORT. GOD
BLESS YOU AND THOSE YOU LOVE.

MICHAEL

Remember all the disputes about whether the new millennium actually began on 1 January 2000 or 1 January 2001? Of course either date would have been an arbitrary choice, tracing human evolution from the unreliably recorded birthday of a great Jewish pacifist. But neither marked anything more significant than the flipping of four numbers on a calendar. September 11, 2001, however, marked a different sort of watershed. If, as the historian Eric Hobsbawn has suggested, the 20th century really began with the assassination in Sarajevo that sparked the First World War, it is fair to suggest that, in the impact it is likely to have on the shape of the decades to follow, the 21st century began with the demolition of the World Trade Center last month.

The terrorists who struck Manhattan on September 11, 2001 took thousands of lives -- the toll has been going up daily as I write. More, they destroyed a powerful symbol of America: the tallest buildings in the richest city in the most powerful nation on earth. The twin towers of the World Trade Center housed many major institutions of global capitalism, from finance management companies to insurance firms, from telecommunications transmitters to an opulent restaurant with an unmatched view of the world. **The destruction of the World Trade Center struck a blow not only at those institutions but at the self-confidence that undergirded them, the self-confidence of a social and political system that, without needing to think about it too much, believed it had found the answer to life's challenges and conquered them all.** The outrage of September 11, 2001 brought the stark consciousness

prosperity, are the forces used by the terrorists in their macabre dance of death and destruction. They crossed frontiers easily, co-ordinated their efforts with technological precision, hijacked planes and crashed them into their targets (as their doomed victims made last-minute calls on their cell-phones to their loved ones). This was a 21st century crime, and it has defined the dangers and the potential of our time as nothing else can.

It has also provoked a reaction in the United States that will, in turn, leave an indelible mark on the new century. The 20th century was famously dubbed, by Time magazine's Henry Luce, as "the American century," but the 21st begins with the US in a state of global economic, political, cultural and military dominance far greater than any world power has ever enjoyed. Washington had been curiously ambivalent about its exercise of that dominance, with many influential figures speaking and acting as if the rest of the planet was irrelevant to America's existence or to its fabled pursuit of happiness. After September 11, 2001, there will be no easy retreat into isolationism, no comfort in the illusion that the problems of the rest of the world need not trouble the United States. Americans now understand viscerally the old cliche of the global village. A fire that starts in a remote thatched hut or dusty tent in one corner of that village can melt the steel girders of the tallest skyscrapers at the other end.

This means the 21st century will be the century of "one world" as never before, with a consciousness that the tragedies of our time are all global in origin and reach, and that tackling them is also a global responsibility that must be assumed by us all.

ON SEPTEMBER 11, 2001, THE 21ST CENTURY WAS BORN

of physical vulnerability to a land that, despite fighting a dozen major wars in its history, had never had to endure an assault on its own soil in the last 187 years. (The last direct hit by an enemy on the continental United States was the burning of Washington by the British in 1814). If only by bringing home to Americans the end of their insulation from the history and geography that bedeviled the rest of the globe, September 11, 2001 changed the world forever.

But the horrifying events of that one day are emblematic of our new century in more ways than one. The defining features of today's world are the relentless forces of globalization, the ease of communications and travel, the shrinking of boundaries, the flow of people of all nationalities and colours across the world, the swift pulsing of financial transactions with the press of a button. **The plane, the cell phone, the computer, are the symbols of our time. These very forces, which in a more benign moment might have been seen as helping drive the world towards progress and**

Interdependence is now the watchword. The terrorist attack was an assault not just on one city but, in its callous indifference to the lives of innocents from 80 countries around the world, an assault on the very bonds of humanity that tie us all together. To respond to it effectively we must be united, and out of the solidarity that the world has demonstrated with the victims of this horror, a unity may emerge across borders that will also mark the new century as different from the ones that preceded it.

Terrorism emerges from blind hatred of an Other, and that in turn is the product of three factors: fear, rage and incomprehension.

Fear of what the Other might do to you, rage at what you believe the Other has done to you, and incomprehension about who or

what the Other really is -- these three elements fuse together in igniting the deadly combustion that kills and destroys people whose only sin is that they feel none of these things themselves. If terrorism is to be tackled and ended, we will have to deal with each of these three factors by attacking the ignorance that sustains them. **We will have to know each other better, learn to see ourselves as others see us, learn to recognize hatred and deal with its causes, learn to dispel fear, and above all just learn about each other.** As this lesson is absorbed and applied, the 21st century could yet become a time of mutual understanding such as we have never seen before.

A world in which it is easier than ever before to meet strangers must also become a world in which it is easier than ever before to see strangers as no different from ourselves.

The terrorists failed to see their victims that way: they saw only objects, dispensable pawns in their drive for destruction.

Our only effective answer to them must be to defiantly assert our own humanity; to say that each one of us, whoever we are and wherever we are, has the right to live, to love, to hope, to dream, and to aspire to a world in which everyone has that right.

A world in which the scourge of terrorism is fought, but so also are the scourges of poverty, of famine, of illiteracy, of ill-health, of injustice, and of human insecurity. A world, in other words, in which terror will have no chance to flourish. That could be the world of the 21st century that has just been born, and it could be the most hopeful legacy of the horror that has given it birth.

Shashi Tharoor[6]

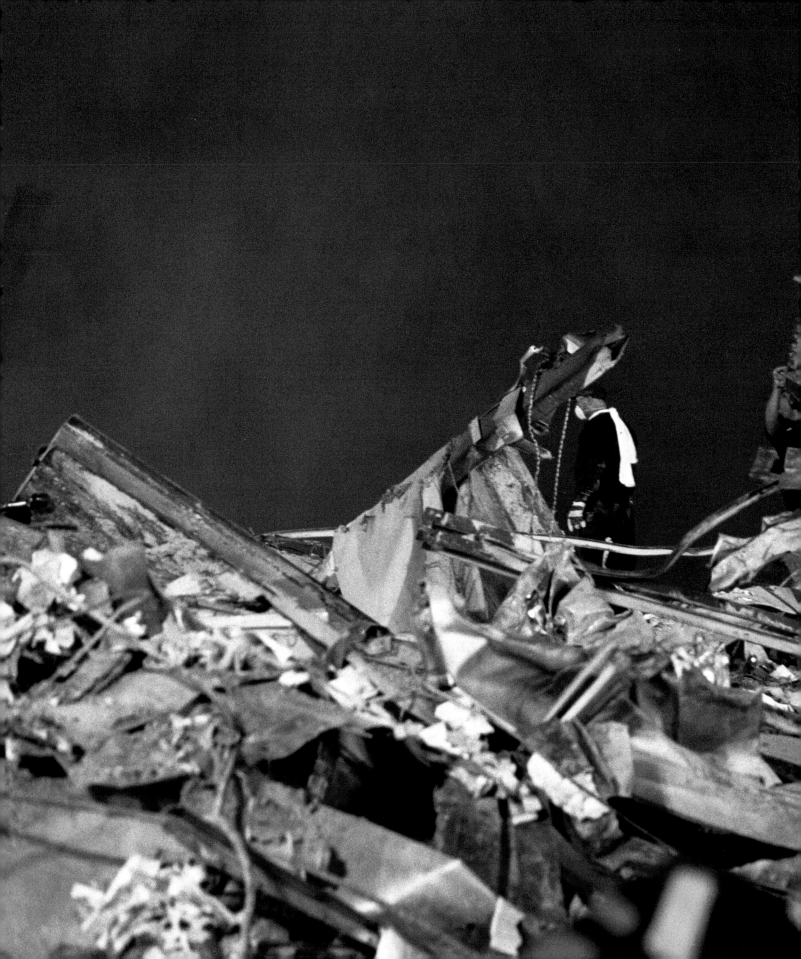

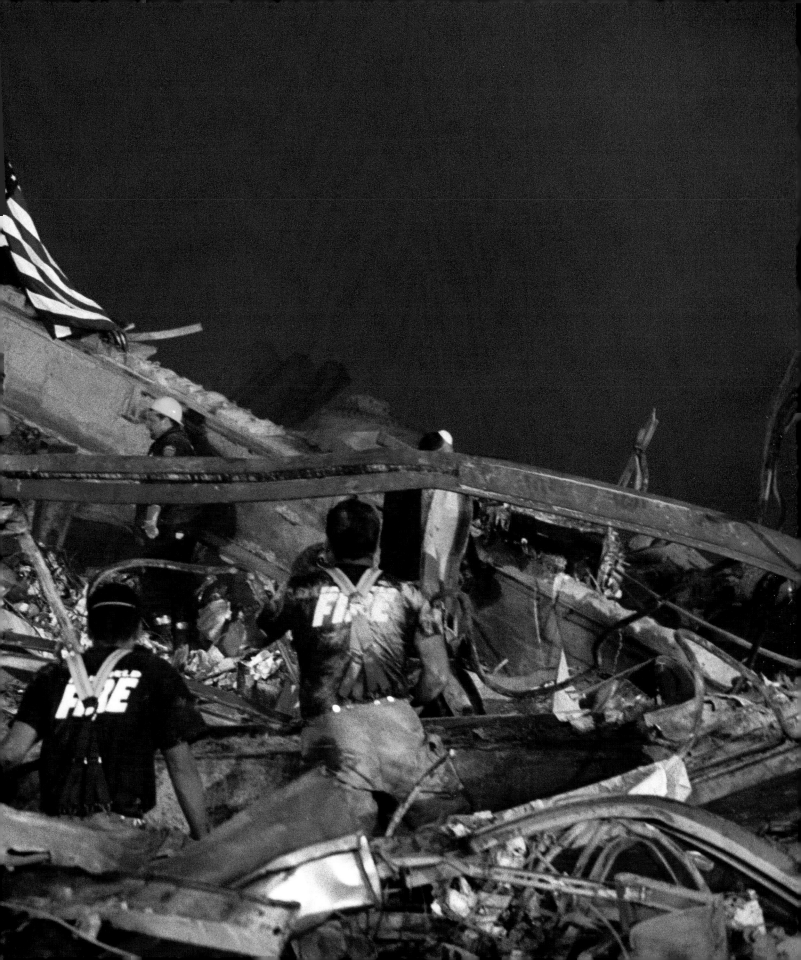

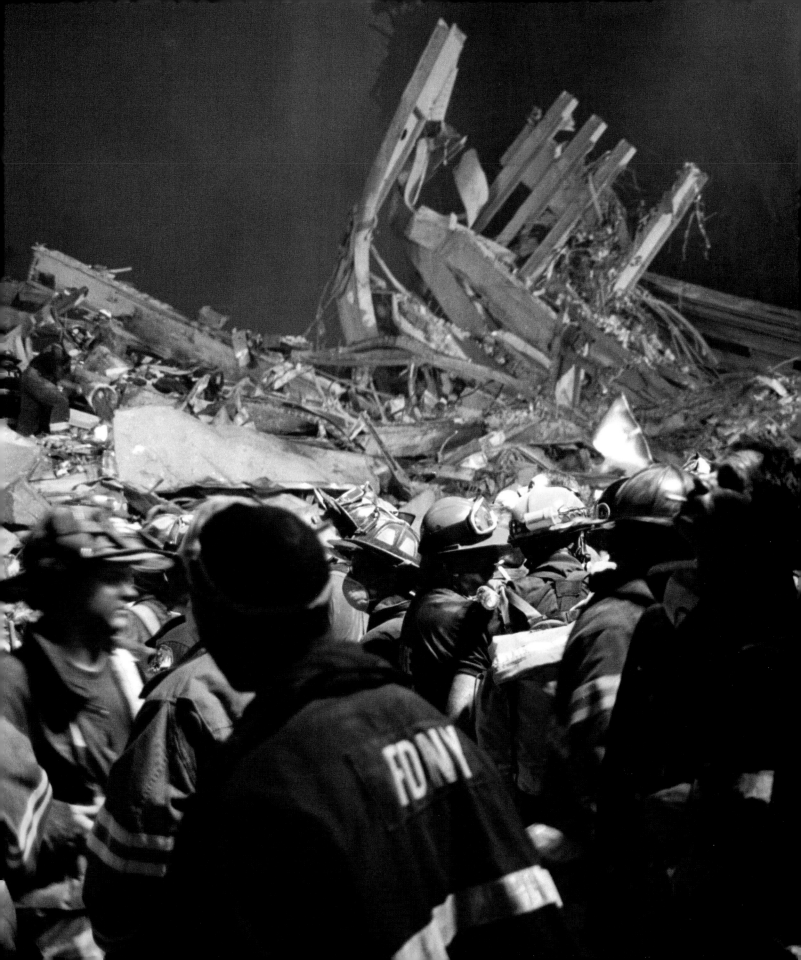

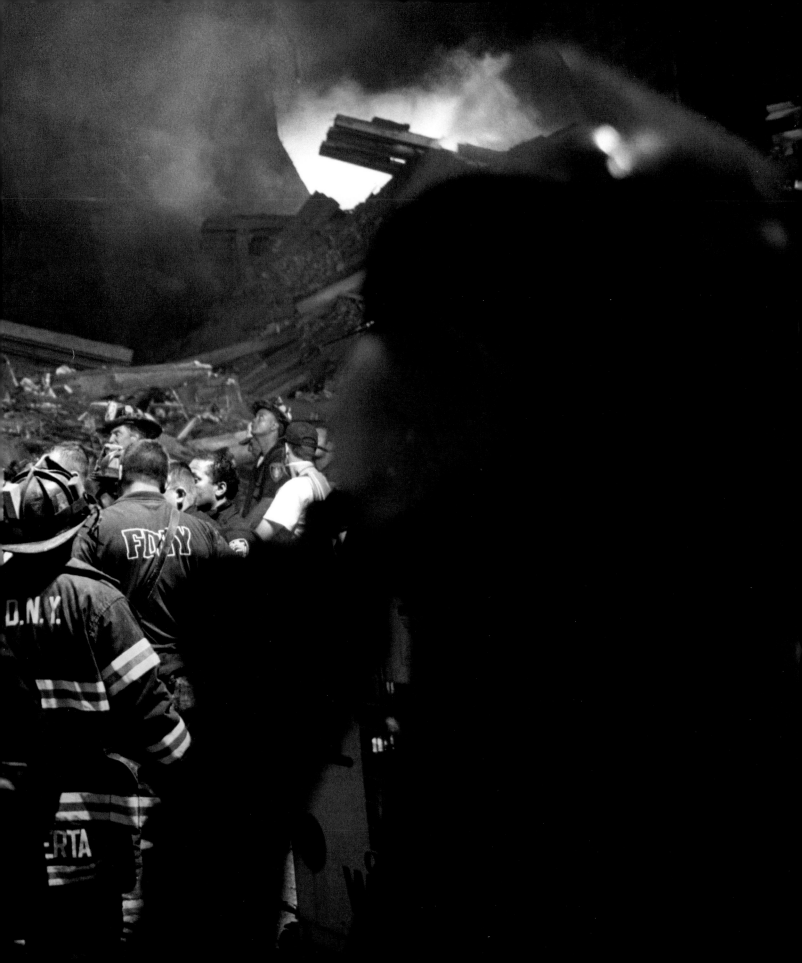

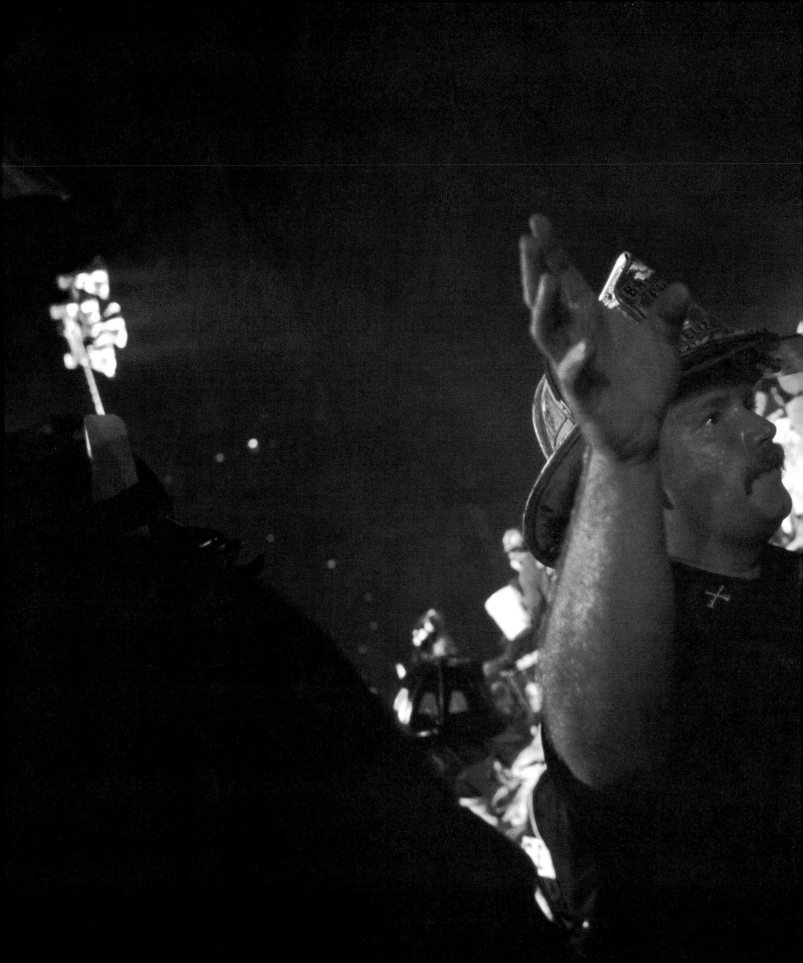

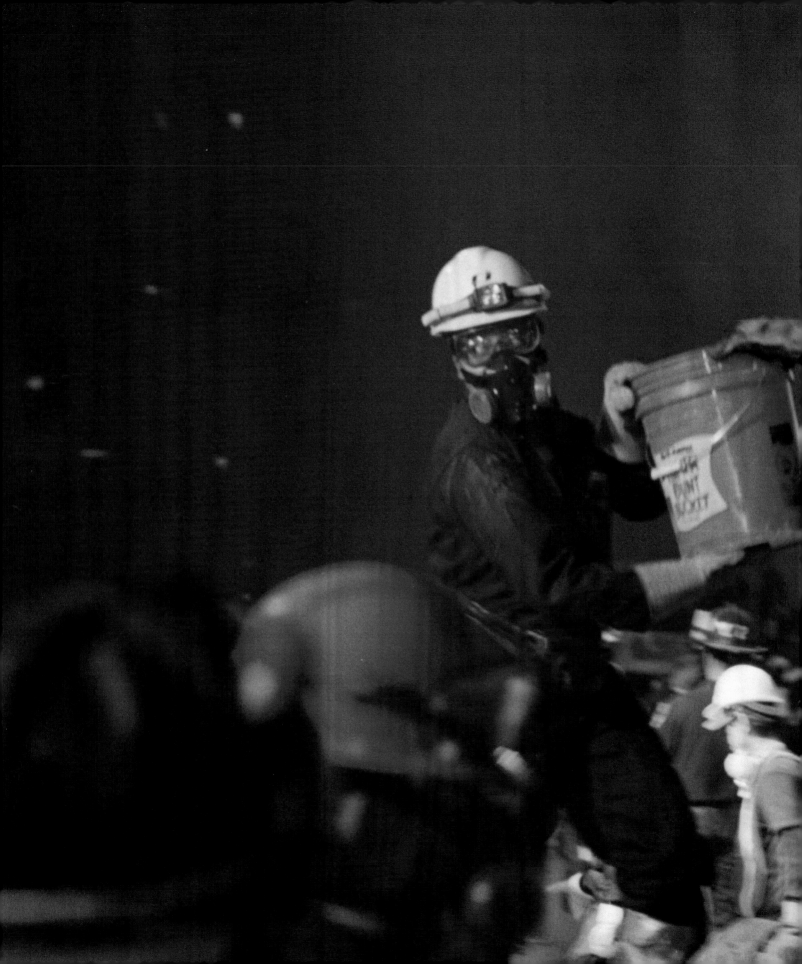

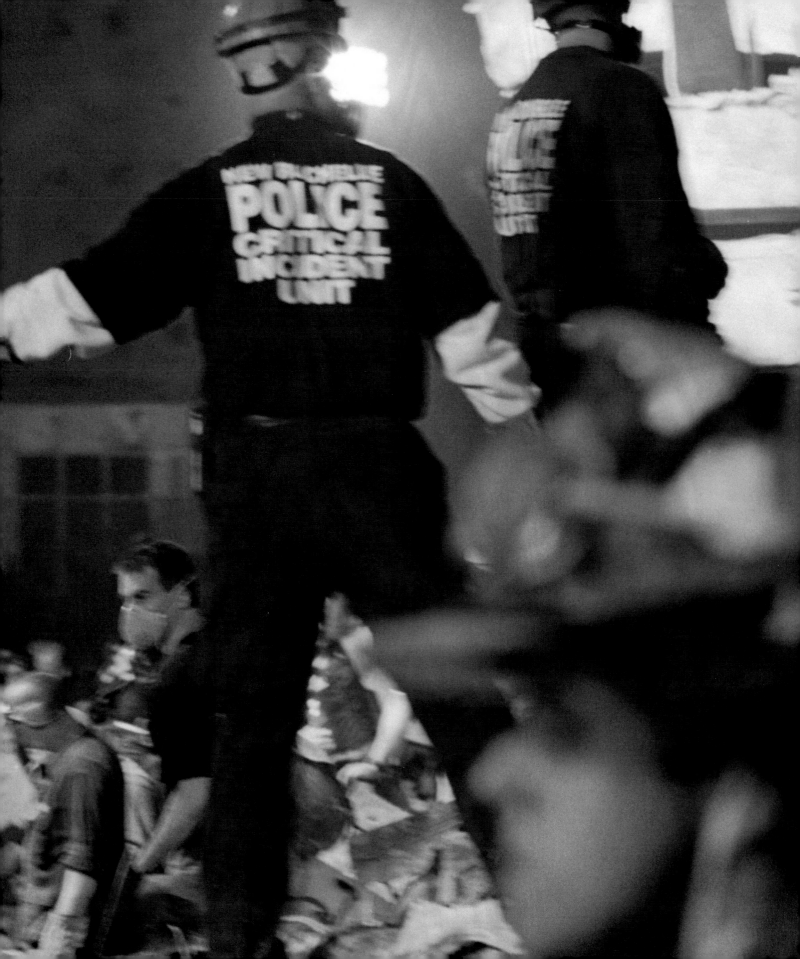

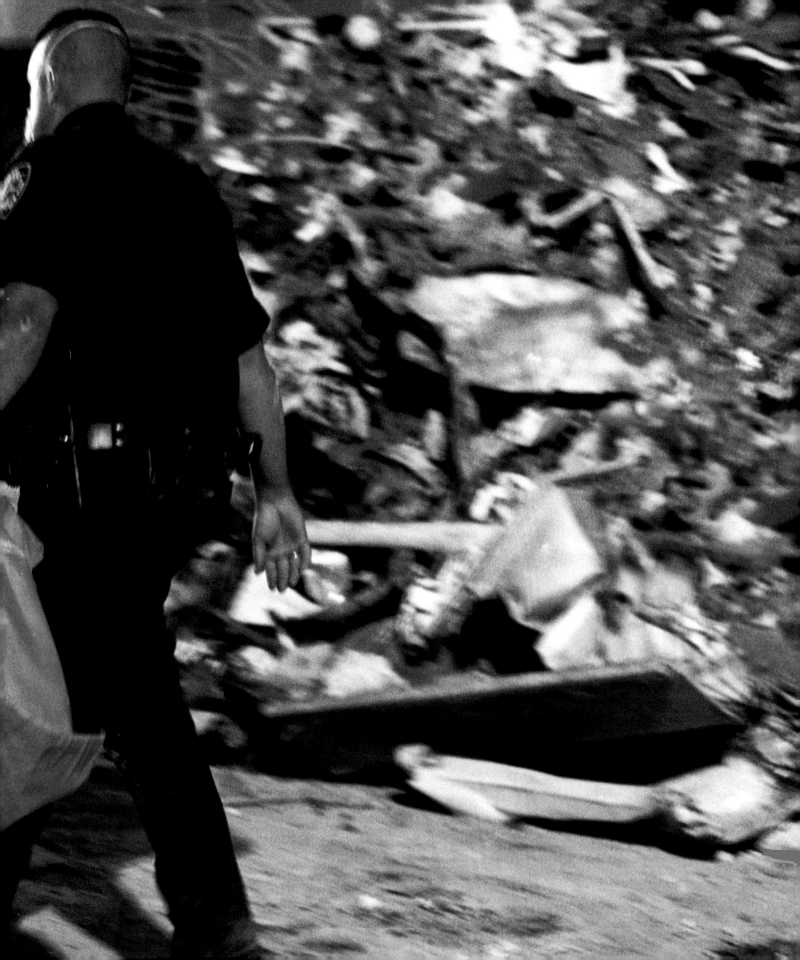

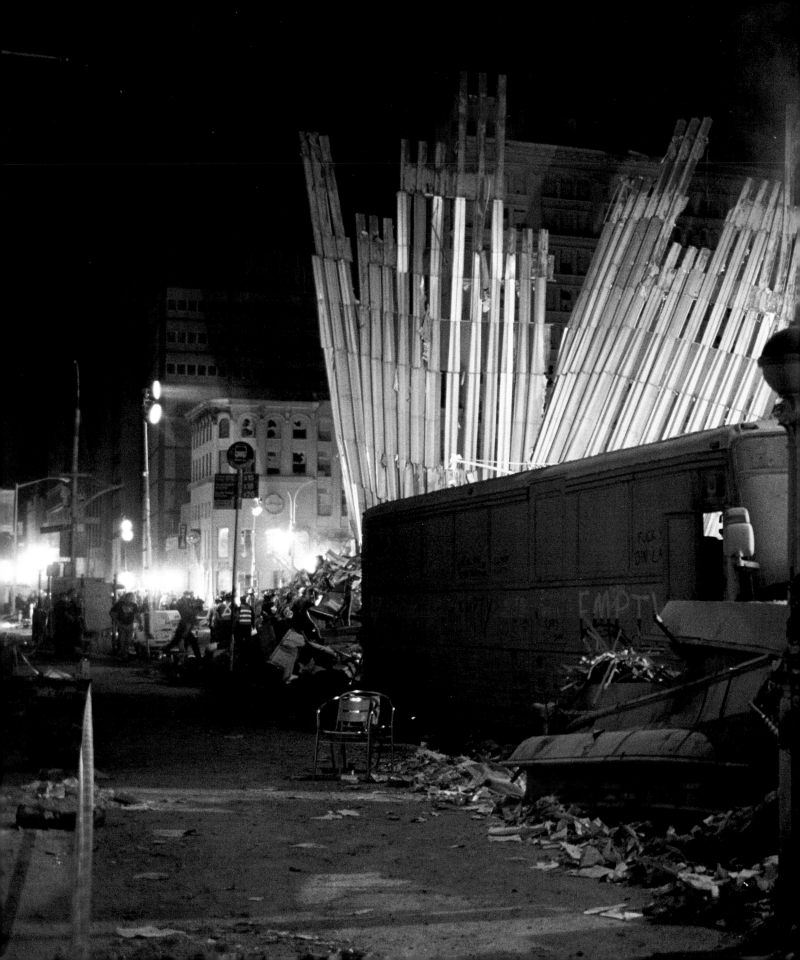

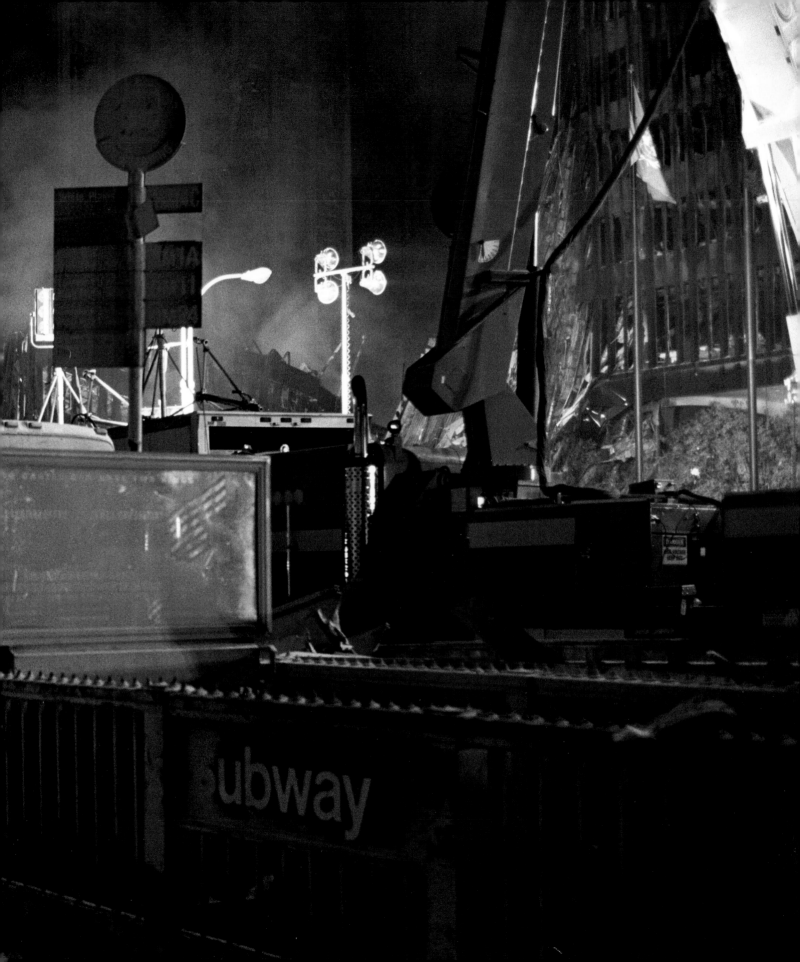

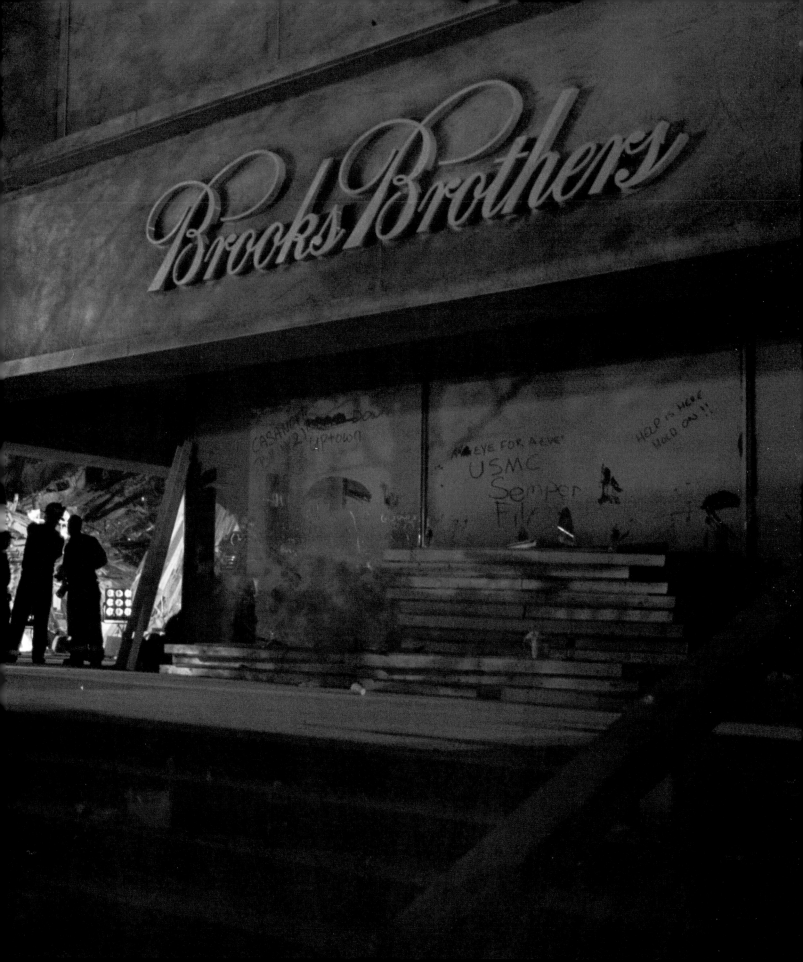

As we hear the calls for tightened American security and a fierce military response to terrorism, it is obvious that none of us has any answers. **However, we feel compelled to ask some questions.**

the deeper wound

Everything has a cause, so we have to ask, what was the root cause of this evil? We must find out not superficially but at the deepest level. There is no doubt that such evil is alive all around the world and is even celebrated.

Does this evil grow from the suffering and anguish felt by people we don't know and therefore ignore? Have they lived in this condition for a long time?

One assumes that whoever did this attack feels implacable hatred for America. Why were we selected to be the focus of suffering around the world?

As fate would have it, I was leaving New York on a jet flight that took off 45 minutes before the unthinkable happened. By the time we landed in Detroit, chaos had broken out. When I grasped the fact that American security had broken down so tragically, I couldn't respond at first. My wife and son were also in the air on separate flights, one to Los Angeles, one to San Diego. **My body went absolutely rigid with fear.** All I could think about was their safety, and it took several hours before I found out that their flights had been diverted and both were safe.

Strangely, when the good news came, my body still felt that it had been hit by a truck. **Of its own accord it seemed to feel a far greater trauma that reached out to the thousands who would not survive and the tens of thousands who would survive only to live through months and years of hell.** And I asked myself, why didn't I feel this way last week? Why didn't my body go stiff when innocent people died through violence in other countries? Around the world my horror and worry are experienced by others every day. Mothers weep over horrendous loss, civilians are bombed mercilessly, refugees are ripped from any sense of home or homeland.

Why did I not feel their anguish enough to call a halt to it?

All this hatred and anguish seems to have religion at its basis. Isn't something terribly wrong when jihads and wars develop in the name of God? Isn't God invoked with hatred in Ireland, Sri Lanka, India, Pakistan, Israel, Palestine, and even among the intolerant sects of America?

Can any military response make the slightest difference in the underlying cause? Is there not a deep wound at the heart of humanity? If there is a deep wound, doesn't it affect everyone?

If all of us are wounded, will revenge work? Will punishment in any form toward anyone solve the wound or aggravate it? Will an eye for an eye, a tooth for a tooth, and a limb for a limb, leave us all blind, toothless and crippled?

Tribal warfare has been going on for thousands of years and has now been magnified globally. Can tribal warfare be brought to an end? Is it possible, as we move into the future, all of us, regardless of our race, religion or even nationality, can transcend our tribal nature?

What are you and I as persons going to do about what is happening? Can we afford to let the deeper wound fester any longer?

This has been a horrible attack on America, but is it not a rift in our collective soul? Isn't this an attack on civilization from without that is also from within?

When we have secured our safety once more and cared for the wounded, after the period of shock and mourning is over, it will be time for soul searching. I only hope that these questions are confronted with the deepest spiritual intent. **None of us will feel safe again behind the shield of military might and stockpiled arsenals.** There can be no safety until the root cause is faced. It is imperative that we pray and offer solace and help to each other. In this moment of deep sorrow for the wounding of our collective soul, the only healing we can accomplish as individuals is to make sure that our every thought, word and deed nurtures humanity.

Love,
Deepak Chopra[7]

Hijacked American Airlines Flight 77 - a Boeing 757 with 64 passengers on board en route to Los Angeles from Washington Dulles - crashes into the south ring of the Pentagon.

9.43 AM

Hijacked United Airlines Flight 93 - a Boeing 757 with 45 passengers on board en route to San Francisco from Newark - crashes in Sommerset County, Pennsylvania.

10.10 AM

American Airline Flight 77

Paul Ambrose
Yeneneh Betru
MJ Booth
Bernard Curtis Brown
Charles Burlingame
Suzanne Calley
William E. Caswell
David M. Charlebois
Sarah Clark
Zandra Cooper
Asia Cottom
James Debeuneure
Rodney Dickens
Eddie Dillard
Charles Droz
Barbara G. Edwards
Charles S. Falkenberg
Dana Falkenberg
Zoe Falkenberg
James Joe Ferguson
Darlene Flagg
Wilson Flagg
Richard P. Gabriel
Ian J. Gray
Stanley Hall
Michele Heidenberger
Bryan Jack
Steven D. "Jake" Jacoby
Ann Judge
Chandler Keller
Yvonne Kennedy
Norma Khan
Karen A. Kincaid
Dong Lee
Jennifer Lewis
Kenneth Lewis
Renee A. May
Dora Menchaca
Christopher Newton
Barbara Olson
Ruben Ornedo
Robert Penniger
Robert R. Ploger
Lisa J. Raines
Todd Reuben
John Sammartino
Diane Simmons
George Simmons
Mari-Rae Sopper
Robert Speisman
Norma Lang Steuerle
Hilda E. Taylor
Leonard Taylor
Sandra Teague
Leslie A. Whittington
John Yamnicky
Vicki C. Yancey
Shuyin Yang
Yuguang Zheng
Hijacker 1
Hijacker 2
Hijacker 3
Hijacker 4
Hijacker 5

The Pentagon[2]

Samantha Allen
Spc. Craig Amundson

Melissa Rose Barnes
(Retired) Master Sgt. Max Beilke
Kris Romeo Bishundat
Carrie Blagburn
Lt. Col. Canfield D. Boone
Donna Bowen
Allen Boyle
Christopher Lee Burford
Daniel Martin Caballero
Sgt. F.C. Jose Orlando Calderon
Angelene C. Carter
Sharon Carver
John J. Chada
Rosa Maria (Rosemary) Chapa
Julian Cooper
Lt. Cmdr. Eric Allen Cranford
Ada M. Davis
Capt. Gerald Francis Deconto
Lt. Col. Jerry Don Dickerson
Johnnie Doctor
Capt. Robert Edward Dolan
Cmdr. William Howard Donovan
Cmdr. Patrick S. Dunn
Edward Thomas Earhart
Lt. Cmdr. Robert Randolph Elseth
Jamie Lynn Fallon
Amelia V. Fields
Gerald P. Fisher
Matthew Michael Flocco
Sandra N. Foster
Capt. Lawrence Daniel Getzfred
Cortz Ghee
Brenda C. Gibson
Ron Golinski
Diane M. Hale-McKinzy
Carolyn B. Halmon
Sheila Hein
Ronald John Hemenway
Maj. Wallace Cole Hogan
Jimmie Ira Holley
Angela Houtz
Brady K. Howell
Peggie Hurt
Lt. Col. Stephen Neil Hyland
Robert J. Hymel
Sgt. Maj. Lacey B. Ivory
Lt. Col. Dennis M. Johnson
Judith Jones
Brenda Kegler
Lt. Michael Scott Lamana
David W. Laychak
Samantha Lightbourn-Allen
Maj. Steve Long
James Lynch
Terrance M. Lynch
Nehamon Lyons
Shelley A. Marshall
Teresa Martin
Ada L. Mason
Lt. Col. Dean E. Mattson
Lt. Gen. Timothy J. Maude
Robert J. Maxwell
Molly McKenzie
Patricia E. (Patti) Mickley
Maj. Ronald D. Milam
Gerard (Jerry) P. Moran
Odessa V. Morris
Brian Anthony Moss
Ted Moy
Lt. Cmdr. Patrick Jude Murphy

Khang Nguyen
Michael Allen Noeth
Diana B. Padro
Spc. Chin Sun Pak
Lt. Jonas Martin Panik
Maj. Clifford L. Patterson
Lt. J.G. Darin Howard Pontell
Scott Powell
(Retired) Capt. Jack Punches
Joseph John Pycior
Deborah Ramsaur
Rhonda Rasmussen
Marsha Dianah Ratchford
Martha Reszke
Cecelia E. Richard
Edward V. Rowenhorst
Judy Rowlett
Robert E. Russell
William R. Ruth
Charles E. Sabin
Marjorie C. Salamone
Lt. Col. David M. Scales
Cmdr. Robert Allan Schlegel
Janice Scott
Michael L. Selves
Marian Serva
Cmdr. Dan Frederic Shanower
Antoinette Sherman
Don Simmons
Cheryle D. Sincock
Gregg Harold Smallwood
(Retired) Lt. Col. Gary F. Smith
Patricia J. Statz
Edna L. Stephens
Sgt. Maj. Larry Strickland
Maj. Kip P. Taylor
Sandra C. Taylor
Karl W. Teepe
Sgt. Tamara Thurman
Lt. Cmdr. Otis Vincent Tolbert
Willie Q. Troy
Lt. Cmdr. Ronald James Vauk
Lt. Col. Karen Wagner
Meta Waller
Staff Sgt. Maudlyn A. White
Sandra L. White
Ernest M. Willcher
Lt. Cmdr. David Lucian Williams
Maj. Dwayne Williams
Marvin R. Woods
Kevin Wayne Yokum
Donald McArthur Young
Edmond Young
Lisa Young

United Airlines Flight 93

Christian Adams
Lorraine G. Bay
Todd Beamer
Alan Beaven
Mark K. Bingham
Deora Bodley
Sandra W. Bradshaw
Marion Britton
Thomas E. Burnett
William Joseph Cashman
Georgine Rose Corrigan
Patricia Cushing
Jason Dahl
Joseph Deluca

Patrick Joseph Driscoll
Edward P. Felt
Jane C. Folger
Colleen Laura Fraser
Andrew Garcia
Jeremy Glick
Olga Kristin Gould White
Lauren Grandcolas
Wanda Anita Green
Donald F. Greene
Linda Gronlund
Richard Jerry Guadagno
LeRoy Wilton Homer
Toshiya Kuge
CeeCee Lyles
Hilda Marcin
Waleska Martinez
Nicole Miller
Louis J. Nacke
Donald Arthur Peterson
Jean Hoadley Peterson
Mark Rothenberg
Christine Anne Snyder
John Talignani
Honor Elizabeth Wainio
Deborah Welsh
Name undisclosed
Hijacker 1
Hijacker 2
Hijacker 3
Hijacker 4

Our country and our concepts of liberty, democracy and human rights emerged victorious from that long twilight struggle. And good things will come of the September 11th tragedy also, God has the power to bring order out of chaos and to transform evil into good.

I passed by the Pentagon minutes before American Airlines Flight 77 struck it.

I was driving from National Airport to a meeting at AFL-CIO headquarters on Pennsylvania Avenue after taking the 7:30 a.m. shuttle from LaGuardia. From Union President John Sweeny's office, I watched the Pentagon burn and men with stinger missiles mobilize on the White House roof. It took me nine hours to drive back to Westchester County, New York in a shared rental car. The hijackers killed five fathers from my parish including a family friend. Like all Americans I felt devastated by the loss of the architectural symbols of American economic power and the skyline of lower Manhattan. But as we rebuild our country, it is important to keep this experience in perspective. America has been through much worse - the world wars and civil wars are examples. In 1916, New York City endured a much greater explosion caused by foreign saboteurs when German spies bombed the Big Tom Ammunitions plant breaking windows 25 miles away.

During the Cold War, we lived our lives beneath the Damocles sword of nuclear annihilation. For 30 years, Americans faced the oscillating prospect of global destruction and went about their business fearlessly. I recall the atom bomb and drills during the Cuban Missile Crisis when the prospect of vaporization by atomic weapons was only 6 minutes away.

During that episode, my father refused a request by the U.S. Marshals that our family flee for a government bunker in the Blue Ridge Mountains. He assembled the eldest of his eight children and told us that he wanted us to continue attending school at Our Lady of Victory in downtown Washington, an example to other families that life must go on. My uncle, the President, also refused to leave Washington. He observed that in the event of a nuclear war, "the living will envy the dead". But he also knew that it was important to remind the world, and each other, that America is the land of the free and the home of the brave, that we would not be cowed, that we had faith in our future.

It's a good thing that Americans, now more than ever, are seeing themselves as part of the global community and viewing with greater empathy the suffering and hardships that are daily endured by our brothers and sisters around the globe. In New York, we lost 5,000 people, the Congo loses 10,000 a week, 1.5 million in total over the past three years. In Bosnia, tens of thousands were murdered, raped and wounded in fratricidal violence and reduced the nation to ruins. Rwanda, Ireland, Somalia, Ethiopia, Burundi, Israel and Palestine have in recent years all experienced strife that dwarfs our losses in downtown Manhattan. Before September 11th, their suffering seemed so far away. Now we understand that we are part of that community.

God has blessed us with an enemy who is truly evil. My generation was plagued by the ambiguities of Vietnam. The consequent failure of conviction plagued and divided our country and tore at our national sense of mission and community.

Today, Americans are united for the first time in decades and that is an extraordinary blessing.

Our greatest challenge as a nation is to find a common ground among our diverse peoples. America is unique in history. We are not united by common race, religion, culture, national origin, language or color. The only thing that unites us and allows us to call ourselves a community and a nation is shared values. We see this common ground most clearly in times like the present when we face an enemy who reminds us, by his own bad behavior, what it is about America that we love.

Finally, we are blessed by the example of the brave American soldiers who hold these common values in such high esteem that they are willing to fight and die for them.

Our challenge now is to pursue our enemy while not compromising the values that unite us as a country - our love for freedom, liberty, human rights, and humanity.

I was grateful after initial bellicose bluster from some American political leaders that America's response was measured and that we did not bomb civilian targets which would have made us no different than our enemies. I was grateful that we dropped more food than bombs - a uniquely American reaction.

If we fight the impulse to compromise our personal liberties at home or the human rights of innocents in the line of fire, as vigorously as we fight our enemies and root out their leaders, we can't help but claim the good from the evil of September 11th.

Robert F. Kennedy Jr., President Waterkeeper Alliance

fighting the forces

In January 2000 I wrote in a newspaper column that "the defining struggle of the new age would be between Terrorism and Security," and fretted that to live by the security experts' worst-case scenarios might be to surrender too many of our liberties to the invisible shadow-warriors of the secret world. Democracy requires visibility, I argued, and in the struggle between security and freedom we must always err on the side of freedom. On Tuesday, Sept. 11, however, the worst-case scenario came true.

They broke our city. I'm among the newest of New Yorkers, but even people who have never set foot in Manhattan have felt its wounds deeply, because New York is the beating heart of the visible world, tough-talking, spirit-dazzling, Walt Whitman's "city of orgies, walks and joys," his "proud and passionate city -- mettlesome, mad, extravagant city!" To this bright capital of the visible, the forces of invisibility have dealt a dreadful blow. No need to say how dreadful; we all saw it, are all changed by it. Now we must ensure that the wound is not mortal, that the world of what is seen triumphs over what is cloaked, what is perceptible only through the effects of its awful deeds.

In making free societies safe -- safer -- from terrorism, our civil liberties will inevitably be compromised. But in return for freedom's partial erosion, we have a right to expect that our cities, water, planes and children really will be better protected than they have been. The West's response to the Sept. 11 attacks will be judged in large measure by whether people begin to feel safe once again in their homes, their workplaces, their daily lives. This is the confidence we have lost, and must regain.

Next: the question of the counterattack. Yes, we must send our shadow-warriors against theirs, and hope that ours prevail. But this secret war alone cannot bring victory. We will also need a public, political and diplomatic offensive whose aim must be the early resolution of some of the world's thorniest problems: above all the battle between Israel and the Palestinian people for space, dignity, recognition and survival. Better judgment will be required on all sides in future. No more Sudanese aspirin factories to be bombed, please. And now that wise American heads appear to have understood that it would be wrong to bomb the impoverished, oppressed Afghan people in retaliation for their tyrannous masters' misdeeds, they might apply that wisdom, retrospectively, to what was done to the impoverished, oppressed people of Iraq. It's time to stop making enemies and start making friends.

To say this is in no way to join in the savaging of America by sections of the left that has been among the most unpleasant consequences of the terrorists' attacks on the United States. "The problem with Americans is ..." -- "What America needs to understand ... " There has been a lot of sanctimonious moral relativism around lately, usually prefaced by such phrases as these. A country which has just suffered the most devastating terrorist attack in history, a country in a state of deep mourning and horrible grief, is being told, heartlessly, that it is to blame for its own citizens' deaths. ("Did we deserve this, sir?" a bewildered worker at "ground zero" asked a visiting British journalist recently. I find the grave courtesy of that "sir" quite astonishing.)

Let's be clear about why this bien-pensant anti-American onslaught is such appalling rubbish. Terrorism is the murder of the innocent; this time, it was mass murder.

To excuse

of invisibility

Salman Rushdie[8]

such an atrocity
by blaming
U.S. government
policies
is to deny the
basic idea
of all morality:
that individuals
are
responsible
for
their
actions.

Furthermore, terrorism is not the pursuit of legitimate complaints by illegitimate means. The terrorist wraps himself in the world's grievances to cloak his true motives. Whatever the killers were trying to achieve, it seems improbable that building a better world was part of it.

The fundamentalist seeks to bring down a great deal more than buildings. Such people are against, to offer just a brief list, freedom of speech, a multi-party political system, universal adult suffrage, accountable government, Jews, homosexuals, women's rights, pluralism, secularism, short skirts, dancing, beardlessness, evolution theory, sex. These are tyrants, not Muslims. (Islam is tough on suicides, who are doomed to repeat their deaths through all eternity. However, there needs to be a thorough examination, by Muslims everywhere, of why it is that the faith they love breeds so many violent mutant strains. If the West needs to understand its Unabombers and McVeighs, Islam needs to face up to its bin Ladens.) United Nations Secretary General Kofi Annan has said that we should now define ourselves not only by what we are for but by what we are against. I would reverse that proposition, because in the present instance what we are against is a no-brainer. Suicidist assassins ram wide-bodied aircraft into the World Trade Center and Pentagon and kill thousands of people: um, I'm against that. But what are we for? What will we risk our lives to defend? Can we unanimously concur that all the items in the above list -- yes, even the short skirts and dancing -- are worth dying for?

The fundamentalist believes that we believe in nothing. In his worldview, he has his absolute certainties, while we are sunk in sybaritic indulgences. To prove him wrong, we must first know that he is wrong. We must agree on what matters: kissing in public places, bacon sandwiches, disagreement, cutting-edge fashion, literature, generosity, water, a more equitable distribution of the world's resources, movies, music, freedom of thought, beauty, love. These will be our weapons. Not by making war but by the unafraid way we choose to live shall we defeat them.

How to defeat terrorism? Don't be terrorized. Don't let fear rule your life. Even if you are scared.

Blaine and Robert Trump

SEPTEMBER 11, 2001

The date stands out like a thunderous explosion - a fireball of death, destruction, pain, anger, unbearable sadness and a loss of innocence. The world we know has changed forever. Never has there been such a dramatic differentiation between good and evil, heroes and villains, highlighting the best and worst mankind has to offer.

We believe September 11, 2001 will become a defining moment in history for generations to come. A time in which the tectonic plates of human culture around the world have shifted in much the same way geological faults cause powerful earthquakes and reformations of the earth itself. It is too soon to know what and how extensive these changes will be. Scholars and students alike will mark the tragic day as the end of a chapter in world history and the beginning of a new era. The nature and intent of enemies of the United States and our allies is clear. Terrorist groups and rogue nations wish to defeat those different from themselves, those who hold different beliefs and are tolerant of others. Terrorists believe that the end justifies the means - any means. This is not unique in world history - only the methods and battlefield differ slightly.

This war will be fought on many fronts by both sides. Conventional military force will be unleashed as is now taking place in Afghanistan with the

requisite bombing missions, missile attacks, carrier battle groups and jet fighter attacks. This war is also being waged in the intelligence gathering community throughout the world and in the world's economic and political arenas. There is no immediate or easy end in sight to this war - just the beginning as established on that fateful day of September 11, 2001.

The victims of the World Trade Center and Pentagon attacks are true heroes of freedom. These people typify the essence of what freedom represents and why it is so essential. None of the victims would have described themselves as heroes - but they are. They represent that which is the best of our society. Hard working firemen, police officers and EMS workers (whose job and calling in life was to help others), restaurant workers, bond traders, secretaries, maintenance workers, lawyers, bankers and the like were all working for themselves, their families and their society, each contributing and benefiting in his or her own way.

The heinous acts of September 11th may help to bring the world closer together in a common goal. The goal of incredible resolve. There are no winners if this war on terrorism fails - only losers.

The American people and all progressive societies around the world must see this war through to its successful conclusion. We must resolve to stay the course no matter how expensive, difficult and pervasive the struggle is.

We hope by these actions, history will one day record that on September 11, 2001 the struggle began to make the world a better and safer place. It is the heroes who perished that day who give us the strength and courage to prevail.

God bless America.

Instructions for use: Remove from newspaper. Place in window. **Embrace freedom.**

From the over 250,000 Kmart associates.

Bill Moyers

This isn't the speech I expected to give today. I intended something else.[9]

For the last several years I've been taking every possible opportunity to talk about the soul of democracy. 'Something is deeply wrong with politics today,' I told anyone who would listen. And I wasn't referring to the partisan mudslinging, or the negative TV ads, the excessive polling or the empty campaigns. I was talking about something deeper, something troubling at the core of politics. The soul of democracy - the essence of the word itself - is government of, by, and for the people. And the soul of democracy has been dying, drowning in a rising tide of big money contributed by a narrow, unrepresentative elite that has betrayed the faith of citizens in self-government.

This wasn't something I came to casually, by the way. It's the big political story of the last quarter century, and I started reporting it as a journalist in the late 70s with the first television documentary about political action committees. More recently, at the Florence and John Schumann Foundation, working with my colleague and son, John Moyers, we show how environmental causes were being overwhelmed by the private funding of elections that gives big donors unequal and undeserved political influence. That's why over the past five years the Schumann brothers - Robert and Ford - and our board have poured both income and principle into political reform through the Clean Money Initiative - the public funding of elections. I intended to talk about this - about the soul of democracy - and then connect it to my television efforts and your environmental work. That was my intention. That's the speech I was working on six weeks ago.

But I'm not the same man I was six weeks ago. And you're not the same audience for whom I was preparing those remarks.

We've all been changed by what happened on September 11. My friend, Thomas Hearne, the president of Wake Forest University, reminded me recently that while the clock and the calendar make it seem as if our lives unfold hour by hour, day by day, our passage is marked by events - of celebration and crisis. We share those in common. They create the memories which make of us a history, and make of us a people, a nation.

Pearl Harbor was that event for my parents generation. It changed their world, and it changed them. They never forgot the moment when the news reached them. For my generation it was the assassinations of the Kennedys and Martin Luther King, the bombing of the 16th Street Baptist Church, the dogs and fire hose in Alabama. Those events broke our hearts. We healed, but scars remain.

For this generation, that moment will be September 11th, 2001 - the worst act of terrorism in our nation's history. It has changed the country. It has changed us.

That's what terrorists intend. Terrorists

don't want to own
our land,
wealth,
monuments,
buildings,
fields, or streams.
They're not after
tangible property.
Sure, they aim to annihilate
the targets they strike.
But their real goal is
to get inside our heads,
our psyche,
and to deprive us
- the survivors -
of peace of mind,
of trust,
of faith,
they aim to prevent us from
believing again
in a world of mercy,
justice
and love,
or working
to bring
that better world to pass.

This is their real target, to turn our imaginations into Afghanistan, where they can rule by fear. Once they possess us, they are hard to exorcise.

This summer our daughter and son-in-law adopted a baby boy. On September 11 our son-in-law passed through the shadow of the World Trade Center to his office up the block. He got there in time to see the eruption of fire and smoke. He saw

the falling bodies. He saw the people jumping to their deaths. His building was evacuated and for long awful moments he couldn't reach his wife, our daughter, to say he was okay. She was in agony until he finally got through - and even then he couldn't get home to his family until the next morning. It took him several days fully to get his legs back. **Now, in a matter-of-fact voice, our daughter tells us how she often lies awake at night, wondering where and when it might happen again, going to the computer at three in the morning - her baby asleep in the next room - to check out what she can about bioterrorism, germ warfare, anthrax, and the vulnerability of children. Beyond the carnage left by the sneak attack terrorists create another kind of havoc, invading and despoiling a new mother's deepest space, holding her imagination hostage to the most dreadful possibilities.**

None of us is spared. The building where my wife and I produce our television programs is in midtown Manhattan, just over a mile from ground zero. It was evacuated immediately after the disaster although the two of us remained with other colleagues to help keep the station on the air. Our building was evacuated again late in the evening a day later because of a bomb scare at the Empire State building nearby. We had just ended a live broadcast for PBS when the security officers swept through and ordered everyone out of the building. As we were making our way down the stairs I took Judith's arm and was suddenly struck by the thought: is this the last time I'll touch her? Could our marriage of almost fifty years end here, on this dim and bare staircase? I ejected the thought forcibly from my mind like a bouncer removing a rude intruder; I shoved it out of my consciousness by sheer force of will. But in the first hours of morning, it crept back.

Returning from Washington on the train last week, I looked up and for the first time in days saw a plane in the sky. And then another, and another - not nearly so many as I used to on that same journey. But so help me, every plane I saw, and every plane I see today, invokes unwelcome images and terrifying thoughts. Unwelcome images, terrifying thoughts - time bombs planted in our heads by terrorists.

I wish I could find the wisdom in this. Then our time together this morning might have been more profitable for you. But wisdom is a very elusive thing. Someone told me once that we often have the experience but miss the wisdom. Wisdom comes, if at all, slowly, painfully, and only after deep reflection. Perhaps when we gather next year the wisdom will have arranged itself like the beautiful colors of a stilled kaleidoscope, and we will look back on September 11 and see it differently. But I haven't been ready for reflection. I have wanted to stay busy, on the go, or on the run, perhaps from the need to cope with the reality that just a few subway stops south of where I get off at Penn Station in midtown Manhattan, five thousand people died in a matter of minutes. One minute they're pulling off their jackets, shaking Sweet'n Low into their coffee, adjusting the picture of a child or sweetheart or spouse in a frame on their desk, booting up their computer - and in the next, it's all over for them.

I've been collecting obituaries of the victims. Practically every day the New York Times runs compelling little profiles of the dead and missing, and I've been keeping them. Not out of some macabre desire to stare at death, but to see if I might recognize a fact, a name, some old acquaintance, a former colleague, even a stranger I might have seen occasionally on the subway or street. That was my original purpose. But as the file has grown I realize what an amazing montage it is of life, an unforgettable portrait of the America those terrorists wanted to shatter. I study each little story for its contribution to the mosaic of my country, its particular revelation about the nature of democracy, the people with whom we share it.

Luis Bautista was one. It was his birthday, and he had the day off from Windows on the World, the restaurant high atop the World Trade Center. But back home in Peru his family depended on Luis for the money he had been sending them since he arrived in New York two years ago speaking only Spanish and there was the tuition he would soon be paying to study at John Jay College of Criminal Justice. So on the eleventh of September Luis Bautista was putting in overtime. He was 24.

William Steckman was 56. For thirty five of those years he took care of NBC's transmitter at One World Trade Center, working the night shift because it let him spend time during the day with his five children and to fix things up around the house. His shift ended at six a.m. ... but this morning his boss asked him to stay on to help install some new equipment, and William Steckman said sure.

Elizabeth Holmes lived in Harlem with her son and jogged every morning around Central Park where I often go walking, and I have been wondering if Elizabeth Holmes and I perhaps crossed paths some morning. I figure we were kindred souls. She too was a Baptist and sang in the choir at the Canaan Baptist Church. She was expecting a ring from her fiance at Christmas.

Linda Luzzicone and **Ralph Gerhardt** were planning their wedding too. They had both sets of parents come to New York in August to meet for the first time and talk about the plans. They had discovered each other in nearby cubicles on the 104th floor of One World Trade Center and fell in love. They were working there when the terrorists struck.

Mon Jahn-bul-lie came here from Albania. Because his name was hard to pronounce his friends called him by the Cajun "Jambalay" and he grew to like it. He lived with his three sons in the Bronx and was supposed to have retired when he turned 65 last year, but he was so attached to the building and so enjoyed the company of the other janitors that he often showed up an hour before work just to shoot the bull. In my mind's eye I can see him that morning, horsing around with his buddies.

Fred Scheffold liked his job too - Chief of the 12th battalion in Harlem. He loved going into fires and he loved his men. But he never told his daughters in the suburbs about the bad stuff in all the fires he had fought over the years. He didn't want to worry them. This morning, his shift had just ended and he was starting home when the alarm rang. He jumped into the truck with the others and at One World Trade Center he pushed through the crowds to the staircase heading for the top. The last time anyone saw him alive he was heading for the top. While hundreds poured past him going down through the flames and smoke, Fred Scheffold just kept going up.

Now you know why I can't give the speech I was working on. Talking about my work in television would be too parochial. And what's happened since the attacks would seem to put the lie to my fears about the soul of democracy. Americans have rallied together in a way that I cannot remember since World War Two. In real and instinctive ways we have felt touched - singed - by the fires that brought down those buildings, even those of us who did not directly lose a loved one. Great and low alike, we have been humbled by a renewed sense of our common mortality. Those planes the terrorists turned into suicide bombers cut through a complete cross-section of America - stockbrokers and dishwashers, bankers and secretaries, lawyers and janitors, Hollywood producers and new immigrants, urbanites and suburbanites alike. One community near where I live in New Jersey lost twenty-three residents. A single church near our home lost eleven members of the congregation. **Eighty nations are represented among the dead. This catastrophe**

has reminded us of a basic truth at the heart of our democracy: no matter our wealth or status or faith, we are all equal before the law, in the voting booth, and when death rains down from the sky.

We have also been reminded that despite years of scandals and political corruption, despite the stream of stories of personal greed and pirates in Gucci's scamming the treasury, despite the retreat from the public sphere and the turn toward private privilege, despite squalor for the poor and gated communities for the rich, we have been reminded that the great mass of Americans have not yet given up on the idea of 'We, the People' and they have refused to accept the notion, promoted so diligently by our friends at the Heritage Foundation and by Grover Norquist and his right-wing ilk, that government - the public service - should be shrunk to a size where they can drown it in the bathtub (that's what Norquist said is their goal.) These right-wingers at Heritage and elsewhere, by the way, earlier this year teamed up with the deep-pocket bankers who finance them, to stop the United States from cracking down on terrorist money havens. As TIME Magazine reports, thirty industrial nations were ready to tighten the screws on off-shore financial centers whose banks have the potential to hide and often help launder billions of dollars for drug cartels, global crime syndicates - and groups like Osama bin Laden's Al-Quaeda organization. Not all off-shore money is linked to crime or terrorism; much of it comes from wealthy people who are hiding money to avoid taxation. And right wingers believe in nothing if not in avoiding taxation. So they and the bankers' lobbyists went to work to stop the American government from participating in the crackdown of dirty money, arguing that closing down tax havens in effect leads to higher taxes on the poor people trying to hide their money. I am not kidding; it's all on the record. The president of the Heritage Foundation spent an hour, according to the New York Times, with Treasury secretary O'Neill, and Texas bankers pulled their strings at the White House, and presto, the Bush administration folded and pulled out of the international campaign against tax havens.

How about that for patriotism? Better terrorists get their dirty money than tax cheaters be prevented from hiding their money. And that from people who wrap themselves in the flag and sing the Star Spangled Banner with gusto. These true believers in the god of the market would leave us to the ruthless cruelty of unfettered monopolistic capital where even the law of the jungle breaks down.

But listen: today's heroes
are public servants.
The twenty-year-old dot com
instant millionaires and
the pugnacious pundits of tabloid
television
and the crafty celebrity stock pickers
on the cable channels
have all been exposed for
what they are
- barnacles on the hulk of
the great ship of state.
In their stead we have
those brave firefighters
and policemen and
Port Authority workers and
emergency rescue personnel
- public employees all,
most of them drawing a
modest middle-class income for
extremely dangerous work.
They have caught
our imaginations
not only for their heroic deeds
but because we know
so many people like them,
people
we took for granted.
For once, our TV screens
have been filled with the modest
declarations of average
Americans
coming to each other's aid.

I find this good, and thrilling, and sobering.

It could offer a new beginning, a renewal of civil values that could leave our society stronger and more together than ever, working on common goals for the public good. The playwright Tony Kushner wrote more than a decade ago: 'There are moments in history when the fabric of everyday life unravels, and there is this unstable dynamism that allows for incredible social change in short periods of time. People and the world they're living in can be utterly transformed, either for the good or the bad, or some mixture of the two.'

He's right. This could go either way. Here's one sighting: in the wake of September 11th there's been a heartening change in how Americans view their government. For the first time in more than thirty years a majority of people say we trust the Federal Government to do the right thing 'just about always' or at least 'most of the time.' It's as if the clock has been rolled back to the early sixties, before Vietnam and Watergate took such a toll on the gross national psychology. This newfound hope for public collaboration is based in part on how the people view what the government has done in response to the attacks. I have to say that overall President Bush has acted with commendable resolve and restraint. But this is a case where yet again the people are ahead of the politicians. They're expressing greater faith in government right now because the long-standing gap between our ruling elites and ordinary citizens has seemingly disappeared. To most Americans, government right now doesn't mean a faceless bureaucrat or a politician auctioning access to the highest bidder. It means a courageous rescuer or brave soldier. Instead of representatives spending their evenings clinking glasses with fat cats, they are out walking among the wounded. In Washington it seemed momentarily possible that the political class had been jolted out of old habits. Some old partisan rivalries and arguments fell by the wayside as our representatives acted decisively on a forty billion dollar fund to rebuild New York. Adversaries like Dennis Hastert and Dick Gephardt were linking arms. There was even a ten-day moratorium on political fundraisers. I was beginning to be optimistic that the mercenary culture of Washington might finally be on its knees. **But I once asked a friend on Wall Street what he thought about the market. "I'm optimistic," he said. "Then why do you look so worried?" And he answered: "Because I'm not sure my optimism is justified."**

I'm not either.

There are, alas, other sightings to report. It didn't take long for the war time opportunists - the mercenaries of Washington, the lobbyists, lawyers, and political fundraisers - to crawl out of their offices on K street determined to grab what they can for their clients. While in New York we are still attending memorial services for firemen and police, while everywhere Americans' cheeks are still stained with tears, while the President calls for patriotism, prayers and piety, the predators of Washington are up to their old tricks in the pursuit of private plunder at public expense. In the wake of this awful tragedy wrought by terrorism, they are cashing in.

Would you like to know the memorial they would offer the almost six thousand people who died in the attacks? Or the legacy they would provide the ten thousand children who lost a parent in the horror? How do they propose to fight the long and costly war on terrorism America must now undertake?

Why, restore the three-martini lunch - that will surely strike fear in the heart of Osama bin Laden. You think I'm kidding, but bringing back the deductible lunch is one of the proposals on the table in Washington right now. There are members of Congress who believe you should sacrifice in this time of crisis by paying for lobbyists' long lunches.

And cut capital gains for the wealthy, naturally - that's America's patriotic duty, too. And while we're at it don't forget to eliminate the Corporate Alternative Minimum Tax, enacted fifteen years ago to prevent corporations from taking so many credits and deductions that they owed little if any taxes. But don't just repeal their minimum tax; give those corporations a refund for all the minimum tax they have ever been assessed. You look incredulous. But that's taking place in Washington even as we meet here in Brainerd this morning.

What else can America do to strike at the terrorists? Why, slip in a special tax break for poor General Electric, and slip inside the Environmental Protection Agency while everyone's distracted and torpedo the recent order to clean the Hudson river of PCB's. Don't worry about NBC, CNBC, or MSNBC reporting it; they're all in the GE family.

It's time for Churchillian courage, we're told. So how would this crowd assure that future generations will look back and say 'This was their finest hour'? That's easy. Give those coal producers freedom to pollute. And shovel generous tax breaks to those giant energy companies; and open the Alaskan wilderness to drilling - that's something to remember the 11th of September for. And while the red, white and blue wave at half-mast over the land of the free and the home of the brave - why, give the President the power to discard democratic debate and the rule-of-law concerning controversial trade agreements, and set up secret tribunals to run roughshod over local communities trying to protect their environment and their health. It's happening as we meet. It's happening right now.

If I sound a little bitter about this, I am; the President rightly appeals every day for sacrifice. But to these mercenaries sacrifice is for suckers. So I am bitter, yes, and sad. Our business and political class owes us better than this. After all, it was they who declared class war twenty years ago and it was they who won. They're on top. If ever they were going to put patriotism over profits, if ever they were going to practice the magnanimity of winners, this was the moment. To hide now behind the flag while ripping off a country in crisis fatally separates them from the common course of American life.

Some things just don't change. Once again the Republican Party has lived down to Harry Truman's description of the GOP as guardians of privilege. And as for Truman's Democratic Party - the party of the New Deal and the fair deal - well, it breaks my heart to report that the Democratic National Committee has used the terrorist attacks to call for widening the soft money loophole in our election laws. How about that for a patriotic response to terrorism? Mencken got it right - the journalist H.L. Mencken, who said that when you hear some men talk about their love of country , it's a sign they expect to be paid for it.

Understandably, in the hours after the attacks many environmental organizations stepped down from aggressively pressing their issues. Greenpeace canceled its 30th anniversary celebration. The Sierra Club stopped all advertising, phone banks and mailing. The Environmental Working Group and the PIRG's postponed a national report on chlorination in drinking water. That was the proper way to observe a period of mourning. Furthermore, in work like this you have to read and respect the mood of a country in crisis, or a misspoken word, even a modest misstep, could lose you the public's ear for years to come.

But the polluters and their political cronies accepted no such constraints. Just one day after the attack, one day into the maelstrom of horror, loss, and grief, Republican senators called for prompt consideration of the President's proposal to subsidize the country's largest and richest energy companies. While America was mourning they were marauding. One congressman even suggested that eco-terrorists might be behind the attacks. And with that smear he and his kind went on the offensive in Congress, attempting to attach to a defense bill massive subsidies for the oil, coal, gas and nuclear companies.

To a defense bill! What a shameless insult to patriotism! What a slander on the sacrifice of our armed forces! To pile corporate welfare totaling billions of dollars

onto a defense bill in a emergency like this is repugnant to the nostrils and a scandal against democracy!

But this is their game. They're counting on your patriotism to distract you from their plunder. They're counting on you to be standing at attention with your hand over your heart, pledging allegiance to the flag, while they pick your pocket!
Let's face it: they present citizens with no options but to climb back in the ring. We are in what educators call "a teachable moment." And we'll lose it if we roll over and shut up.

What's at stake is democracy. Democracy wasn't canceled on the 11th of September, but democracy won't survive if citizens turn into lemmings.

Yes, the President is our Commander-in-chief, and in hunting down and destroying the terrorists who are trying to destroy us, we are "all the President's men" - as Henry Kissinger put it after the bombing of Cambodia. But we are not the President's minions. If in the name of the war on terrorism President Bush hands the state over to the energy industry, it's every patriot's duty to join the local opposition. Even in war, politics is about who gets what and who doesn't. If the mercenaries in Washington try to exploit the emergency and America's good faith to grab what they wouldn't get through open debate in peace time, the disloyalty will not be in our dissent but in our subservience. The greatest sedition would be our silence.

Yes, there's a fight going on - against terrorists around the globe, but just as certainly there's a fight going on here at home, to decide the kind of country this will be during and after the war on terrorism. To the Irishman's question - 'Is this a private fight or can anyone get in it?' - the answer has to be : "Come on in. It's our economy, our environment, our country, and our future. If we don't fight, who will?"

What should our strategy be? Here are a couple of suggestions. During two trips to Washington in the last ten days I heard people talking mostly about two big issues of policy: economic stimulus and the national security. How do we renew our economy and safeguard our nation? Guess what? Those are your issues, and you are uniquely equipped to address them with powerful language and persuasive argument.

For example: if you want to fight for the environment, don't hug a tree; hug an economist. Hug the economist who tells you that fossil fuels are not only the third most heavily subsidized economic sector after road transportation and agriculture - they also promote vast inefficiencies. Hug the economist who tells you that the most efficient investment of a dollar is not in fossil fuels but in renewable energy sources that not only provide new jobs but cost less over time. Hug the economist

who tells you that the price system matters; it's potential the most potent tool of all for creating social change. Look what California did this summer in responding to it's recent energy crisis with a price structure that rewards those who conserve and punishes those who don't. Californians cut their electric consumption by up to 15%.

Do we want to send the terrorists a message? Go for conservation. Go for clean, home-grown energy. And go for public health. If we reduce emissions from fossil fuel, we will cut the rate of asthma among children. Healthier children and a healthier economy - how about that as a response to terrorism?

As for national security, well, it's time to expose the energy plan before Congress for the dinosaur it is. Everyone knows America needs to reduce out reliance on fossil fuel. But this energy plan is more of the same: more subsidies for the rich, more pollution, more waste, more inefficiency. Let's get the message out.

Start with John Adams' wakeup call. The head of NRDC says the terrorist attacks spell out in frightful terms that America's unchecked consumption of oil has become our Achilles heel. It constrains our military options in the face of terror. It leaves our economy dangerously vulnerable to price shocks. It invites environmental degradation, ecological disasters, and potentially catastrophic climate change.

Go to Tompaine.com and you will find the two simple facts we need to get to the American people: first, the money we pay at the gasoline pump helps prop up oil-rich sponsors of terrorism like Saddam Hussein and Muammar al-Quaddafi. Second, a big reason we spend so much money policing the Middle East - $30 billion every year, by one reckoning - has to do with our dependence on the oil there. So John Adams got it right - the single most important thing environmentalists can do to ensure America's national security is to fight to reduce our nation's dependence on oil, whether imported or domestic.

I know you see the magnitude of the challenge. I know you see what we're up against. I know you get it - the work that we must do. It's why you mustn't lose heart. Your adversaries will call you unpatriotic for speaking the truth when conformity reigns. Idealogues will smear you for challenging the official view of reality. Mainstream media will ignore you, and those gasbags on cable TV and the radio talk shows will ridicule and vilify you. But I urge you to hold to these words: "In the course of fighting the present fire, we must not abandon our efforts to create fire-resistant structures of the future."Those words were written by my friend Randy Kehler more than ten years ago, as America geared up to fight the Gulf War. They ring as true today. Those fire-resistant structures must include an electoral system that is no longer dominated by big money, where the voices and problems of average people are attended on a fair and equal basis. They must include an energy system that is more sustainable, and less dangerous. And they must include a media that takes its responsibility to inform us as seriously as its interest in entertaining us.

My own personal response to Osama bin Laden is not grand, or rousing, or dramatic. All I know to do is to keep doing as best I can the craft that has been my calling now for most of my adult life. My colleagues and I have rededicated ourselves to the production of several environmental reports that were in progress before September 11. As a result of our two specials this year - Trade Secrets and Earth on Edge - PBS is asking all of public television's production teams to focus on the environment for two weeks around Earth Day next April. Our documentaries will anchor that endeavor. One will report on how an obscure provision in the North America Free Trade Agreement (NAFTA) can turn the rule of law upside down and undermine a

community's health and environment. Our four-part series on America's First River looks at how the Hudson River shaped America's conservation movement a century ago and, more recently, the modern environmental movement. We're producing another documentary on the search for alternative energy sources, another on children and the environment - the questions scientists, researchers and pediatricians are asking about children's vulnerability to hazards in the environment - and we are also making a stab at updating the health of the global environment that we launched last June with Earth on Edge.

What does Osama bin Laden have to do with these? He has given me not one but five thousand and more reasons for journalism to signify on issues that matter. I began this talk with the names of some of them - the victims who died on the 11th of September. I did so because I never want to forget the humanity lost in the horror. **I never want to forget the e-mail Forrester Church told me about - sent by a doomed employee in the World Trade Center who just before his life was over wrote: "Thank you for being such a great friend." I never want to forget the man and woman holding hands as they leap together to their death. I never want to forget those fireman who just kept going up; they just kept going up. And I never want to forget what Forrester said of this disaster - that the very worst of which human beings are capable can bring out the very best.**

I've learned a few things in my 67 years. One thing I've learned is that the kingdom of the human heart is large. In addition to hate, it contains courage. In response to the sneak attack on Pearl Harbor, my parents' generation waged and won a great war, then came home to establish a more prosperous and just America. I inherited the benefits of their courage. So did you. The ordeal was great but prevail they did.

We will, too, if we rise to the spiritual and moral challenge of survival. Michael Berenbaum has defined that challenge for me. As President of the Survivors of the Shoah Visual History Foundation, he worked with people who escaped the Holocaust.

Here's what he says:
"The question is what to do with the very fact of survival. Over time survivors will be able to answer that question not only by a statement about the past but by what they do with the future. Because they have faced death, many will have learned what is more important: life itself, love, family, community. The simple things we have all taken for granted will bear witness to that reality. The survivors will not be defined by the lives they have led until now but by the lives that they will lead from now on. For the experience of near death to have ultimate meaning, it must take shape in how one rebuilds from the ashes. Such for the individual; so, too, for the nation."

but by the lives we will lead from now on.

So go home - make the best grants you've ever made. And the biggest - we have too little time to pinch pennies. Back the committed and courageous people in the field - and back them with media to spread their message. Stick your own neck out. Let your work be charged with passion, and your life with a sense of mission. For when all is said and done, the most important grant you'll ever make is the gift of yourself, to the work at hand.

We're survivors you and I. We will be defined not by the lives we led until the 11th of September,

October 13, 2001

The World Trade Center Disaster: A sister-in-law's story.

I awoke late that morning of September 11, 2001, and turned on the television set for the latest news, when I was faced with a horrifying view of the World Trade Center Towers in flames. It was 9:05 a.m. It took me a few minutes to realize that my brother-in-law, a fire fighter with the New York Fire Department (NYFD), was stationed in Manhattan and might be in personal danger. I immediately called my sister. The phone lines were down. Luckily, I was able to reach her by cell phone. It seems my brother-in-law had gone to work early that morning and was on duty prior to 8:30 a.m. He liked to get to work early so he could relieve fire fighters who were coming off duty. My sister was growing increasingly anxious as she had been unsuccessful in reaching her husband by telephone since the incident. It was now about 9:30 a.m. My sister and I watched our respective television sets with bated breath, as we stayed on our cell phones, somehow unable to end the call.

We watched in horror as the towers burned. At 9:50 a.m. the first tower started collapsing ... from top to bottom ... one floor settling on top of another ... like a planned implosion ... huge billows of fire and smoke at the top ... people screaming and running in the streets below ... debris and thick clouds of smoke and white powder covering everything in its wake. People were seen jumping out of windows prior to the collapse, with powerless onlookers screaming in horror from street level. When the first tower collapsed, I found myself screaming "Oh my God, it's all over. It's all over. They're all dead." As my sister and I sobbed together, still connected by cell phone, we watched the second tower collapse at 10:28 a.m. We were speechless. The horror of that morning will stay etched in our minds and souls forever.

The
hours
that followed
the terrorist attack
were filled with
anxious anticipation
as we waited
for a
phone call
to let us know
that
my brother-in-law
was all right,
that he
survived
the buildings' collapse,
and that he was
out there doing what
he loved best,
helping people.

So we waited and
waited.

Hours turned into days.

Days turned

into weeks.

That call never came.

The days following the disaster are becoming but a vague and painful memory. As friends and family visited my sister with offers of food, money and emotional support, the entire community rallied in support. My brother-in-law's parents, brother, sister, and extended family came from Brooklyn, Pennsylvania, Long Island and Florida. They filled out a missing person's report and combed all area hospitals for any sign of their loved one. The Mayor of their town came to the house to offer my sister assistance. Local members

of the New York Police Department and New York Fire Department came by with daily reports from 'Ground Zero.' Our hope raised and crashed on a daily basis as the magnitude of the disaster was slowly revealed. It has now been four weeks since the initial disaster. The rescue operation has now become a recovery operation. My brother-in-law is still listed as 'missing.' His body has not yet been recovered.

On September 30, I was faced with the full impact of the disaster when I was taken on a tour of Ground Zero with other victims' family members by The Red Cross. As we approached downtown Manhattan, we were met by the smell of burning debris and death. It was a deeply disturbing reminder of the reality that surrounded us. Our van drove up to the park and marina on the water's edge behind The World Trade Center. We passed rows of wash stations guarded by people in protective clothing and masks. Small jeeps with EMS workers, OSHA workers, contractors, fire fighters and the police were in constant motion. Refreshment stations offered sustenance to the workers and families on site. We went on a walking tour of the Memorial for fire fighters and then approached the collapsed towers. As we faced the Center, with our backs to the water, I was struck with the background ... buildings whose facades had been devastated by the explosions, windows missing, soot everywhere, pieces of buildings and debris blowing in the wind. The two main towers were no more. The atrium over the Winter Garden was scarred with a large gaping hole where a piece of a neighboring building had come crashing through. I remembered the many times I had walked through that atrium on my way to meet business clients at the North Tower. The bridges connecting the differing buildings were sliced off, with much of the facades missing and their guts revealed. The apartment buildings adjacent, which housed some 3,000 people now stood vacant, abandoned after the disaster. Affected by toxic flying debris and structural instability, its inhabitants are now homeless, seeking shelter in friends' living rooms and hotels.

I was also struck with the details of what I saw. Workers wearing protective clothing from head to toes were kneeling in the bushes, carefully picking out debris from the landscape, a handful at a time. Office papers, crumpled and soot covered, could be seen everywhere, bringing a personal touch to the horrific scene.

When I looked up, I saw the perimeter of the two domes of adjacent buildings packed with debris, standing like two memorial wreaths of human remains. As we walked slowly and painstakingly toward 'Ground Zero,' the buildings faded into the background and we faced the enormous pile of debris and broken pieces of facade which were the North and South Towers. We were less than 50 feet away from the edge of the scene. Time stood still as we observed the scene we had seen countless times on television. We looked with incomprehension at the estimated million tons of debris ... mangled steel beams, stripped pieces of facades, sheets of metal studs and mounds of gray soot. There were no visible signs of human remains or belongings. No desks, chairs, file cabinets. Everything and everyone seems to have been pulverized as the 110 floors of concrete slabs toppled on each other. The people around me sobbed. Mothers screamed in anguish. A little girl, about 10 years old was carried away screaming hysterically by her older brother. As strangers standing together in this large graveyard where nearly 5,000 people were still missing, we mourned the loss of our loved ones and of our country's security. The ride back home was silent. We were emotionally drained by an experience which would not soon be forgotten.

On September 11, 2001, my brother-in-law, a NYFD fire fighter in Manhattan, was one of the first fire fighters on site after the North Tower of The World Trade Center was attacked. He was assigned to the 82nd floor from which he never returned. He was last seen climbing up one of the fire exit stairs as he helped people evacuate the building.

As a 'Proby,' my brother-in-law was a member of the New York Fire Department (NYFD) for only 2 months, looking forward to the end of his 3 month probation period, being sworn in and assigned to a permanent fire house. In one of the last conversations I had with him, he expressed how happy he was to get up every day and go to a job he loved. After much soul searching, he had taken a hefty pay cut from his previous job to join the NYFD, a job in which he felt he could make a difference. He was also an enlisted Marine and volunteer fire fighter in his small town in the suburbs of New York where he lived with his family. He leaves behind his wife and 3 young children, age 8 years, 6 years and 21 months.

Our
only
consolation
is that
he
died doing
what he loved
to do ...
he followed his heart.

Weeks after the initial disaster, my older niece and nephew still hold onto the hope that their father will be found. That is the most heart breaking part of this personal story. Their baby sister is too young to realize the loss. We are praying that with consistent love,

patience and counseling, they will be able to survive the loss of their beloved father and lead healthy and productive lives. When I look at my nieces and nephew, I am reminded of all the young children who have lost one or both parents in the disaster. I am saddened to think of the life events that will be missed ... birthdays, holidays, junior league games, school plays, graduations, weddings. It is truly devastating how one senseless act of violence can affect so many thousands of lives.

Since that unforgettable day of September 11, followed by weeks of anguish as the recovery of our missing loved one proved futile, I have searched for the meaning in all of this. Through personal experience, I have learned that all of life's events teach us valuable lessons. And, through my faith, I have learned that God uses all things for good. As I prayed that indeed some good might come out of this tragedy, I have watched America come together, help each other, turn to God and re-evaluate personal priorities. My heart and hope is being renewed as I watch one senseless act of violence being replaced with thousands of random acts of kindness by people throughout the world, who have rallied their support for the United States of America through kind words, donations and volunteering of time and services to help the victims and their families. Sadly, it has taken such a tragic event to remind us of who we truly are ... 'One Nation Indivisible, under God.' And, as a child of God, I only pray that the lessons we learn from this event include tolerance, forgiveness and peace. Let us refrain from further senseless acts of violence. Instead let us learn to love and practice random acts of kindness.

Martine Maurin

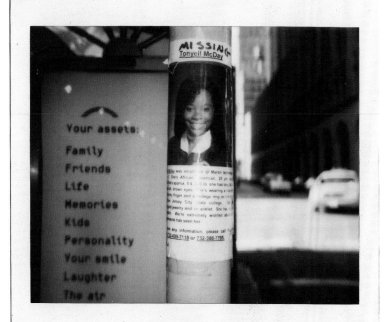

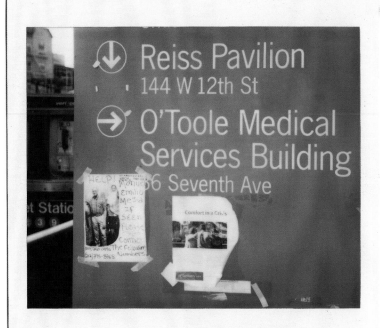

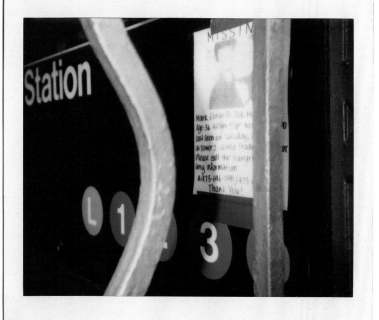

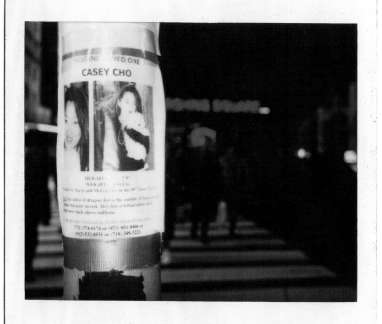

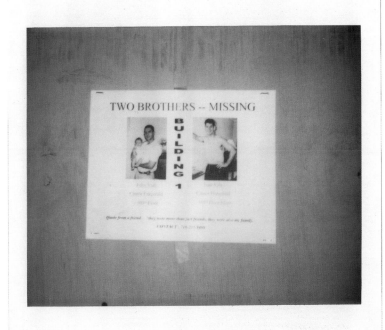

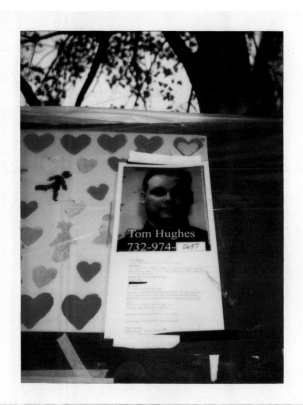

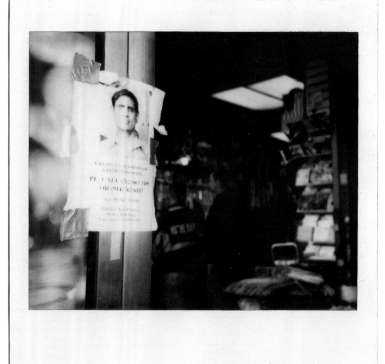

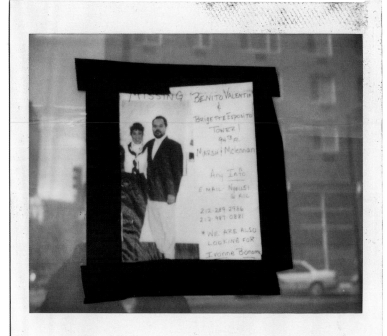
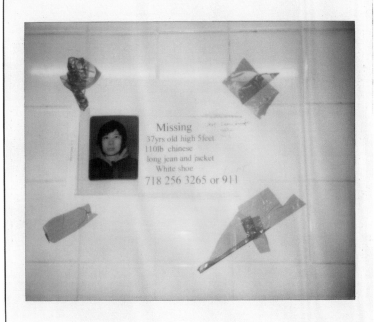
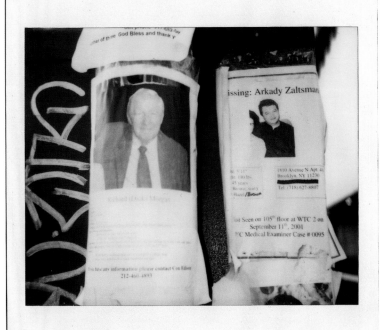

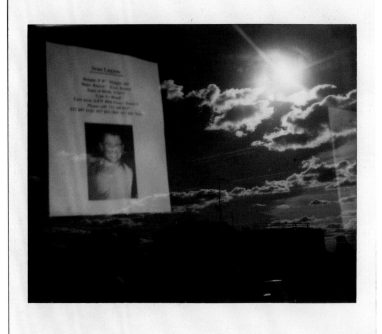

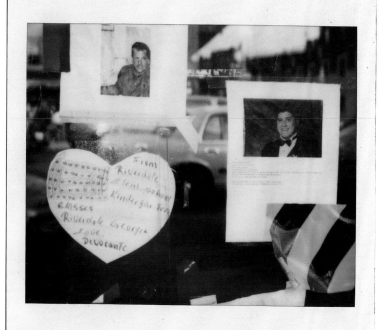

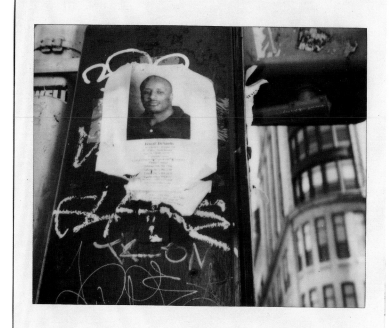

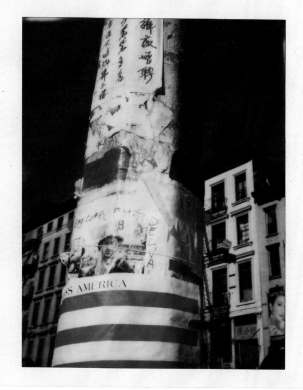

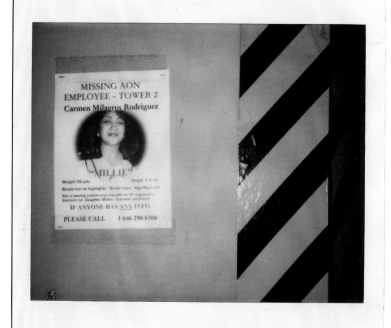

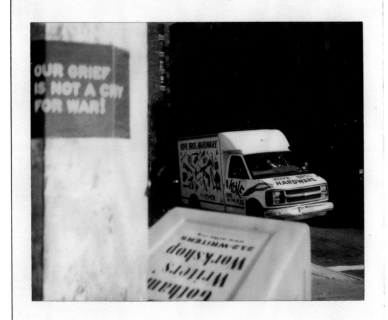

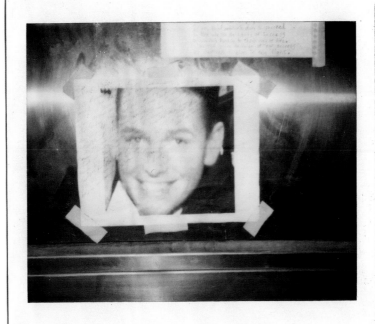

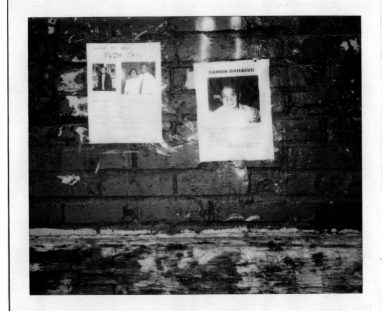

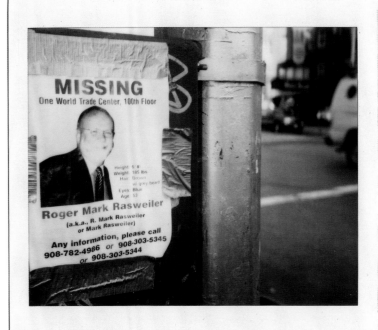

The Towers. What Do I Know About The World,

THIS:

WE HAVE STOLEN SOMETHING OF INCALCULABLE VALUE TO OUR CHIL

The Towers are the first inescapable fact of my life. They cannot be denied we define **it**.

Something can only be known by its absence. This is unbearably true: My future not of our desire but of bleak reality visible perhaps only years from with, took for granted, celebrated. **I hate the fact that we have entered the**

What Is Different Than Before?

DREN THAT WILL NEVER BE RECOVERED, AS INVISIBLE AS IT MAY BE.

or argued with, or made less of. **It** has happened. **It** is here now, however

America. My Frank Capra America is over. We are morphing into some alternate
now, but nonetheless I mourn the loss of the texture of the nation I grew up
world.
Richard Dreyfuss

Liam Neeson

Not being a wordsmith in the best of times, my mind is now like a desert in after the Sept. 11 tragedy.

For I cannot isolate that date from my early years of coming of age in war torn Northern Ireland where murder, mayhem, hatred, injustice and not a little fear were everyday occurrences.

The nationalities of the perpetrators were different, but their intentions were the exact same, namely to kill and to terrorize.

**Different
country,
same shit!**

However as my family physician Dr. Kevin Cahill recently said, as mentally scarred as we are by these traumatic events, we must never underestimate our capacity to heal and to grow, for we can and we simply must go on, and we all must learn from this disaster.

God Bless the Pope.

God save the Queen.

Allah is great!

search of moist words that might come close to describing my mental world

How My World Has Changed Since September the 11th.

My world has changed totally.

Nothing I love will ever again be looked at or touched or smelled or appreciated without a tiny wisp of sadness in some corner of my mind that will remind me all that is familiar or joyful or even aggravating can disappear in a moment.

My love for family and friends, always tucked away in a small part of my consciousness, has suddenly taken center stage and is no longer accepted merely as a fact of my life but rather as its very core.

I do not sleep and I am no longer able to read or watch anything that does not pertain to the events of September 11. Piles of magazines and books begin to make a small fortress of disbelief around my bed.

My humor stays intact, but there is no safe outlet for it. The same joke that makes one friend laugh makes another gasp.

What are the two rarest things to be found in the Taliban?

Happy women and a beard trimmer.

I hope you are the friend who is laughing. Joan Rivers

It was a day when we all saw our future differently.

By that moment I thought I had seen it all: as a former war correspondent for my newspaper in Bulgaria, and an International Red Cross delegate the last 12 years, I've seen a "bouquet" of the worst of all recent tragedies. I went through the agony in Beirut 20 years ago, the Cambodian blood bath, Afghanistan in the Spring of 1980, the long convulsions of Sarajevo, Kosovo, and Belgrade, the skeletons of starving Ethiopia, the body bags after the earthquake in Armenia, and the hell in Romania after Ceaucescu. I covered a long list of natural and man-made disasters, which caused my wife and parents hundreds of sleepless nights ...

But what I saw on 11 September, was something different. And it goes far beyond the two collapsing twin towers. It was the rising spirit out of the ruins, the gigantic effort made by thousands of firefighters, emergency medical teams, policemen and Red Cross workers, rushing to help all those who were still - or presumed - alive, or injured, or frightened ... Never have I seen such a Biblical scene where madness and compassion, terror and humanity, hatred and love, desperation and hope, brutality and kindness were so closely intertwined, like the melted steel columns of the collapsed towers and the bare arms of the brave rescuers searching for traces of life under the ruins.

Being a Red Cross man, I am expected to be neutral ... Yet, I will not be in this case, for my heart cannot remain neutral to what my colleagues from the American Red Cross in New York did. While I was trying to evacuate my team of International Red Cross representatives working in our Office in Mid-town Manhattan and at the UN building, calling meanwhile the schools where my son and daughter were supposed to be at this tragic morning, my American colleagues were already on the spot, saving other people's lives. Bob Bender, Mark Edelman, Dolores Swirin and many others had difficulties answering my calls. Not because the lines were busy - or scrambled - but because they were busy saving lives and souls.

It is now a well known history: the American Red Cross sent thousands of its volunteers to help the wounded City and the victims of this tragedy; collecting blood; clothes, cash, opening shelters; counseling those who were in tears; reunifying divided families or tracing the missing ... My guess is that the American Red Cross never had such a public response to its appeal: 200 million dollars donated in less than two weeks after the two gigantic fire balls over Manhattan ... Never had I in my life so many calls and e-mail messages from all over the US, and from all over the world, from Christians, Muslims, Hindus and Jews, offering their services to the Red Cross. A guest of mine, the Indian Red Cross Secretary General Dr. Ramalingham, who came to address an important UN meeting on the same day when the tragedy struck New York, offered immediately to donate blood. My colleague Bernt Apeland, a Norwegian, insisted on going right away to the site, "to dig out hope" buried under millions of tons of rubble ... Despite the heavily scrambled phone lines, friends from places as far as Zagreb, Ljubljana and Sofia called, asking: "Do you guys need our help?"

But this is not my point. The main story is, that a few days later, when the International Federation of Red Cross and Red Crescent Societies (IFRC), headquartered in Geneva, launched its appeal to assist an estimated one million Afghan refugees that could be heading to Pakistan, Iran, Tajikistan or Uzbekistan, the American Red Cross was among the first to respond to this appeal, by donating shelter and medical supplies for up to 50,000 people. "The fundamental principals of humanity, unity, impartiality not only guide us in New York City, but also our assistance to the Afghan refugees," said Doug Allan, Director of the American Red Cross' International Disaster Response Unit. The same offers came again, from all over the world ...

Now you know what my point is: while New York was still in tears, while rage and calls for retaliation were still in the air, full of dust and the bitter smell of Death, thousands of American citizens chose the Red Cross to channel money to Afghan refugees ...

This is not only amazing. This is a shocking act of courage and wisdom. This is what transformed New York from the City of grief to the City of rising hope. Hope for all, who are now seeing the future of the world differently.

Encho Gospodinov,
Head of Delegation, Permanent Observer to the UN in New York, International Federation of Red Cross and Red Crescent Societies.

THE CITY OF RISING HOPE . STRICTLY PERSONAL

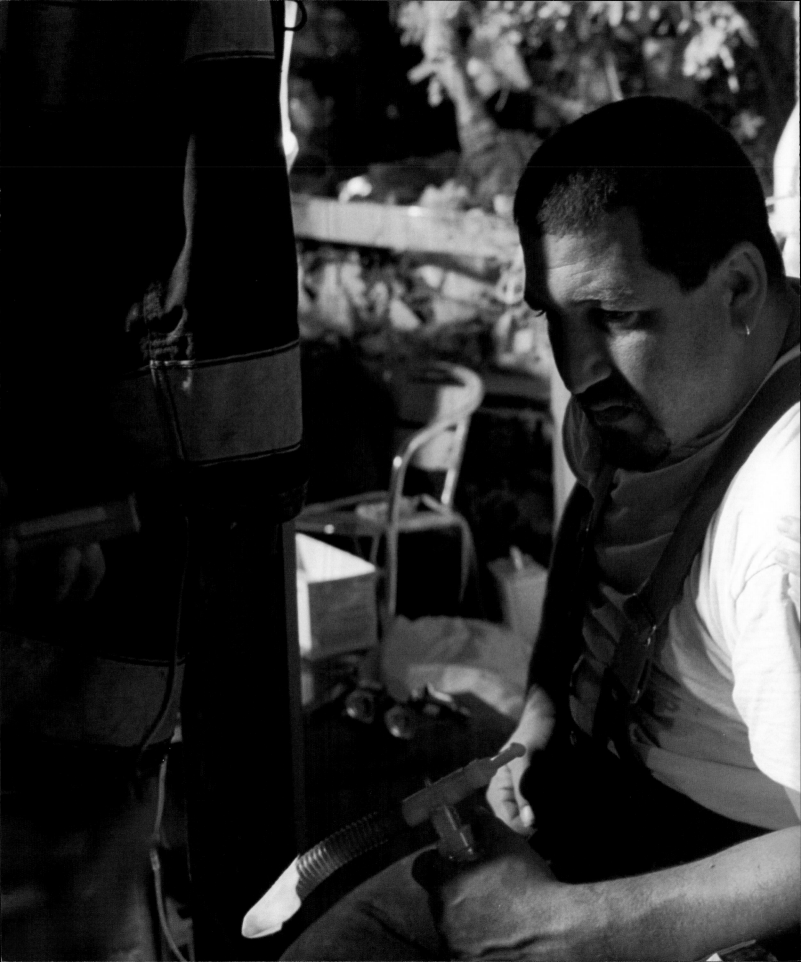

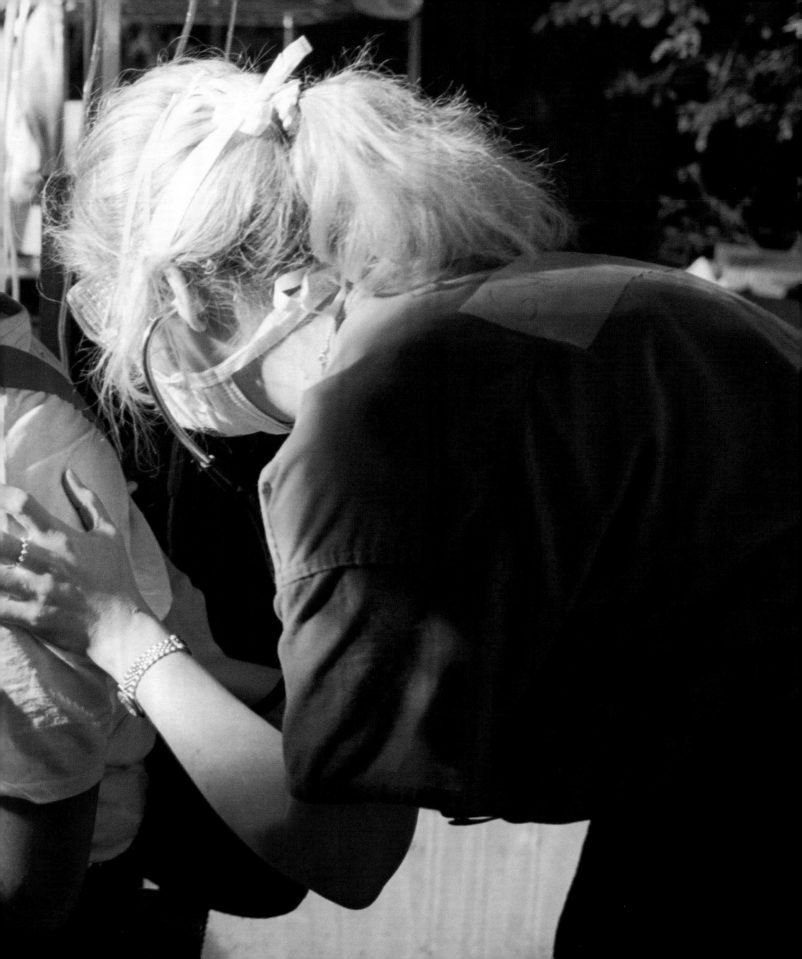

9.11.2001 Paul Owen

I was startled by the sound of a jetliner flying very low over my apartment building. I couldn't believe that it was flying in the city, below the height of the taller buildings. The engines were going full blast and the sound was intense. I watched the jetliner fly straight into one of the World Trade Towers.

Being an EMT I felt an immediate need and responsibility to help. I tried calling the hospitals to join an emergency squad. Soon my phone stopped working. I went to NYU to use my office phone. All hospital lines were busy. Someone told me that one of the towers just collapsed. I thought of all the people that would be in or near the building, and the need for even more help now.

I decided to go straight down to the Towers and try to hook-up with a squad. On my way, the second tower collapsed. People seemed awestruck and many were crying as they moved en masse uptown away from the attack site. A doctor and I were allowed to pass the police lines. The place was surreal. It looked like the aftermath of Mt. Saint Helens. Everything was covered with thick ashen dust. One had to wear a mask to breathe. I recall a street vendor's cart standing by the curb, abandoned, covered in dust, with all the bagels still piled high. I located an EMS squad from St. Vincent's, introduced myself and they said, "jump in." Their ambulance was covered with the ashen dust, all smashed in the back. I opened the back door to find the inside trashed. It looked like everything else around me. We drove closer but couldn't get through because of all the rubble. At this point I could see about a half block in the smoke and dust. We were told to go to Fulton Street. As we tried to work our way back and around we were instructed to set up a triage center at the Duane Street Fire Station. We gathered medical supplies and equipment for the hundreds of injured that we expected would soon be pouring in (I was concerned about the lack of oxygen tanks, especially because of the intense smoke and dust).

One fireman had been in the building when it fell. He had survived but was in critical condition. We sent him off in an ambulance and hoped he would be OK. We treated people who had been high in the towers, and managed to get out with minor injuries, so I knew that many must have escaped.

I was glad to be an EMT but felt inadequate, even while helping people. It was frustrating. We weren't allowed to go to the rubble because other buildings were still falling. **We knew that there were hundreds/thousands who needed help, but where were they?**

Did they not know that we had set up a triage center? The number of patients trickled to none. In the afternoon we moved all of our supplies to the Chelsea School, where the main triage center was being set up. Late that night we were still waiting around, with only the firemen going and coming from the burning ruins.

I still feel in a daze, almost calm. It must be a dream. Fortunately, I can sleep at night, perhaps because I never remember my dreams. Yet, the instant I awake a sadness and depression sweeps over me. It lingers if I don't get up and busy myself with preparing for the day.

The towers were like two huge light bulbs that made my bedroom bright, even with the blinds closed. Now I go to sleep with the smoky glow of "ground zero" lighting up my room. The smell of smoke, a constant reminder.

The world has changed. The city seems in a trance. I feel like I am wandering in an unfamiliar place, engulfed in deep sadness. I feel as though I need to be very careful, very gentle, as though everything might break. I walk a little slower and speak more carefully to people. I need to touch others, not to say that it's all right, because it isn't, but perhaps to confirm a need for each other. Everyone is caring and interested in others. That makes me feel good about being here.

I went to the country on Thursday afternoon. It was a beautiful sunny day, blue sky with fluffy white clouds. There were birds chirping, life seemed more peaceful than I ever remembered. I walked around trying to find some equilibrium between where I was and where I had just been.

Even now it is difficult to comprehend the contrast between that beautiful, peaceful day and the hateful destruction that so harshly interrupted it. I can still see the plane, flying away from me, as though in slow motion, like a crystal clear nightmare. I heard myself say "oh no" before the plane hit, knowing that it was going to.

I watched the jetliner fly straight into one of the World Trade Towers.

TWIN TOWERS

Uri Avnery

After the smoke has cleared, the dust has settled down and the initial fury blown over, humankind will wake up and realize a new fact: there is no safe place on earth.

A handful of suicide-bombers has brought the United States to a standstill, caused the President to hide in a bunker under a far-away mountain, dealt a terrible blow to the economy, grounded all aircraft, and emptied government offices throughout the country. This can happen in every country. The Twin Towers are everywhere.

Not only Israel, but the whole world is now full of gibberish about "fighting terrorism." Politicians, "experts on terrorism" and their likes propose to hit, destroy, annihilate etc., as well as to allocate more billions to the "intelligence community." They make brilliant suggestions. But nothing of this kind will help the threatened nations, much as nothing of this kind has helped Israel.

There is no patent remedy for terrorism. The only remedy is to remove its causes.

One can kill a million mosquitoes, and millions more will take their place. In order to get rid of them, one has to dry the swamp that breeds them. And the swamp is always political.

A person does not wake up one morning and tell himself: Today I shall hijack a plane and kill myself. Nor does a person wake up one morning and tell himself: Today I shall blow myself up in a Tel-Aviv discotheque. Such a decision grows in a person's mind through a slow process, taking years. The background is ideological -- religious, national or social.

No fighting underground can operate without popular roots and a supportive environment that is ready to supply new recruits, assistance, hiding places, money and means of propaganda. An underground organization wants to gain popularity, not lose it. Therefore it commits attacks when it thinks that this is what the surrounding public wants. Terror attacks always testify to the public mood.

That is true in this case, too. The initiators of the attacks decided to implement their plan after America has provoked immense hatred throughout the world. Not because of its might, but because of the way it uses its might. It is hated by the enemies of globalization, who blame it for the terrible gap between rich and poor in the world. It is hated by millions of Arabs, because of its support for the Israeli occupation and the suffering of the Palestinian people. It is hated by multitudes of Muslims, because of what looks like its support for the Jewish domination of the Islamic holy shrines in Jerusalem. And there are many more angry peoples who believe that America supports their tormentors.

Until
September 11, 2001
- a date to remember -
Americans
could
entertain the illusion
that
all
this
concerns
only
others,

in
far-away places
beyond
the seas,
that
it does not
touch
their
sheltered lives
at home. **No more.**

That is the other side of globalization: all the world's problems concern everyone in the world. Every case of injustice, every case of oppression. Terrorism, the weapon of the weak, can easily reach every spot on earth. Every society can easily be targeted, and the more developed a society is, the more it is in danger. Fewer and fewer people are needed to inflict pain on more and more people. Soon one single person will be enough to carry a suitcase with a tiny atomic bomb and destroy a megalopolis of tens of millions.

This is the reality of the 21st century that started this week in earnest. It must lead to the globalization of all problems and the globalization of their solutions. Not in the abstract, by fatuous declarations in the UN, but by a global endeavor to resolve conflicts and establish peace, with the participation of all nations, with the US playing a central role.

Since the US has become a world power, it has deviated from the path outlined by its founders. It was Thomas Jefferson who said: No nation can behave without a decent respect for the opinion of mankind. (I quote from memory). When the US delegation left the world conference in Durban, in order to abort the debate about the evils of slavery and in order to court the Israeli right, Jefferson must have turned over in his grave.

If it is confirmed that the attack on New York and Washington was perpetrated by Arabs - and even if not! - the world must at long last treat the festering wound of the Israeli-Palestinian conflict, which is poisoning the whole body of humanity. One of the wise guys in the Bush administration said only a few weeks ago: "Let them bleed!" - meaning the Palestinians and the Israelis. Now America is bleeding. He who runs away from the conflict is followed by it, even into his home. Americans, and Europeans too, should learn this lesson.

The distance from Jerusalem to New York is small, and so is the distance from New York to Paris, London and Berlin. Not only multinational corporations embrace the globe, but terror organizations do so, too. In the same way, the instruments for the solution of conflicts must be global.

Instead of the destroyed New York edifices, the twin towers of Peace and Justice must be built.

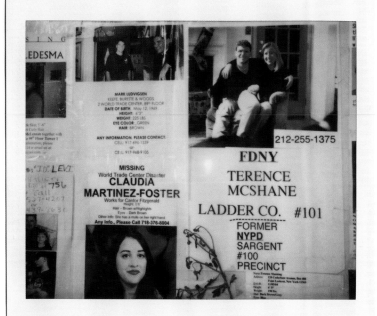

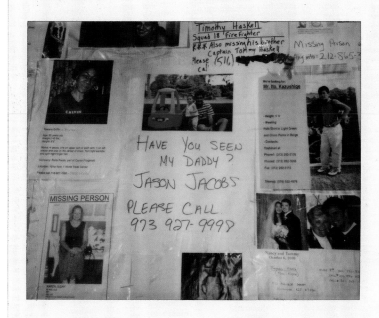

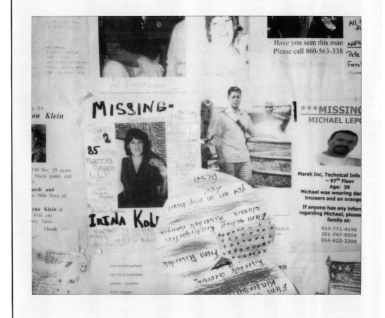

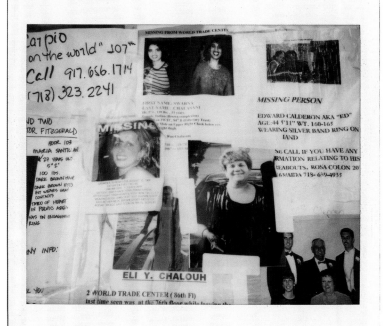

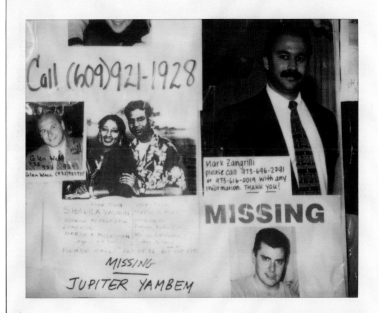

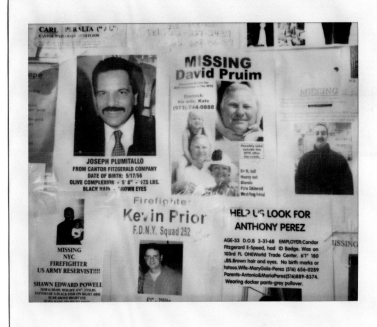

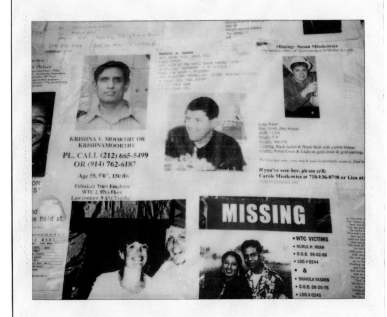

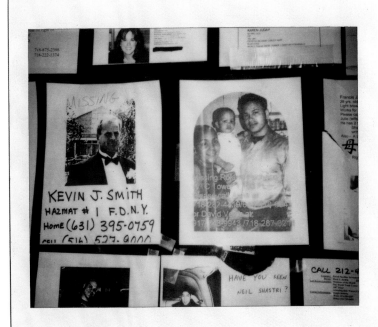

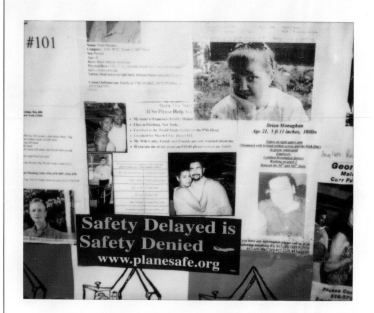

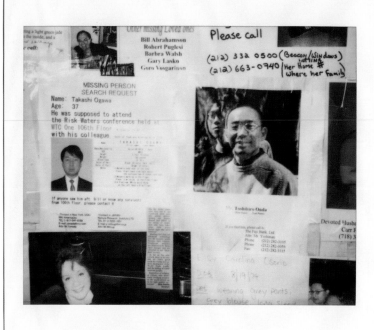

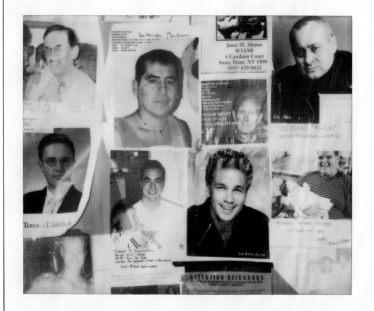

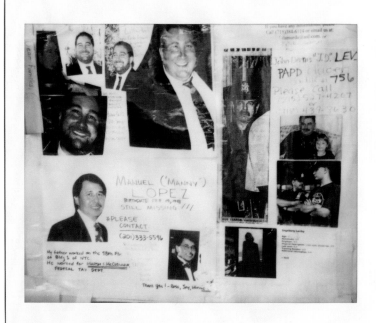

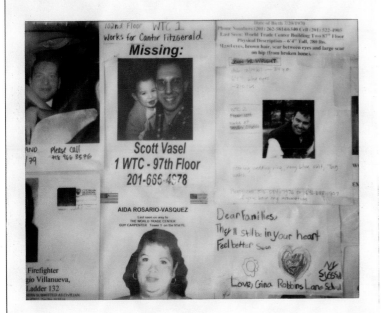

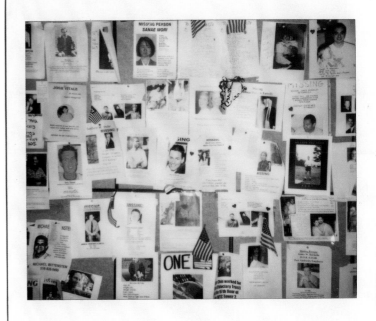

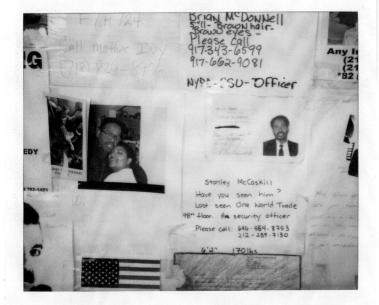

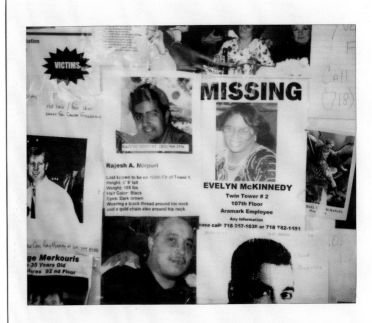

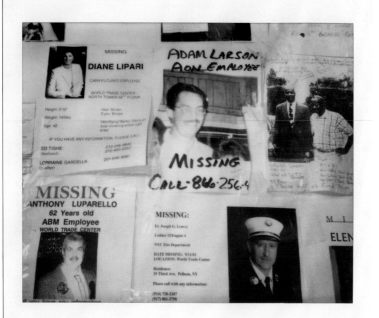

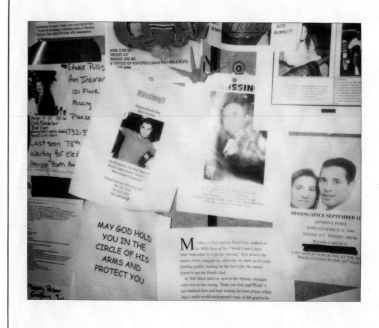

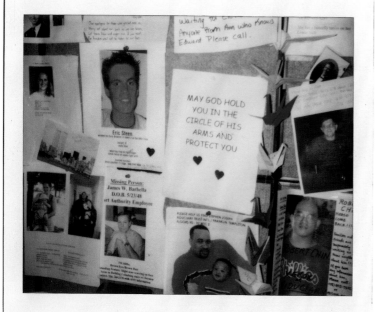

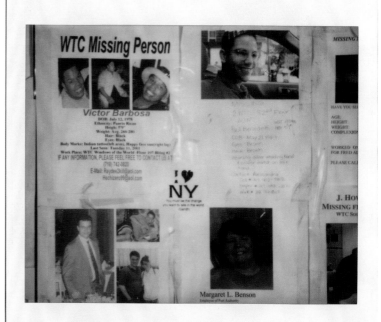

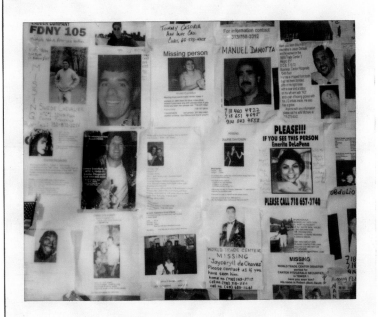

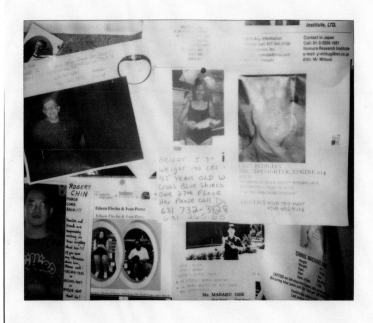

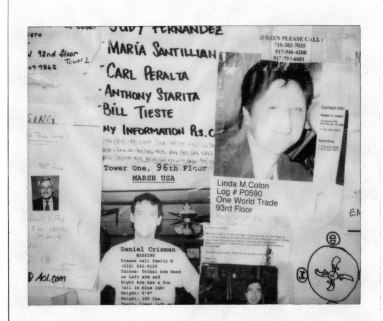

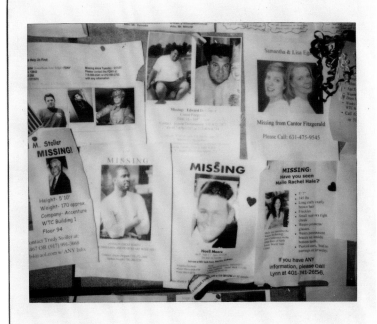

ST JOHN'S, NEWFOUNDLAND

TUESDAY, 11 SEPTEMBER 2001

At Malpensa airport in Milan it was 10.30 in the morning and I was about to board flight Delta 085 bound for New York. It was the first time I had flown with Delta. Previously I had always used TWA for crossing overseas, but a few months ago the company had cancelled its routes out of Italy. I remember that as I passed the American Airlines desk it occurred to me that I could just as well have booked with them. I had no idea that in a short while the logo with the two AA would be splashed across every television screen in the world.

We took off, on time, into an extraordinarily clear blue sky. "It will be a good trip," I thought as I settled myself and my belongings into three seats in the last row. "I will be able to read and sleep in peace."

I was in fact dozing peacefully when I was woken by an unusual noise. It was unidentifiable, certainly strange, as if the drowsy hum of the engines had suddenly changed its rhythm. Rubbing my eyes, I glanced at my watch. It must be 11 am in New York, I thought. Two hours and we will be landing at Kennedy.

"Ladies and Gentlemen," said the voice on the loudspeaker, "this is your captain speaking. I am sorry to have to tell you that because one of our passengers has been taken seriously ill, we have to make an emergency landing. Please will you return your seats to their upright position and fasten your seat belts..." Nothing to worry about, everything quite normal, pity about the delay ... I wonder which passenger has been taken ill.

But when we land no one leaves the plane.

ST JOHN'S NEWFOUNDLAND. A tiny airport surrounded as far as the eye can see by low-growing pines basking in mellow sunshine. Nothing else in sight. No ambulance, no one approaching the plane. Only a still, blue sky.

Then a military helicopter is wheeled out of a hangar. Further off, at the edge of the runway, a little knot of men in yellow jackets looks as if they are pointing at us excitedly. Later we will learn that it was not our plane they were pointing at but at 34 other aircrafts, invisible to us, that were preparing to land.

Again the calm voice of the captain on the loudspeaker: "Ladies and gentlemen, I must confess that I lied to you. We have landed not for a sick passenger but for a more serious safety reason."

My memories of the twelve hours following this announcement are confused. Twelve hours of being unable to leave the aircraft, plunged in a surreal atmosphere that was simultaneously calm and tragic. I have since heard many accounts, all different, but all sharing one thing: everybody remembers the moment in which they saw the Twin Towers on television.

But there was no television on board the plane. News arrived in bits and pieces. The captain announced that he was going to attend a briefing and would then tell us what he could. When he returned it was to say that we would have to go on waiting. The

phones on board were not working, nor, it seemed were the American mobile phones of those few fortunate enough to have them. European mobiles, like mine, were obviously out of range.

From time to time the captain played the radio through the loud-speaker, and we heard tense voices and fragmentary interpolations of which we could understand very little. A few passengers managed to tune portable radio transistors, but the news passing from seat to seat and row to row became ever more confused. The number of hijacked planes was first 3, then 4, then 5, then 8... at one point it was 15... There was a catastrophe in New York and also Washington ... the Pentagon was on fire... and the White House... The only certainty was that the United States was being subjected to some unimaginably devastating terrorist attack.

"The first name to crop up will be Bin Laden's," I said to the passenger seated nearest to me. "Who is Bin Laden?" Apparently no one around me had ever heard the name. I am afraid, I thought, that the name will become only too familiar. Their view was different. "The Palestinians," they asserted confidently, "it must be the Palestinians."

In the bar at the rear of the cabin, frustrated smokers had staked out their territory close to the open door. To prevent people falling out, two yellow ropes had been stretched across the opening, and by holding on to these it was possible to lean out and look around. Not that there was anything to see: it was now late at night and very dark.

Returning to my seat, I continued to think about Afghanistan. From the first moment I had heard about the attack I had linked it to the assassination two days earlier of Masoud, commander in charge of the anti-Taliban forces. Although the news agencies continued to say that he was not seriously wounded in the attack, I had no doubt that he was dead because not a single photograph of him had appeared since. I knew that the United States intended to support his fight against the Taliban, guilty - according to Washington - of hiding Bin Laden. Without Masoud, the legendary hero of the Panjshir Valley, the Northern Alliance was a headless body. The elimination in Afghanistan of such a charismatic leader threw an even more frightening light on the terrorist attack under way, and intimated an even more uncertain future.

People spoke very little, however, as if their perception of what was happening made any words superfluous. Consciously or unconsciously all of us, we transatlantic travellers, realized that the world awaiting us when we left that aeroplane would not be the same world we had left when we boarded it that morning.

Meanwhile everyone did what they could. The flight attendants dried their tears and prepared coffee, passengers volunteered their help and wheeled the refreshment trolley up and down the aisle. The hours crawled by.

By this time we knew that the twin towers of the World Trade Center, attacked by suicide pilots, were in flames.

Some slept, a few talked in hushed tones. There were three young honeymoon couples married only the day before. A stewardess had managed to recharge her mobile phone; as soon as this became known a queue of supplicants formed in the aisle. An elderly man whose wife was on crutches wept as he clutched the phone. He had learned that his daughter in New York was alive.

The United States will have to react, I thought. There will be a military response. But against whom? My thoughts returned to that tortured land I had left only three months ago. It has been called **the land of arrogance**. But it is also a land of beauty and of suffering.

Since the spring of 1996 I have been to Afganistan four times, first as a journalist, then on humanitarian missions for the United Nations. "A forgotten war," they said, "of which the media have grown tired." The media would now be pouring out rivers of words, about the Taliban, terrorism and Afghanistan, so tightly bound up with each other, so guilty.

But where will it leave those poor wretched people - the women, the old, the children with eyes the colour of jade, matted hair and faces covered with scabs - who for more than twenty years have been subjected to hunger and war, war and hunger and who have nothing to do with terrorism? More bombs will fall from the sky, and it will matter little to them whether they are dropped by the Russians, the war-like people whose struggle for power left their country in ruins, or by a faraway nation intent upon punishment.

All they know is that their homes will be destroyed and they will be forced to flee yet again.

How relative our perception of suffering can be!

In Afghanistan I saw houses reduced to rubble, the dead and the wounded lying in hospitals, amputees hobbling through the streets, women weeping over their children dying of starvation, illness, cold and dehydration. And felt a great surge of grief on their behalf. But those Twin Towers that were collapsing in New York seemed unreal. Only later, on reaching Manhattan, did the agony of thousands become a material, palpable fact.

to the covered stadium where our identities would be checked and we would be sorted out. In only a few short hours, St John's, a town of just over ten thousand inhabitants, had geared itself up to handle six thousand stranded passengers.

It happened as I passed all the fire stations with their little red lighted candles, bunches of flowers with cards written by children, and saw the survivors, tall grown men with faces -- from which horror had drained all expression. When I saw the hundreds of sheets of notepaper attached to lamp posts and walls, at Grand Central and Penn Station, with faded photographs. Young, smiling faces ... MISSING PERSON: was wearing a gold chain bracelet ... blue suit and white shirt ... tattoo behind the ear ... When I mingled with the slow-moving, continuous procession around Ground Zero in the silence, the acrid smell, the smoke, the hum of the generators, the exhausted activity of the rescue workers with their faces powdered by ash, the souls of the dead hovering in the air around, and saw the hundreds of teddy bears hanging among faded flowers on the railings beside the river. How much unnecessary, futile, unjustly-caused grief! Every day the pain would strike deeper into one's consciousness.

But my arrival in Manhattan was still six days away. Meanwhile, for the passengers traveling on Delta flight number 085, midnight (local time) came and went without our being any the wiser about what was going to happen to us. Then, at four in the morning, came the announcement that we were to prepare to disembark. All hand luggage had to be left in the aircraft, including mobile phones and computers. We were allowed to take only the barest necessities, wallets and passports to which, on our own initiative, we added blankets and pillows belonging to the airline.

In front of the airport a line of coaches was drawn up to ferry us

I still wonder at the efficiency, generosity and support shown by the people of the island. Before we had even gotten into the stadium, we were met on the approach road by a line of volunteers welcoming us with encouraging smiles, proffering sandwiches, apples, cakes and drinks. Inside were long tables laden with cups of hot tea and coffee and freshly-baked muffins and scones. Free telephone lines had been set up for us to contact our families waiting anxiously for news. The Red Cross, the Salvation Army and all the little local humanitarian organizations were present in full operational force, distributing medicines, toilet articles and blankets to those who needed them. "I have been on my feet all night," one cheerful volunteer told me, "and in two hours I have to be at my normal work. But that's OK. The only thing that matters is being able to help you."

Standing in the queue clutching my blanket as I waited my turn to register with the Red Cross, it was difficult to keep back the

tears. I had seen so many, so many refugees over the last few years. In Angola, Kenya, Sudan, Chechnya, Ingushetia, Bosnia, Kosovo, Afghanistan, Pakistan. I had seen them struggling, exhausted and terrorized, along the refugee routes. I had seen them as they arrived in the camps without a shred of a tent for protection against the rain or the burning sun. Or, even more sadly, installed in huts whose very solidity implied they had lost all hope of ever returning home.

women. Looking again at the newspapers bought at Malpensa on the morning of the 11th, it occurred to me that between then and this Sunday evening an eternity rather than five days had passed. And for once a rhetorical phrase seemed anything but banal.

At that moment, I was the refugee albeit in privileged conditions.

I was not escaping from a war, my house had not been destroyed. I had comfortable shoes on my feet, warm clothes on my back, and I had passport, money and credit cards in my pocket. Yes, I was a refugee, but - and it was this, I believe, that brought the lump to my throat - I had not been met by armed guards, humiliating checks and orders to be obeyed, but by these extraordinarily charitable people. For the next five days (and five sleepless nights) over a thousand of us were accommodated in private houses. Others were put up in schools, convention centers, military barracks. At every step we were helped, cared for, fed and comforted with never-failing warmth and generosity.

The passengers from our plane were camped in the ballroom of the Delta Hotel where, day and night, a gigantic television screen tuned in to CNN showed the planes crashing, the Twin Towers in flames, the collapse, the smoke, the terror. And the Pentagon on fire, and the President whose firm speech contrasted with the dismay in his eyes.

To get some fresh air into our lungs we walked through the narrow streets of the town and down to the port with its picturesque fishing boats moored beside the quay. One's companions in misfortune were immediately identifiable from the uniform we were wearing. For the sake of having a clean change of clothes we had all acquired local T-shirts and nearly everyone sported a crimson Maple Leaf on his or her chest!

However, we dared not stray too far from our collection points for fear of not hearing the loudspeaker announce the departure of our particular flight.

Delta 085 must have been one of the last to be called because it was Sunday evening by the time we were able to board once again. We all embraced the stewardesses we had not seen since that dark Wednesday morning. The crew was the same as before, and everything we had left on the plane was still in its place.

I found my bags and baggage intact, including, still lying on the seat, the case for my glasses. I would have been sad to lose this, for it was a precious memento, hand-embroidered by Afghan

But our journey was not yet over. No sooner had we taken off than we were told that we were not to land at New York but Atlanta. Here the enormous Delta's hub was congested with passengers in the same plight as ourselves. Pulling my trolley behind me, I was heading for the passengers-in-transit desk when I found myself greeted by a burst of applause. On both sides of the arrivals aisle Delta employees in uniform were clapping every passenger as they appeared. They looked as exhausted as any of us, and as I looked at them standing there with solemn faces, I thought sadly about the news of the crisis facing the airline industry and the consequent loss of jobs. More victims of September 11th, more human beings who, having done more than their duty required in the emergency, would perhaps, on account of it, be thrown out of work.

In Atlanta I was able to stay the night with a journalist friend working with CNN. To sleep in a proper bed, not having to share it with anyone, was wonderful. In the morning my friend's wife, Pia, drove me to the airport and - still uncertain as to whether I would actually arrive - I left for New York.

But everything went well and we arrived in bright afternoon sunshine. The route by which I had always come to New York on my way from Europe approached Kennedy Airport from the side away from Manhattan. Coming from the South this time, after flying low over the Statue of Liberty we dipped over Ground Zero before landing at La Guardia. So I was able to see the devastation in every detail, the smoke, the flames.

For too many days I had held back the tears. It was no longer possible. I wept uncontrollably. And when we entered the half empty terminal, I saw I was not the only one.

anna cataldi [10]

This is not a story of heroism or horror, but a fervent thank-you letter to Canada.

On the morning of 11 September I was on a Lufthansa flight from Munich to Newark. As we flew over the uninhabited far northeast of Canada, a voice from the cockpit announced that there had been "acts of terrorism" in New York and Washington, that United States borders and air space were closed, that Canadian airports were filling up with diverted planes and that we could expect at any time a 180 degree turn and a return to either Shannon or Munich.

In fact that did not happen and we were the last flight into Halifax Airport in Nova Scotia; later planes were sent to Gander and Greenland, according to information then available. As we approached, the airfield had the look of an aircraft parking lot with planes of many nationalities wing-tip to wing-tip as far as the eye could see. After nearly ten hours on the ground in the plane - with a carton of Doritos for food - we saw the headlights of a long line of school buses lumbering toward us for the trip from our corner of the airport to the terminal.

My first sight on emerging from Immigration to board another school bus was of the flag of Nova Scotia and the red and white Canadian flag flying at half-staff. It brought one near tears and was an indication of the unobtrusive but attentive kindness we were to be shown in the next several days beginning with the jolly driver who said that we were taller than his usual charges and the Volunteer Firemen who registered us for the 100 kilometer drive through the darkness to Camp Aldershot where incredibly young soldiers assigned us to bunk beds in dormitory rooms.

Perhaps it was two or three o'clock in the morning by the time we lined up in the Dining Hall and were fed a sumptuous breakfast of everything from juice and coffee to eggs, bacon, sausages, pancakes, yogurt, fruit, dished up by smiling ladies who must have been roused from their beds to prepare this. Wherever we offered our inadequate thanks, the response was always, "But we're glad to do it, we feel so sorry for you." One grey-haired Red Cross volunteer's answer was, "You helped us when we needed it." I was at a loss to think when until he said, "In 1917 when the ship blew up in our harbor."

We were some 1200 people, passengers from several flights, at Camp Aldershot where we spent the days trying to comprehend the unbelievable images on CNN, standing in line for towels and toothbrushes, to see the nurse or doctor, to request replacement prescriptions, to eat breakfast, lunch and dinner, to use the laundry facilities, and for access to the phones that had been set up for our free use. I learned from one of the soldiers that the Provincial Government had asked the citizens of Atlantic Canada to limit their own use of phones and Internet connections in order to free the circuits for our use.

Every few hours some new service or diversion was provided: cartons of toys for the children, sets of clothes for infants; tours of the area by Volunteer Firemen in their vans; offers by people of the town of rides into nearby Kentville. Then books and magazines appeared on a table in the main building and boxes of apples from the Valley's orchards. A Day Care Center for the children was set up by local people.

O CANADA !

Ruth Bains Hartmann

The night before we left, as we were eating our early supper outdoors in the unseasonably balmy weather, musicians appeared from town to be joined by an accomplished flutist from among the passengers for a concert of music and dance.

Our departure was sudden, one planeload at a time. With an hour's notice we were required to assemble with our belongings which by now included our cabin baggage (our luggage was still in the hold of the plane) and the items we had bought in Kentville to replace our

travel-dirty clothes; line up; sign out; show passports. We were given a box lunch at the door, then walked through a gauntlet of Red Cross volunteers waving Goodbye and set off in school buses past soldiers, at salute.

But this was not our departure from Canada. Our next stop was at the Motherhouse of Mount St. Vincent, a large hilltop complex overlooking Bedford Bay where we were warmly greeted, assigned rooms, single or double, with beds rather than bunks; bathrooms with shower curtains rather than communal facilities; and again given delicious food graciously served at dinner and an early breakfast.

The nuns waved us off at 9 AM Atlantic time on a 24-hour bus journey, with many stops, to Newark Airport. This was a strenuous and exhausting few days for me, but not a hardship, only an inconvenience, because, thanks to Canadian solicitude, I had been able, after many phone calls, to ascertain that my daughter, son-in-law and two grand-daughters who live just blocks from the disaster, had safely evacuated and were living in my West Side apartment.

To the Red Cross Volunteers and Volunteer firemen, the soldiers of Camp Aldershot, the citizens of Kentville, the nuns of Mount St. Vincent, my thanks and a wish that you never need help from such a disaster, but if you do, a hope that we can respond with equal speed, efficiency, kindness and grace.

Thank you.

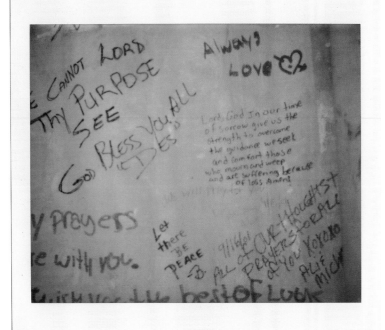

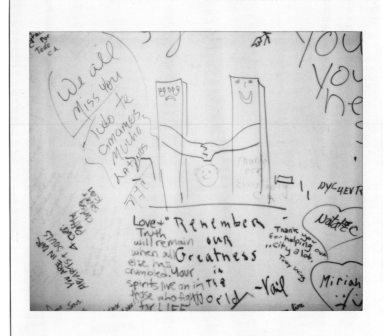

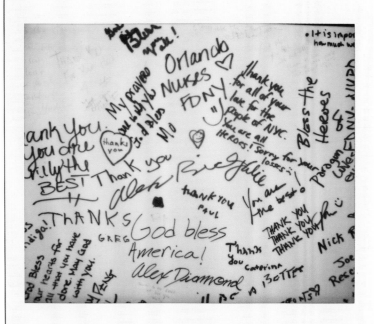

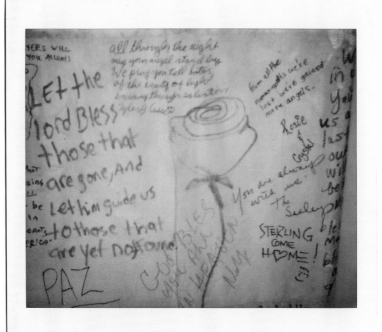

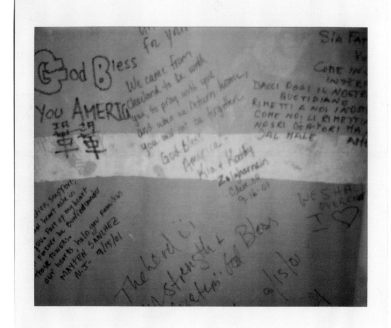

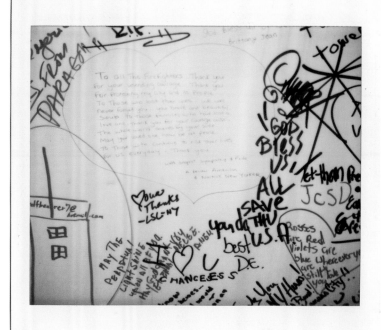

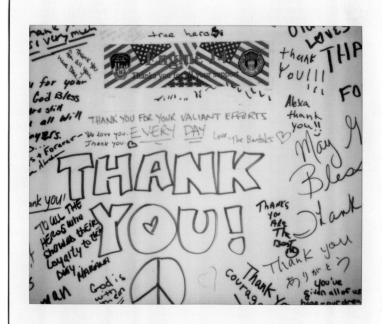

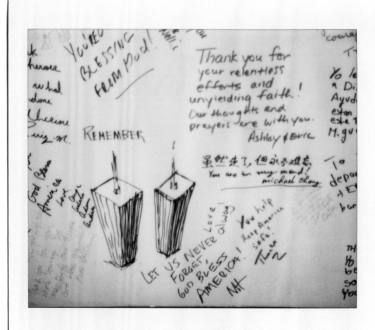

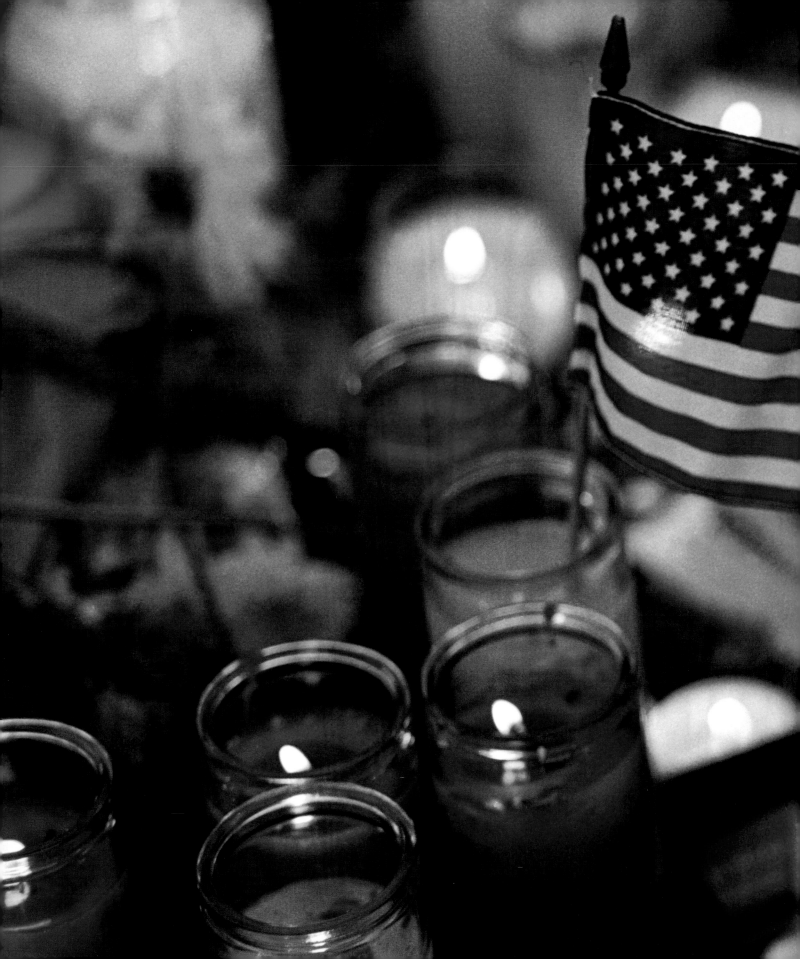

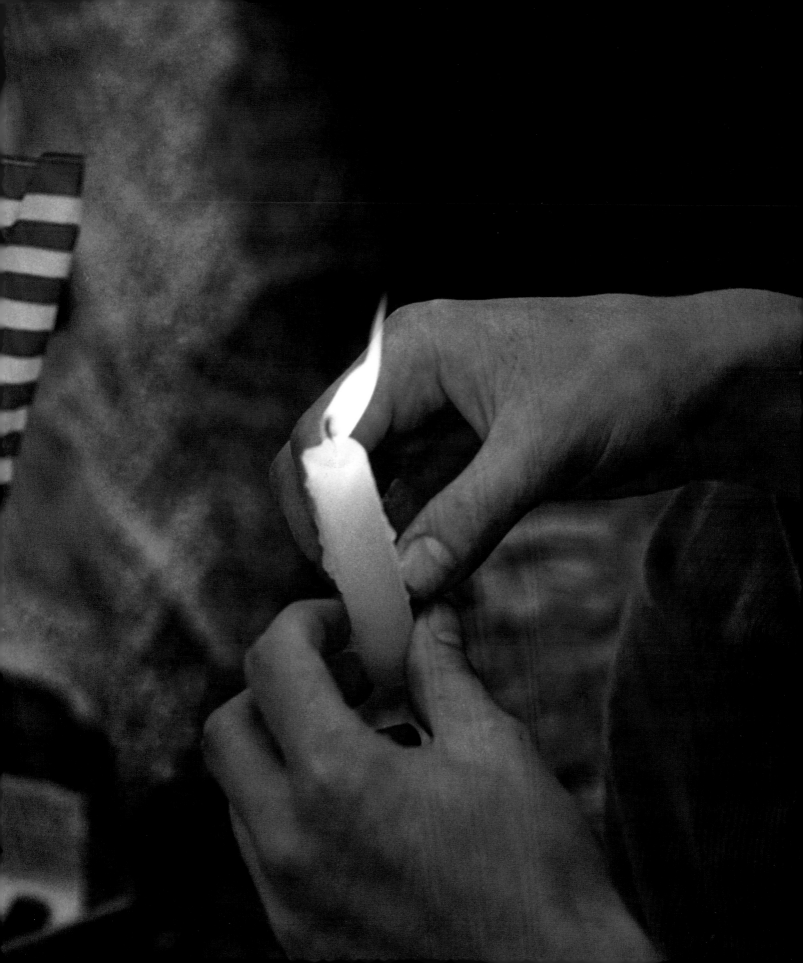

THE COUNTDOWN MOHSIN HAMID

My parents went out for dinner in Islamabad the other night. They sat among tables of foreign journalists who chatted about the war they had come to cover. My mother was frightened. She told my sister to consider leaving Pakistan. My sister refused.

She just graduated from college in June, from N.Y.U., as a matter of fact, and she loves her job. She does not intend to give it up. She is working on a television promo for the South Asian Federation Games, due to be held soon in Islamabad. The games may now be canceled, but in her office people are still trying to stay on deadline and on budget.

My sister says you just have to be careful. Stay away from public places, avoid large gatherings. Because people say the country may tear itself in two.

Recently, in the mosque near our house, there was a calm appeal to support the Afghans. They are desperately poor, it was said, running out of food and fuel for heat in the coming winter. Less temperate voices have called for civil war if the government supports America in an attack on Afghanistan. And the Taliban have moved troops to the border.

People in Pakistan were not awakened to the possibility of violence by a surprise attack that claimed the lives of thousands of unsuspecting innocents.

Instead,
they
have been
forced
to
watch
it
coming
from
far
off
in the
horizon,
as they
read
the
news
about
New York
and
Washington
and
waited
for
the
reverberations
of
these
distant
tragedies
to
reach them.

In that period of mounting dread, there were polite phone calls between heads of state and orderly airport closings. The embassies and multinational corporations sent home dependents and nonessential personnel. Twenty-four-hour news stations showed the gathering of carrier battle groups, special forces, aviation fuel.

People had time to see their lives changing.

Perhaps because she stays home when my father and sister go to work, my mother now seems the most frightened of the three. She is normally a woman of impeccable poise, so I find it unsettling to hear her voice slip from steady on the phone. "We could go," she says. "But what about your aunts and uncles and cousins? Not everyone can leave. So everyone stays." She tells me she attended a peace rally and watched as a small group of bearded protesters passed by, accompanied by a much larger flock of journalists. "It was as if they were the Beatles," she says. Despite everything, my mother has not lost her ability to be amused.

She watches television, still surprised that famous correspondents she has seen reporting from Bosnia and Somalia are now standing in front of buildings near the house. "I have complete sympathy for the Americans," she says. "It is terrible, what happened. But now they are so angry. They talk about a war on terrorism. But they never seem to think what they do terrifies normal people here."

I can remember seeing my father afraid only once, when I was in hospital as a child, before I underwent surgery for a vicious case of sinusitis. But having seen him then, I can imagine how he looks now -- his lips a bit pale, more wrinkles in his forehead.

"Nothing is happening," he says.

"The shops are empty. The streets are quiet. Even the police seem few and far between.

But every night we turn on the television,

and we see what is coming.

We just have no idea what it will mean for us."

Having no idea makes them nervous. An explosion brought my sister running from her bathroom. My parents reassured her the sound was only thunder. My sister, of course, claims she was not afraid. "The first few days, it was pretty bad," she says. "But then a week passes and you say, I can't wait forever. So you get on with it. I guess that must be a little bit like what people are doing in New York."

She used to live on Thompson Street, only a few blocks from my place on Cornelia. "You know," she considers, "I'm glad I'm not in New York now. When the attack happened, I almost wished I were there. I still felt more like a New Yorker than someone from Islamabad. But now I hear how scared my Pakistani friends are, the abuse they're getting, and I'm glad I'm not there. I don't want to remember New York that way."

So my family waits, like many families in Pakistan, watching battle plans being discussed on television, ex-guerrillas being interviewed about the Afghan terrain, radical figures threatening bloodshed if Pakistan helps America. Meanwhile, the long summer has come to an end in Islamabad. The city is green and bougainvilleas are blooming. Fresh pomegranates are arriving from nearby orchards, along with grapes and apples.

The fruit, which rarely makes the news, still makes people smile.[11]

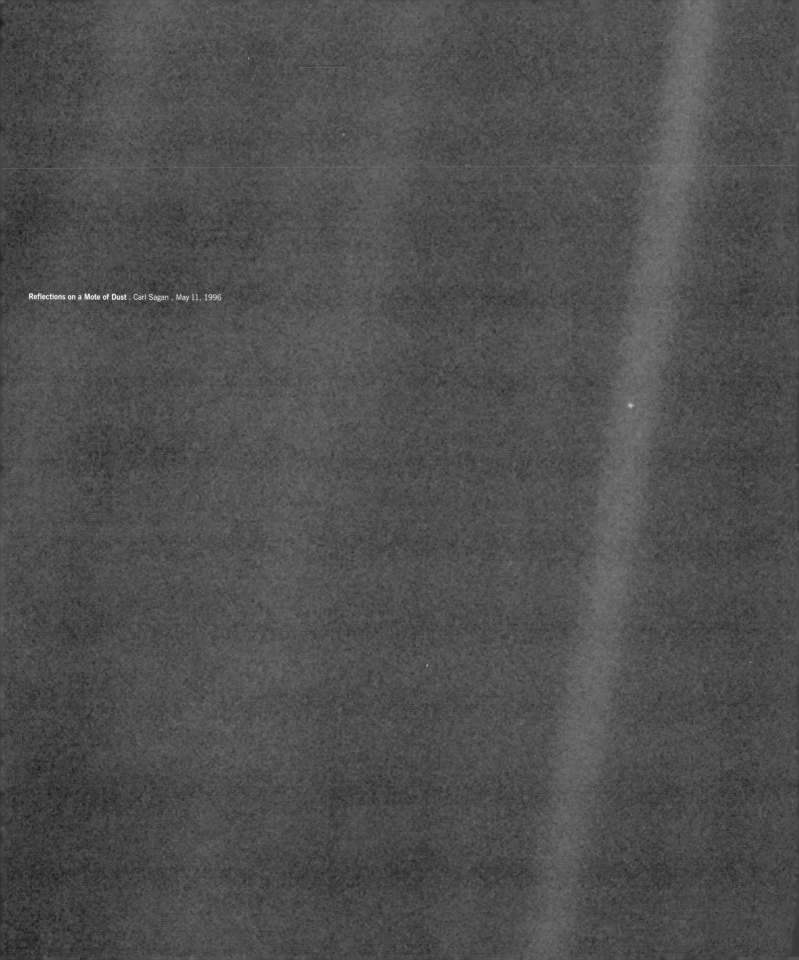

Reflections on a Mote of Dust . Carl Sagan . May 11, 1996

We succeeded in taking that picture (from deep space), and, if you look at it, you see a dot.

That's here. That's home. That's us.

On it, everyone you ever heard of, every human being who ever lived, lived out their lives. The aggregate of all our joys and sufferings, thousands of confident religions, ideologies and economic doctrines, every hunter and forager, every hero and coward, every creator and destroyer of civilizations, every king and peasant, every young couple in love, every hopeful child, every mother and father, every inventor and explorer, every teacher of morals, every corrupt politician, every superstar, every supreme leader, every saint and sinner in the history of our species, lived there on a mote of dust, suspended in a sunbeam.

The earth is a very small stage in a vast cosmic arena. Think of the rivers of blood spilled by all those generals and emperors so that in glory and in triumph they could become the momentary masters of a fraction of a dot. Think of the endless cruelties visited by the inhabitants of one corner of the dot on scarcely distinguishable inhabitants of some other corner of the dot. How frequent their misunderstandings, how eager they are to kill one another, how fervent their hatreds. Our posturings, our imagined self-importance, the delusion that we have some privileged position in the universe, are challenged by this point of pale light.

Our planet is a lonely speck in the great enveloping cosmic dark. In our obscurity -- in all this vastness -- there is no hint that help will come from elsewhere to save us from ourselves. It is up to us. It's been said that astronomy is a humbling, and I might add, a character-building experience. **To my mind, there is perhaps no better demonstration of the folly of human conceits than this distant image of our tiny world.**

To me, it underscores our responsibility to deal more kindly and compassionately with one another and to preserve and cherish that pale blue dot, the only home we've ever known. [12]

Created and Designed by: Giorgio Baravalle . de.MO
Editors: Giorgio Baravalle and Cari Modine with the collaboration of Ambreen Qureshi
Funds Coordinator: Lisa Alexander Walsh
Graphic Design Assistant: Kristin Bingman

Printed in the United States at Meridian Printing, East Greenwich, Rhode Island. Distributed by F&W Publications Inc., Cincinnati, Ohio.

Published in 2001 by de.MO 123 Nine Partners Lane Millbrook New York 12545 **www.de-mo.org** de.MO is a Trademark of design.Method of Operation Ltd.

First edition . Second print . Library of Congress Control Number: 2001119441 ISBN 0-9705768-2-X

Donors. All of the writers and the following photographers donated their contributions to this book: Samantha Appleton, Alan Chin, Gary Fabiano and Deborah Hardt. Jodi Brenner and MSNBC for donating the stills from video footage. Tanya Savickey & Peter Russell of ABIGGERBOAT Inc. for donating digital scanning and retouching services. Richard Hunt and F&W Publications for donating advertising and publicity services. **A special thank you to Cari Modine for her dedication and belief in this project.**

Thank you to my wife Elizabeth for her continuing inspiration and incredible patience. This project will not have been possible without you.

Notes
[1] Michael Daly, Daily News, Sunday September 30, 2001.
[2] This is an unofficial and partial list of people missing or confirmed dead as of 10.15.2001. For the World Trade Center it consists of 2,568 names taken from various news and newspapers sources. As of October 31 2001, according to Fox News, there are 3,692 persons missing. We will amend both lists in future editions, when the official version will be issued by the proper authorities. We apologize for any misspelled names or mistakes.
[3] Excerpt from interview by Svetlana Vukovic and Svetlana Lukic of Radio B92, Belgrade.
[4] Courtesy the New Yorker.
[5] Thomas L. Friedman, New York Times.
[6] Shashi Tharoor, a senior UN official, is the author of six books including, most recently, of the new novel *Riot* . A version of this article will appear on *The American Scholar*.
[7] *Deeper Wound: Recovering Your Soul from Fear and Suffering - 100 Days of Healing,* Harmony Books New York, New York.
[8] Courtesy of the Wylie Agency.
[9] Speech delivered to the Environmental Grantmakers Association, Brainerd, NM, October 16, 2001.
[10] Translated from Italian by Avril Bardoni.
[11] Mohsin Hamid is the author of *Moth Smoke*, a novel.
[12] Carl Sagan (1934-1996) excerpt from a commencement address delivered May 11, 1996.

 © The New York Times

 © Jules Naudet / Gamma

 © Richard Drew / Associated Press

 Stills from video footage of 2WTC hit by plane, 2WTC tower collapse, 1WTC tower collapse and Pentagon after being hit by plane, courtesy of MSNBC

 © Gary Fabiano

 © Shannon Stapleton / Reuters

 © Alan Chin

 © Deborah Hardt

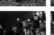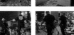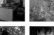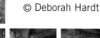 © Samantha Appleton

 All Polaroids © Ambreen Qureshi for de.MO

This narrow-angle color image of the Earth, dubbed 'Pale Blue Dot', is a part of the first ever 'portrait' of the solar system taken by Voyager 1. From Voyager's great distance Earth is a mere point of light. Coincidentally, Earth lies right in the center of one of the scattered light rays resulting from taking the image so close to the sun. This blown-up image of the Earth was taken through three color filters - violet, blue and green - and recombined to produce the color image.

ROBIN HOOD RELIEF FUND

At the request of hundreds of concerned New Yorkers and community leaders, Robin Hood has established the Robin Hood Relief Fund to help victims of the World Trade Center tragedy and their families.

The Robin Hood Relief Fund will do what Robin Hood has always done - find the most effective ways to help New Yorkers in need. In particular, Robin Hood will work to ensure that the needs of poor and lower-income victims of the World Trade Center attack are met in both the immediate and long term, including the families of those missing or injured, the heroic firefighters and police officers, and all others impacted by the economic consequences of this tragedy and its aftermath. Because Robin Hood's board of directors underwrites all administrative costs, 100% of the money raised will go directly to the most effective organizations aiding victims and their families.

The Robin Hood Relief Fund will operate separately from Robin Hood's continuing efforts to fight poverty in New York City. It will do what Robin Hood has always done - effectively help people in need. No money will be diverted from Robin Hood's ongoing frontline efforts to help poor New Yorkers build better lives for themselves and their families. Many of the groups Robin Hood currently supports throughout the city have already played key roles in relief efforts providing food, shelter, and health care to both victims and rescue workers.

Further contributions
can be made
online at www.robinhood.org
with a credit card.

Checks made payable to
The Robin Hood Relief Fund
can be mailed to
Robin Hood,
111 Broadway, 19 th Floor
New York NY 10006